STEVE BRODNER

LIVING & DYING IN AMERICA

STEVE BRODNER

LIVING & DYING IN AMERICA

A DAILY CHRONICLE
2020—2022

Fantagraphics Books Inc.
7563 Lake City Way NE
Seattle, WA 98115

www.fantagraphics.com
@fantagraphics

Editor: Gary Groth
Associate Editor: Kayleigh Waters
Designer: Jacob Covey
Production: Christina Hwang
Promotion: Jacq Cohen
VP / Associate Publisher: Eric Reynolds
President / Publisher: Gary Groth

ISBN: 978-1-68396-553-4
Library of Congress Control Number: 2021951175
First Fantagraphics Books edition: June 2022
Printed in China

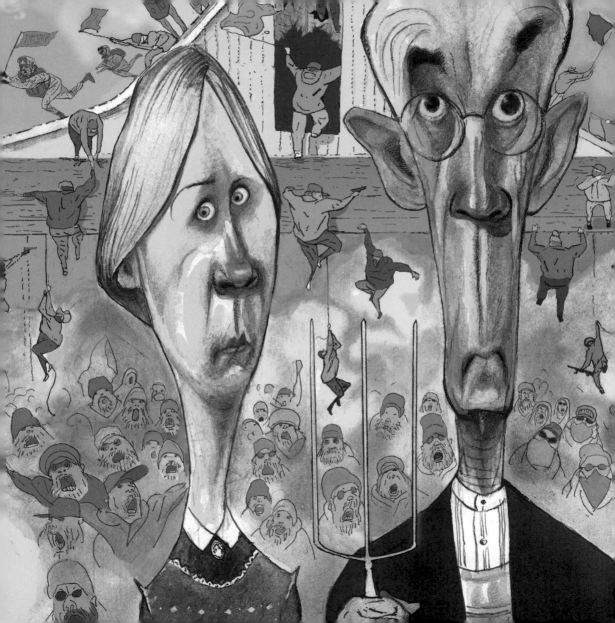

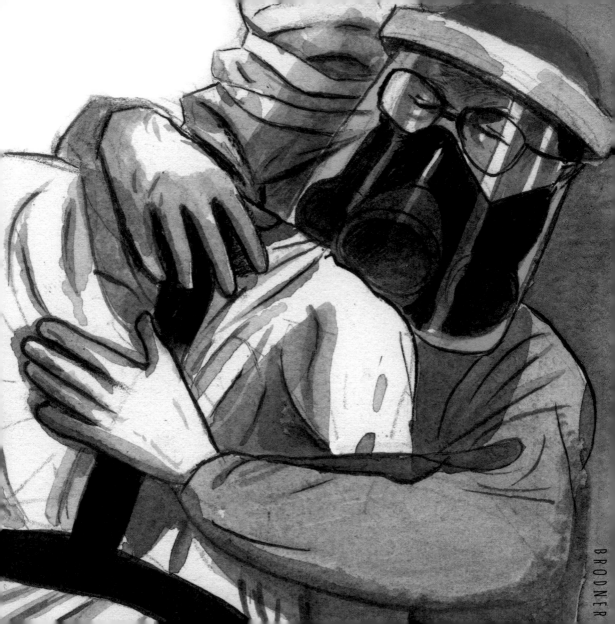

Edward Sorel
FOREWORD

Back in 1960, A.J. Leibling reminded his fellow citizens that "Freedom of the press is guaranteed only to those who own one." Steve Brodner knows the truth of that statement all too well. For although he is considered by many (including me) to be the most brilliant caricaturist working today, he finds fewer and fewer outlets for his no-holds-barred graphic commentary.

When, in the spring of 2020, Brodner felt compelled to chronicle the pandemic that was ravaging New York City and the world, he began his illustrated newsletter, LIVING AND DYING IN AMERICA. He was not the first man to document the devastation brought on by a plague. In the 17th century Samuel Pepys fastidiously kept a record of the effects that the bubonic plague had on London. It is thanks to the Pepys diary that we learn that one of the ways that Londoners protected themselves against the deadly virus was by drinking cognac with cow urine. (Trump's miracle cure, chloroquine phosphate, was still several centuries in the future.)

One difference between Pepys diary and Brodner's is that the Brit was a Secretary of the Admiralty, and never criticized another government official, no matter how corrupt or incompetent. Brodner, on the other hand, delights in mingling his sympathetic portraits of noble hospital workers with vicious portraits of Trump's hoodlums in high places.

It should be noted that although Brodner always carries around a heavy load of seething rage against political villains, he still manages to be a loving and enthusiastic teacher to his students at the School of Visual Arts, an amusing companion to his friends, and— when not savaging politicians— a comic artist with a delightful light touch that brightens one's day. ✳

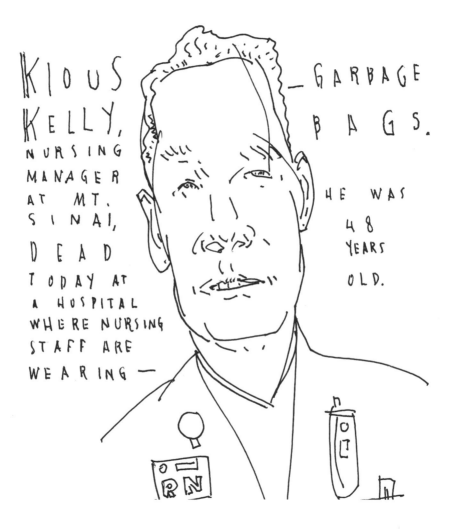

KIOUS KELLY, NURSING MANAGER AT MT. SINAI, DEAD TODAY AT A HOSPITAL WHERE NURSING STAFF ARE WEARING — GARBAGE BAGS.

HE WAS 48 YEARS OLD.

RABBI ROMI COHN, 91, BROOKLYN, SAVED 56 FAMILIES IN CZECHO-SLAVAKIA IN 1944, GIVING REFUGEES FALSE GERMAN IDS, DIED OF CORONAVIRUS TUESDAY.

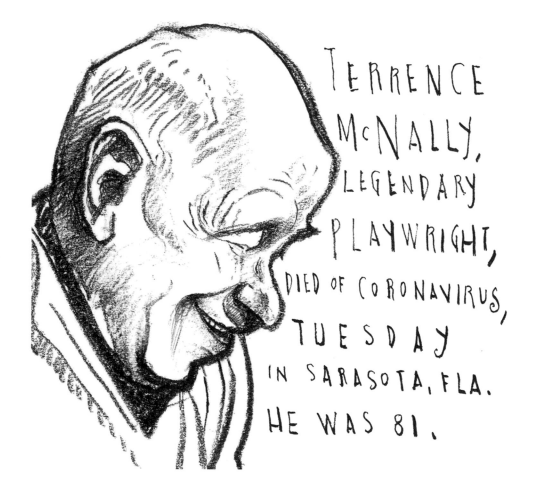

TERRENCE McNALLY, LEGENDARY PLAYWRIGHT, DIED OF CORONAVIRUS, TUESDAY IN SARASOTA, FLA. HE WAS 81.

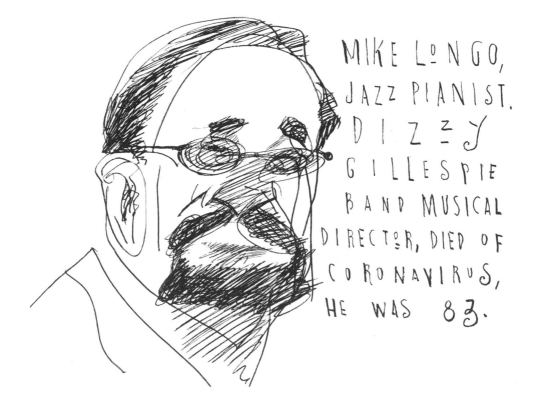

MIKE LONGO, JAZZ PIANIST. DIZZY GILLESPIE BAND MUSICAL DIRECTOR, DIED OF CORONAVIRUS, HE WAS 83.

TOMIE de PAOLA,
BELOVED CHILDREN'S BOOK
AUTHOR, ILLUSTRATOR.
DIED OF CORONAVIRUS.
MARCH 30

JENNY POLANCO: GROUND- BREAKING FASHION DESIGNER, 62.

DIED IN PANDEMIC.

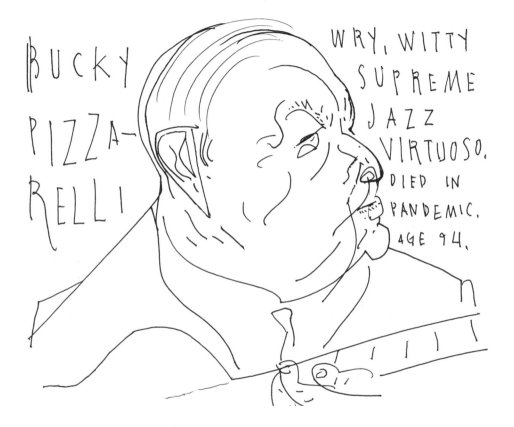

BUCKY PIZZA- RELLI

WRY, WITTY SUPREME JAZZ VIRTUOSO. DIED IN PANDEMIC, AGE 94.

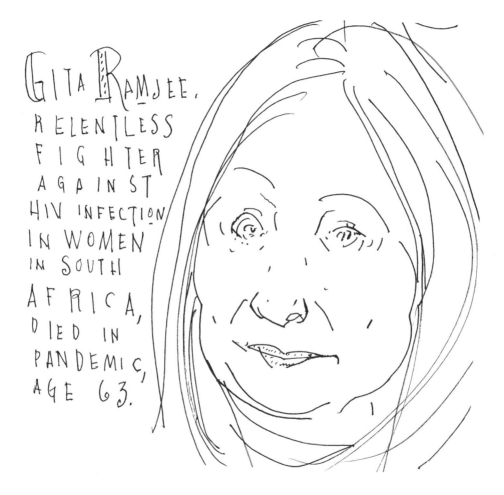

GITA RAMJEE,
RELENTLESS
FIGHTER
AGAINST
HIV INFECTION
IN WOMEN
IN SOUTH
AFRICA,
DIED IN
PANDEMIC,
AGE 63.

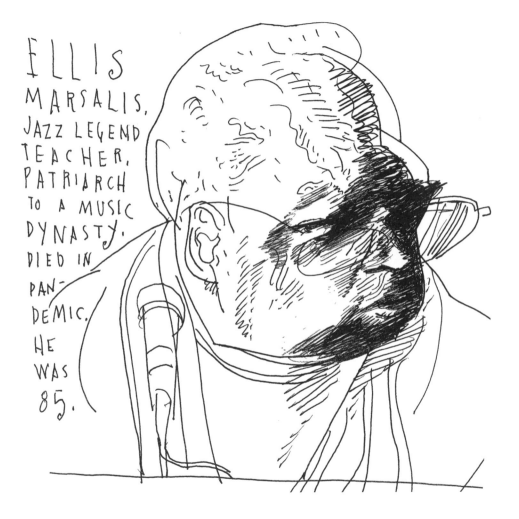

ELLIS MARSALIS, JAZZ LEGEND TEACHER, PATRIARCH TO A MUSIC DYNASTY, DIED IN PAN-DEMIC. HE WAS 85.

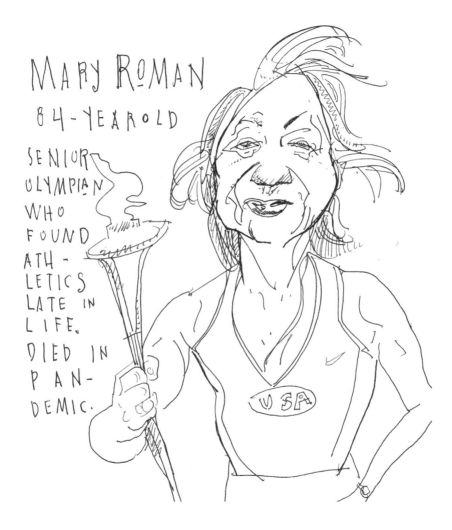

MARY ROMAN
84-YEAROLD

SENIOR
OLYMPIAN
WHO
FOUND
ATH-
LETICS
LATE IN
LIFE.
DIED IN
PAN-
DEMIC.

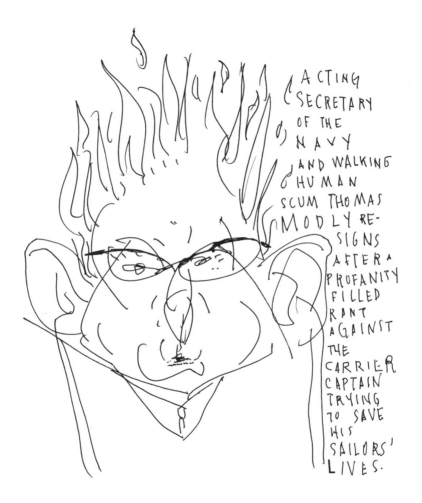

ACTING SECRETARY OF THE NAVY AND WALKING HUMAN SCUM THOMAS MODLY RESIGNS AFTER A PROFANITY FILLED RANT AGAINST THE CARRIER CAPTAIN TRYING TO SAVE HIS SAILORS' LIVES.

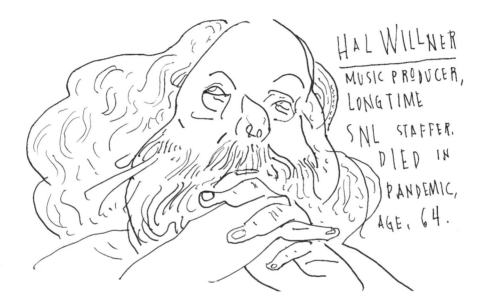

HAL WILLNER
MUSIC PRODUCER,
LONGTIME
SNL STAFFER.
DIED IN
PANDEMIC,
AGE, 64.

JOHN PRINE,
ESSENTIAL
SONGWRITER
AND GUITARIST.
HIS LYRICS
REFLECTED
LIFE AS
HE LIVED
AND SAW IT
IN ALL ITS
HEARTBREAK.
DIED IN PANDEMIC,
AGE, 73.

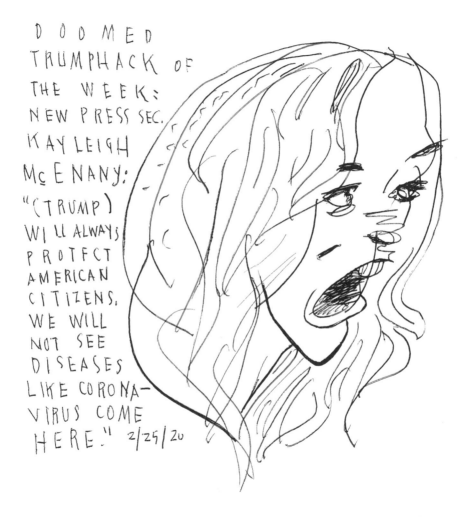

DOOMED
TRUMPHACK OF
THE WEEK:
NEW PRESS SEC.
KAYLEIGH
McENANY:
"(TRUMP)
WILL ALWAYS
PROTECT
AMERICAN
CITIZENS,
WE WILL
NOT SEE
DISEASES
LIKE CORONA-
VIRUS COME
HERE." 2/25/20

SANDRA SANTOS VIZCAINO, BELOVED 3RD GRADE TEACHER AT P.S. 9, BROOKLYN. DIED IN PANDEMIC. AGE 54.

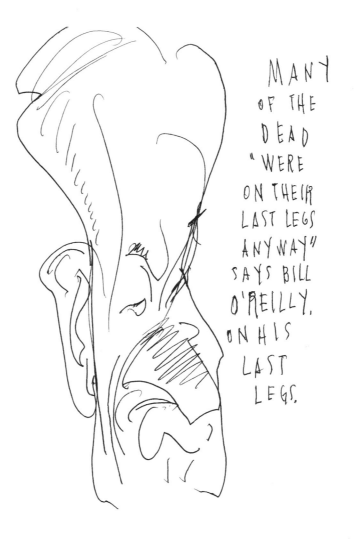

MANY
OF THE
DEAD
"WERE
ON THEIR
LAST LEGS
ANYWAY"
SAYS BILL
O'REILLY,
ON HIS
LAST
LEGS.

CORONAVIRUS RIPPING THROUGH US
NURSING HOMES, ASSISTED LIVING ETC. EXAMPLES:
IN WASHINGTON STATE, 163 LONG TERM FACILITIES,
200+ DEAD. RICHMOND, VA. : 39 DEAD AT ONE
NURSING HOME. IN SAN ANTONIO 17 OF 84 PEOPLE
INFECTED.

STAFF GETTING
INFECTED-
NOT
COMING
TO
WORK
-

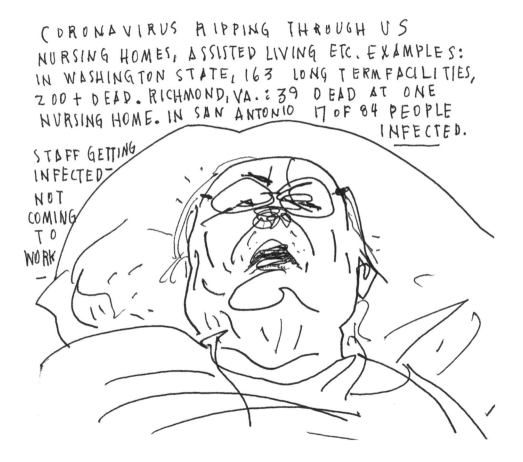

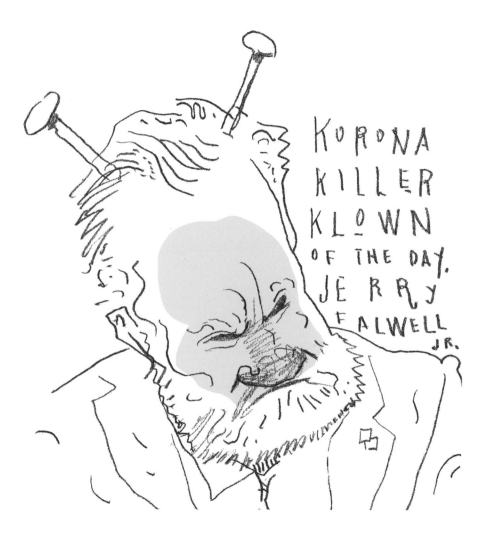

KORONA KILLER KLOWN OF THE DAY, JERRY FALWELL JR.

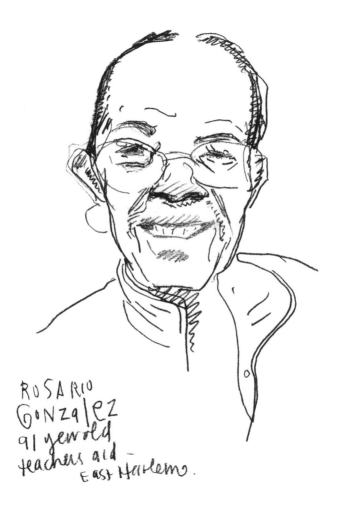

ROSARIO
Gonzalez
91 yer old
teachers aid —
East Harlem.

"IN OUR NEW AGE OF
TERRIFYING LETHAL
GADGETS, WHICH
SUPPLANTED SO
SWIFTLY THE OLD
ONE, THE FIRST
GREAT
AGGRESSIVE
WAR,
IF IT
SHOULD
COME,
WOULD
BE
LAUNCHED
BY

CBS

SUICIDAL
LITTLE MAD
MEN PUSHING
AN ELECTRONIC
BUTTON."
WILLIAM L. SHIRER,
"RISE AND FALL OF
THE THIRD REICH."

EARL BAILEY, 56, WAS A NURSE IN BROWARD COUNTY, FLA. HE WAS DETERMINED TO BEAT THE ILLNESS AT HOME SO HE WOULDN'T USE A HOSPITAL BED THAT OTHERS MIGHT NEED. HE WENT INTO CARDIAC ARREST THERE.

BENJAMIN HIRSCHMANN, 24, WAS AN INTERN FOR MICH. STATE SENATOR PETER LUCIDO. HIS DOCTOR TREATED HIM TELEPHONICALLY AND TOLD HIM TO USE COUGH SYRUP. HE WAS DENIED A COVID-19 TEST. HE DIED AT HOME.

EMILY WALLACE WAS A 67-YEAR-OLD WITH DOWN SYNDROME LIVING IN A GROUP HOME IN GA. SHE HAD A "DO-NOT-RESUSCITATE" LIVING WILL. OTHERWISE SHE MIGHT HAVE BEEN SUBJECT TO A TRIAGE DIRECTIVE ORDERING THAT THE INTELLECTUALLY DISABLED NOT BE GIVEN LIFE-SAVING SUPPORT.

ISRAEL "IZZY" TOLENTINO, 33, WAS A FIREMAN IN PASSAIC, N.J. HIS FRIENDS SAID HE WAS DEFINED BY HIS DRIVE TO HELP OTHERS: "IZZY CARED ABOUT EVERYONE FIRST."

NANCY JO McKEOWEN, 80, WAS A FORMER GENERAL ELECTRIC WORKER, A DAUGHTERS OF THE AMERICAN REVOLUTION, MEMBER AND A NURSING HOME RESIDENT IN LOUISVILLE. "THEY SAY I GOT THE VIRUS," SHE TOLD HER DAUGHTER, "I'M GONNA FIGHT THIS."

WILLIAM MIRANDA, 96, WAS INJURED AT OMAHA BEACH ON D-DAY IN 1944 AND RECEIVED TWO BRONZE STARS FOR HIS SERVICE. HE WORKED FOR 44 YEARS AS A MECHANIC AND ELECTRICIAN AT A STEEL MILL IN ASHLAND, KY.

PRISCILLA CARROW, 65, WAS A CO-ORDINATING MANAGER AT ELMHURST HOSPITAL IN QUEENS. SHE WAS TOLD TO SELF-QUAR-AN-TINE AFTER SHE WAS EXPOSED TO A PATIENT WITH THE VIRUS. SHE WAS PLANNING TO RETIRE THIS YEAR.

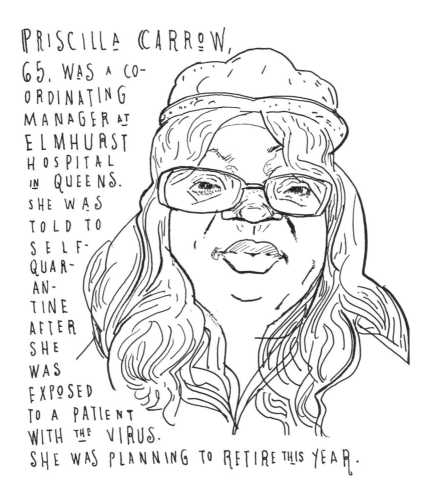

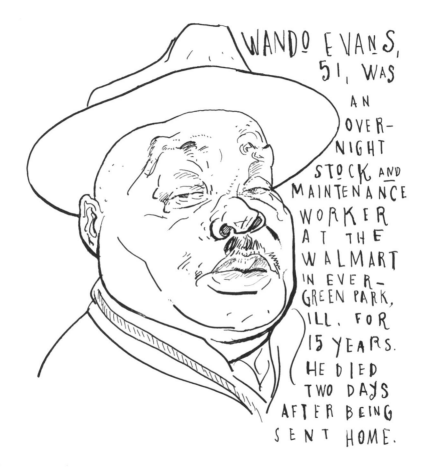

WANDO EVANS, 51, WAS AN OVER-NIGHT STOCK AND MAINTENANCE WORKER AT THE WALMART IN EVER-GREEN PARK, ILL. FOR 15 YEARS. HE DIED TWO DAYS AFTER BEING SENT HOME.

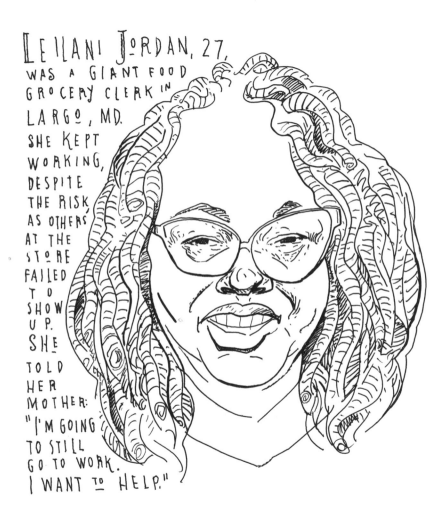

LEILANI JORDAN, 27, WAS A GIANT FOOD GROCERY CLERK IN LARGO, MD. SHE KEPT WORKING, DESPITE THE RISK, AS OTHERS AT THE STORE FAILED TO SHOW UP. SHE TOLD HER MOTHER: "I'M GOING TO STILL GO TO WORK. I WANT TO HELP."

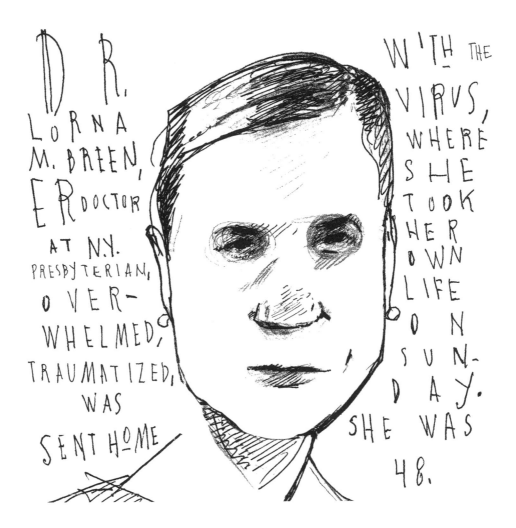

DR. LORNA M. BREEN, ER DOCTOR AT N.Y. PRESBYTERIAN, OVER-WHELMED, TRAUMATIZED, WAS SENT HOME WITH THE VIRUS, WHERE SHE TOOK HER OWN LIFE ON SUNDAY. SHE WAS 48.

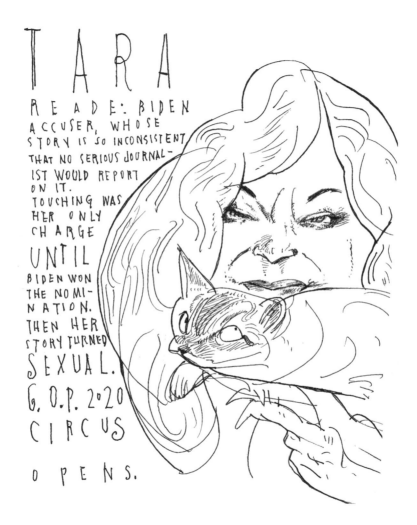

TARA

READE: BIDEN ACCUSER, WHOSE STORY IS SO INCONSISTENT THAT NO SERIOUS JOURNAL- IST WOULD REPORT ON IT. TOUCHING WAS HER ONLY CHARGE UNTIL BIDEN WON THE NOMI- NATION. THEN HER STORY TURNED SEXUAL. G.O.P. 2020 CIRCUS

OPENS.

MONTY BENNETT, OWNER OF A HUGE HOTEL CORPORATION, GOT $70 MILLION IN the PAYCHECK PROTEC-TION PLAN. AND SAYS HE'S KEEP-ING IT.

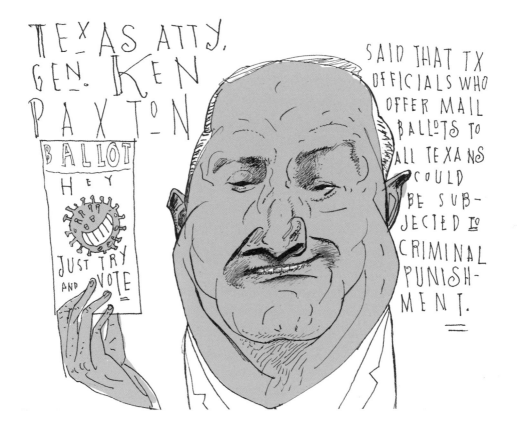

TEXAS ATTY.
GEN. KEN
PAXTON

BALLOT
HEY
JUST TRY
AND VOTE

SAID THAT TX
OFFICIALS WHO
OFFER MAIL
BALLOTS TO
ALL TEXANS
COULD
BE SUB-
JECTED TO
CRIMINAL
PUNISH-
MENT.

KEVIN HASSET

TRUMP ECONOMIC ADVISOR WITH ÑO MEDICAL BACKGROUND WHATSOEVER

CREATED THE CV-19 SKEPTIC-BASED MODEL TRUMP AND KUSHNER HAVE EMBRACED, WHICH NOW ENDANGERS THE ENTIRE COUNTRY.

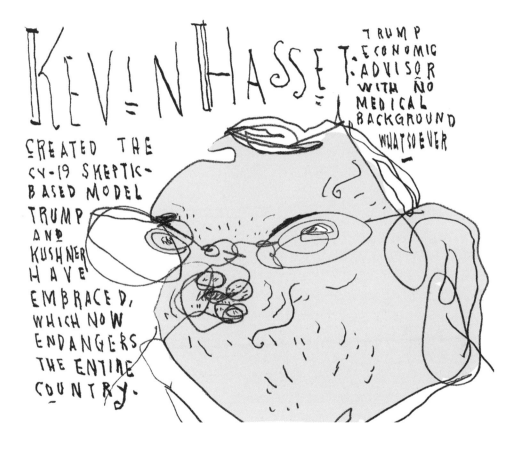

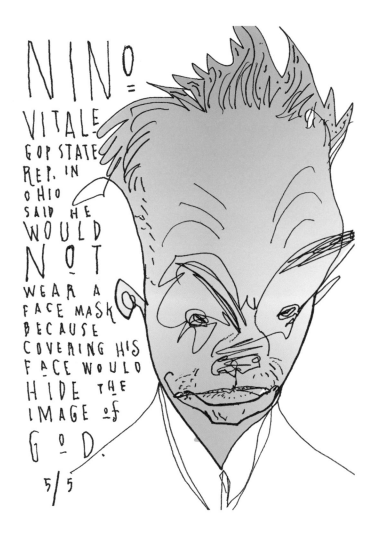

NINO VITALE GOP STATE REP. IN OHIO SAID HE WOULD NOT WEAR A FACE MASK BECAUSE COVERING HIS FACE WOULD HIDE THE IMAGE OF GOD.

5/5

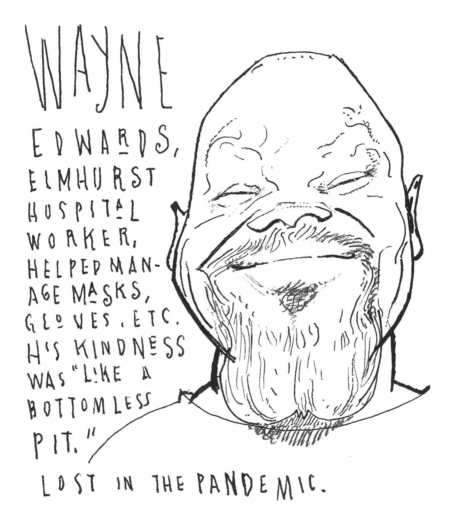

WAYNE EDWARDS, ELMHURST HOSPITAL WORKER, HELPED MAN-AGE MASKS, GLOVES, ETC. HIS KINDNESS WAS "LIKE A BOTTOMLESS PIT."

LOST IN THE PANDEMIC.

GOV. KIM REYNOLDS OF IOWA, BRAGGING TONIGHT ABOUT COVID-19 SUCCESS WITHOUT MENTIONING 730 POSITIVE IN A TYSON SLAUGHTERHOUSE IN PERRY, 400 IN WATERLOO, 220+ IN COLUMBUS JUNCTION, AND 100 IN MADISON COUNTY, THE STATE'S PASSING 10K CASES, AS SHE REOPENS I O W A.

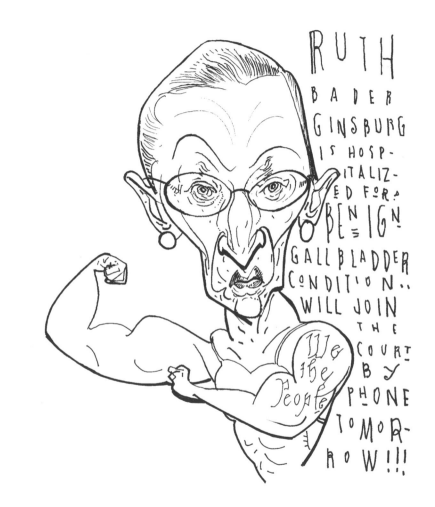

RUTH BADER GINSBURG IS HOSPITALIZED FOR BENIGN GALLBLADDER CONDITION.. WILL JOIN THE COURT BY PHONE TOMORROW!!!

We the People

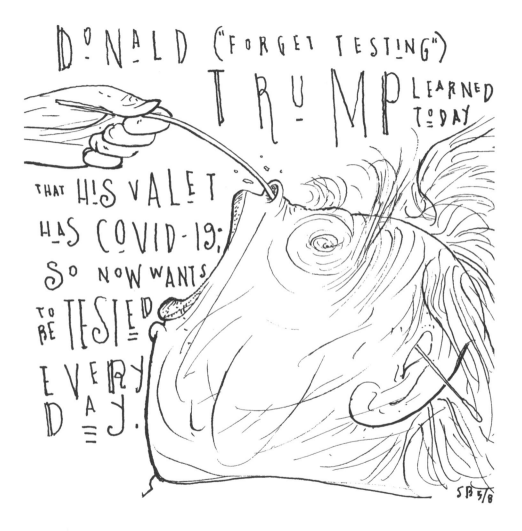

DONALD ("FORGET TESTING") TRUMP LEARNED TODAY THAT HIS VALET HAS COVID-19; SO NOW WANTS TO BE TESTED EVERY DAY.

SB 5/8

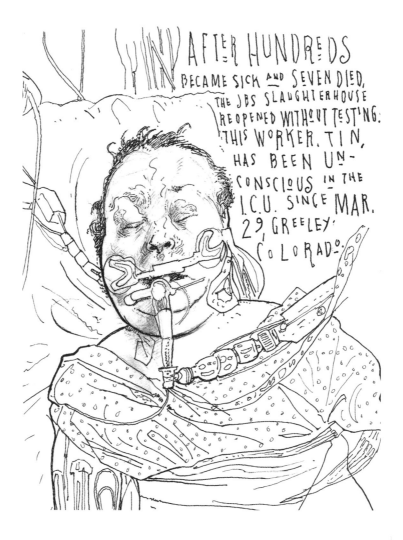

AFTER HUNDREDS BECAME SICK AND SEVEN DIED, THE JBS SLAUGHTERHOUSE REOPENED WITHOUT TESTING. THIS WORKER, TIN, HAS BEEN UNCONSCIOUS IN THE I.C.U. SINCE MAR. 29, GREELEY, COLORADO.

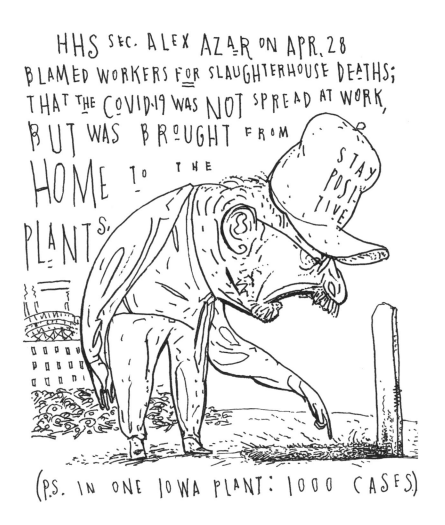

HHS Sec. ALEX AZAR ON APR. 28 BLAMED WORKERS FOR SLAUGHTERHOUSE DEATHS; THAT THE COVID-19 WAS NOT SPREAD AT WORK, BUT WAS BROUGHT FROM HOME TO THE PLANTS.

STAY POSITIVE

(P.S. IN ONE IOWA PLANT: 1000 CASES)

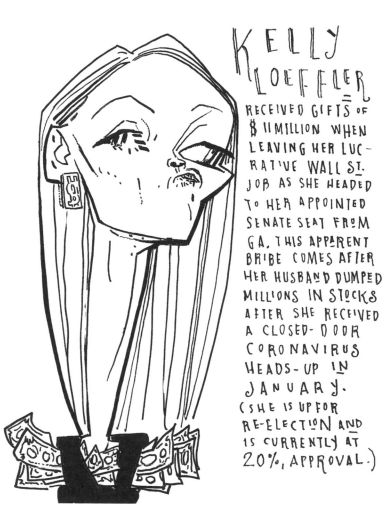

KELLY KLOEFFLER = RECEIVED GIFTS OF $11MILLION WHEN LEAVING HER LUCRATIVE WALL ST. JOB AS SHE HEADED TO HER APPOINTED SENATE SEAT FROM GA. THIS APPARENT BRIBE COMES AFTER HER HUSBAND DUMPED MILLIONS IN STOCKS AFTER SHE RECEIVED A CLOSED-DOOR CORONAVIRUS HEADS-UP IN JANUARY. (SHE IS UP FOR RE-ELECTION AND IS CURRENTLY AT 20% APPROVAL.)

Leo DE LA CRUZ, AGE UNKNOWN WAS A GERIATRIC PSYCHIATRIST AT CHRIST HOSPITAL IN JERSEY CITY, NJ. "HE WAS A GOOD PERSON, A SWEET MAN THAT WAS LOVED BY EVERYONE." THE HOSPITAL'S TUCKER WOODS AND MARIE DUFFY SAID IN A STATEMENT.

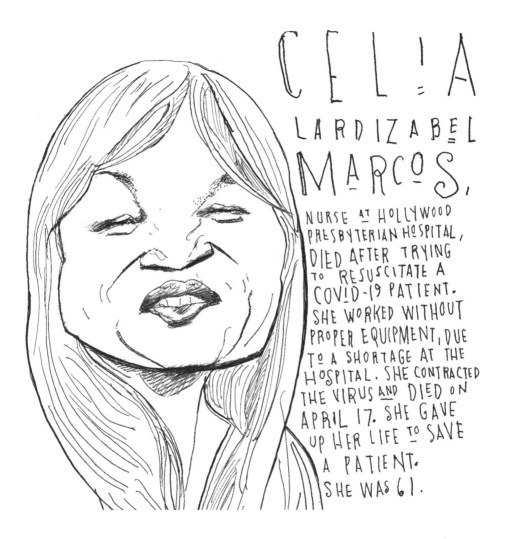

CELIA LARDIZABEL MARCOS,

NURSE AT HOLLYWOOD PRESBYTERIAN HOSPITAL, DIED AFTER TRYING TO RESUSCITATE A COVID-19 PATIENT. SHE WORKED WITHOUT PROPER EQUIPMENT, DUE TO A SHORTAGE AT THE HOSPITAL. SHE CONTRACTED THE VIRUS AND DIED ON APRIL 17. SHE GAVE UP HER LIFE TO SAVE A PATIENT. SHE WAS 61.

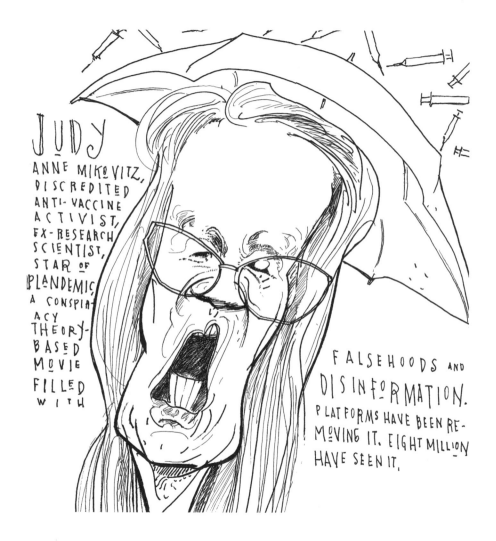

JUDY

ANNE MIKOVITZ, DISCREDITED ANTI-VACCINE ACTIVIST, EX-RESEARCH SCIENTIST, STAR OF PLANDEMIC, A CONSPIRACY THEORY-BASED MOVIE FILLED WITH FALSEHOODS AND DISINFORMATION. PLATFORMS HAVE BEEN REMOVING IT. EIGHT MILLION HAVE SEEN IT.

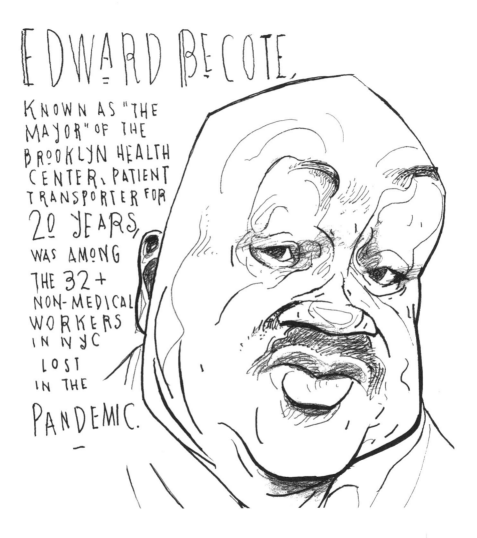

EDWARD BECOTE,

KNOWN AS "THE MAYOR" OF THE BROOKLYN HEALTH CENTER, PATIENT TRANSPORTER FOR 20 YEARS, WAS AMONG THE 32 + NON-MEDICAL WORKERS IN NYC LOST IN THE PANDEMIC.

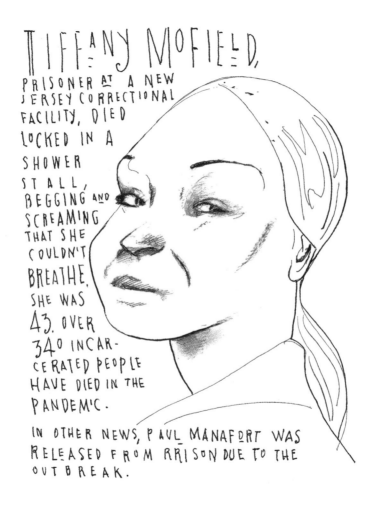

TIFFANY MOFIELD,
PRISONER AT A NEW
JERSEY CORRECTIONAL
FACILITY, DIED
LOCKED IN A
SHOWER
STALL,
BEGGING AND
SCREAMING
THAT SHE
COULDN'T
BREATHE.
SHE WAS
43. OVER
340 INCAR-
CERATED PEOPLE
HAVE DIED IN THE
PANDEMIC.

IN OTHER NEWS, PAUL MANAFORT WAS
RELEASED FROM PRISON DUE TO THE
OUTBREAK.

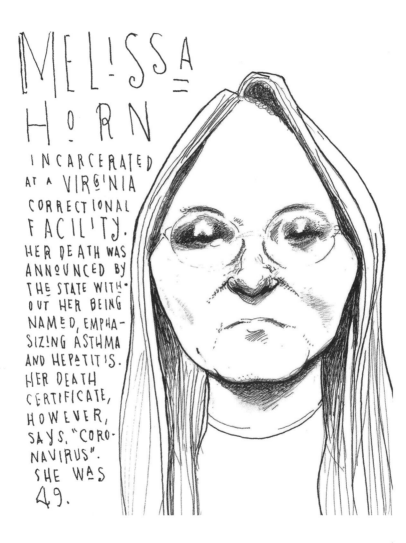

MELISSA HORN

INCARCERATED AT A VIRGINIA CORRECTIONAL FACILITY. HER DEATH WAS ANNOUNCED BY THE STATE WITHOUT HER BEING NAMED, EMPHASIZING ASTHMA AND HEPATITIS. HER DEATH CERTIFICATE, HOWEVER, SAYS, "CORONAVIRUS". SHE WAS 49.

STEVE LINICK STATE DEPT. INSPECTOR GENERAL, SACKED TONIGHT. HE HAD BEEN INVESTIGATING MIKE POMPEO'S USE OF A STATE DEPT. EMPLOYEE IN PERSONAL TASKS FOR SEC. & MRS. POMPEO.

SACKED

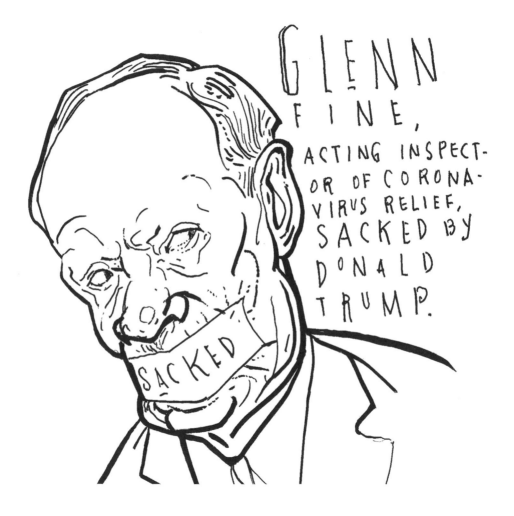

GLENN FINE, ACTING INSPECTOR OF CORONAVIRUS RELIEF, SACKED BY DONALD TRUMP.

SACKED

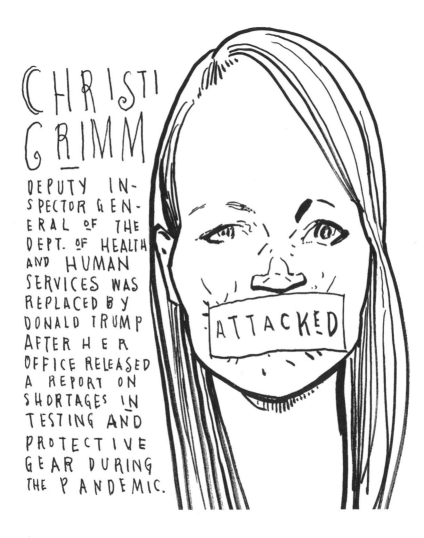

CHRISTI GRIMM

DEPUTY INSPECTOR GENERAL OF THE DEPT. OF HEALTH AND HUMAN SERVICES WAS REPLACED BY DONALD TRUMP AFTER HER OFFICE RELEASED A REPORT ON SHORTAGES IN TESTING AND PROTECTIVE GEAR DURING THE PANDEMIC.

ATTACKED

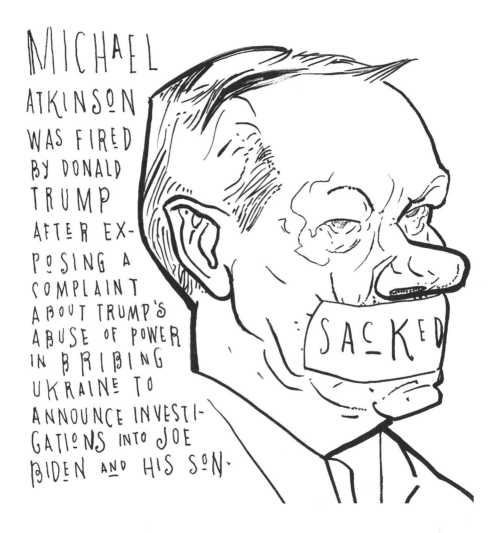

MICHAEL ATKINSON WAS FIRED BY DONALD TRUMP AFTER EX-POSING A COMPLAINT ABOUT TRUMP'S ABUSE OF POWER IN BRIBING UKRAINE TO ANNOUNCE INVESTI-GATIONS INTO JOE BIDEN AND HIS SON.

SACKED

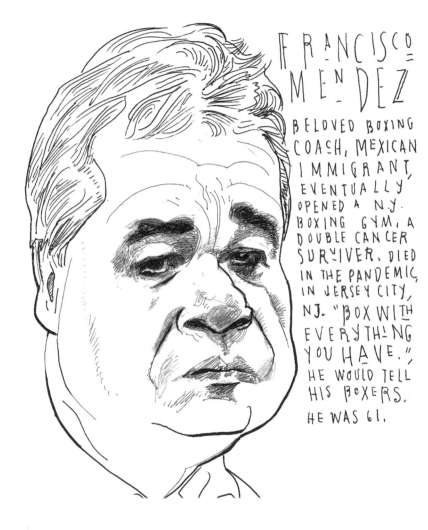

FRANCISCO MENDEZ

BELOVED BOXING COACH, MEXICAN IMMIGRANT, EVENTUALLY OPENED A N.Y. BOXING GYM, A DOUBLE CANCER SURVIVER. DIED IN THE PANDEMIC, IN JERSEY CITY, NJ. "BOX WITH EVERYTHING YOU HAVE." HE WOULD TELL HIS BOXERS. HE WAS 61.

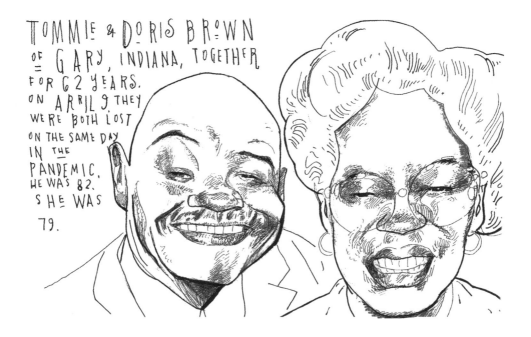

TOMMIE & DORIS BROWN OF GARY, INDIANA, TOGETHER FOR 62 YEARS. ON APRIL 9 THEY WERE BOTH LOST ON THE SAME DAY IN THE PANDEMIC. HE WAS 82. SHE WAS 79.

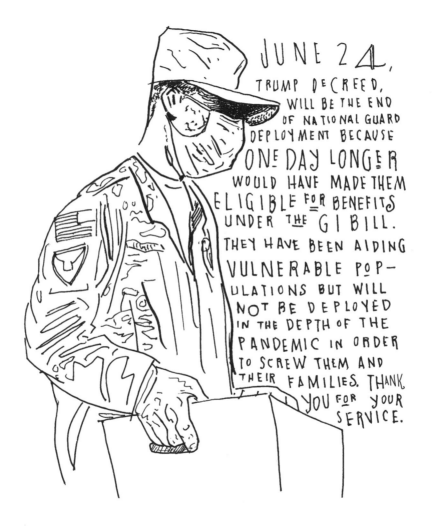

JUNE 24, TRUMP DECREED, WILL BE THE END OF NATIONAL GUARD DEPLOYMENT BECAUSE ONE DAY LONGER WOULD HAVE MADE THEM ELIGIBLE FOR BENEFITS UNDER THE GI BILL. THEY HAVE BEEN AIDING VULNERABLE POPULATIONS BUT WILL NOT BE DEPLOYED IN THE DEPTH OF THE PANDEMIC IN ORDER TO SCREW THEM AND THEIR FAMILIES. THANK YOU FOR YOUR SERVICE.

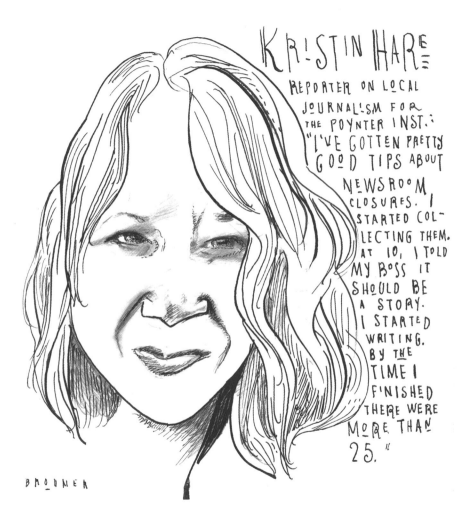

KRISTIN HARE

REPORTER ON LOCAL
JOURNALISM FOR
THE POYNTER INST.:
"I'VE GOTTEN PRETTY
GOOD TIPS ABOUT
NEWSROOM
CLOSURES. I
STARTED COL-
LECTING THEM.
AT 10, I TOLD
MY BOSS IT
SHOULD BE
A STORY.
I STARTED
WRITING.
BY THE
TIME I
FINISHED
THERE WERE
MORE THAN
25. "

BROOMER

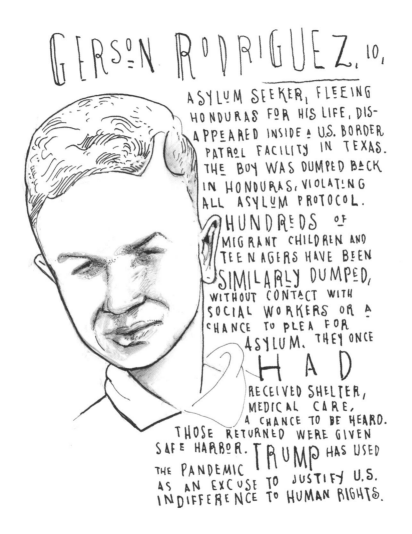

GERSON RODRIGUEZ, 10,

ASYLUM SEEKER, FLEEING HONDURAS FOR HIS LIFE, DISAPPEARED INSIDE A U.S. BORDER PATROL FACILITY IN TEXAS. THE BOY WAS DUMPED BACK IN HONDURAS, VIOLATING ALL ASYLUM PROTOCOL. HUNDREDS OF MIGRANT CHILDREN AND TEENAGERS HAVE BEEN SIMILARLY DUMPED, WITHOUT CONTACT WITH SOCIAL WORKERS OR A CHANCE TO PLEA FOR ASYLUM. THEY ONCE HAD RECEIVED SHELTER, MEDICAL CARE, A CHANCE TO BE HEARD. THOSE RETURNED WERE GIVEN SAFE HARBOR. TRUMP HAS USED THE PANDEMIC AS AN EXCUSE TO JUSTIFY U.S. INDIFFERENCE TO HUMAN RIGHTS.

VALENTINA BLACKHORSE, 28, NAVAJO RISING STAR, BEAUTY PAGEANT WINNER, ON TRACK TO A POLITICAL CAREER, LOST IN PANDEMIC.

MOTHER OF A ONE-YEAR-OLD. NAVAJO NATION, MONUMENT VALLEY.

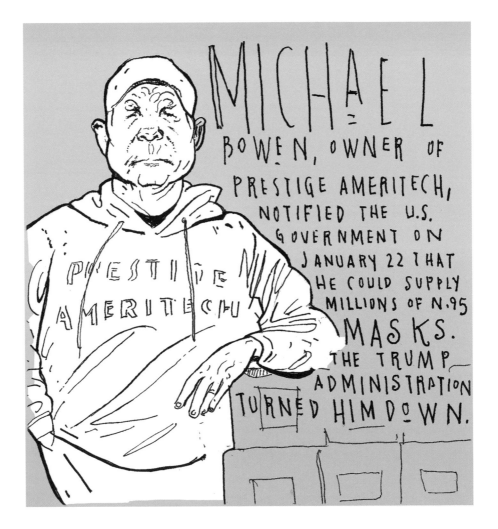

MICHAEL BOWEN, OWNER OF PRESTIGE AMERITECH, NOTIFIED THE U.S. GOVERNMENT ON JANUARY 22 THAT HE COULD SUPPLY MILLIONS OF N.95 MASKS. THE TRUMP ADMINISTRATION TURNED HIM DOWN.

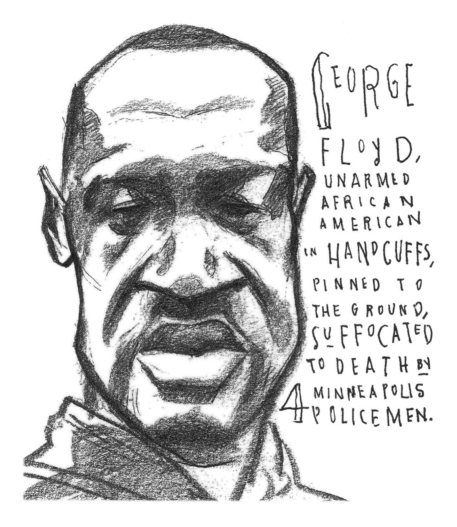

GEORGE
FLOYD,
UNARMED
AFRICAN
AMERICAN
in HANDCUFFS,
PINNED TO
THE GROUND,
SUFFOCATED
TO DEATH BY
4 MINNEAPOLIS
POLICEMEN.

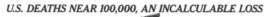

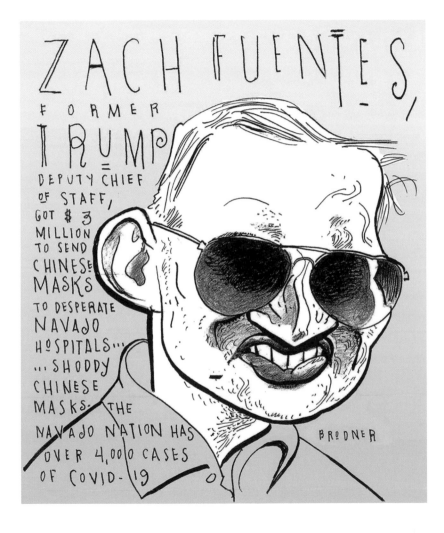

ZACH FUENTES, FORMER TRUMP = DEPUTY CHIEF OF STAFF, GOT $3 MILLION TO SEND CHINESE MASKS TO DESPERATE NAVAJO HOSPITALS... ...SHODDY CHINESE MASKS. THE NAVAJO NATION HAS OVER 4,000 CASES OF COVID-19

BRODNER

HENNEPIN CO. ATTY. FREEMAN, REGARDING THE CASE AGAINST MINNEAPOLIS OFFICERS CLEARLY SEEN IN THE KILLING OF GEORGE FLOYD: "THERE'S OTHER EVIDENCE THAT DOESN'T SUPPORT A CRIMINAL CHARGE." —SOMETHING THAT JUSTIFIED AN UNARMED MAN'S MURDER.

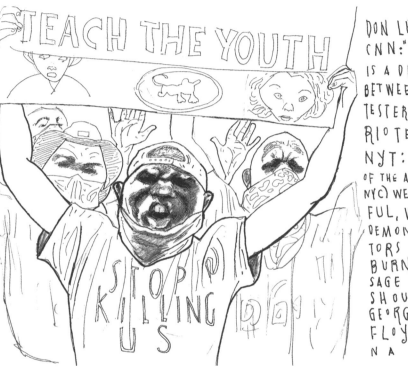

DON LEMON, CNN: "THERE IS A DIFFERENCE BETWEEN PROTESTERS AND RIOTERS."

NYT: "MOST OF THE ACTIONS (IN NYC) WERE PEACEFUL, WITH DEMONSTRATORS WAVING BURNING SAGE AND SHOUTING GEORGE FLOYD'S NAME."

PROTESTS AND RIOTS WERE ATTENDED BY THIS MAN, WHO BROUGHT ALONG HIS MILITARY-STYLE WEAPON. SEEN IN MINNEAPOLIS TONIGHT. 5/31

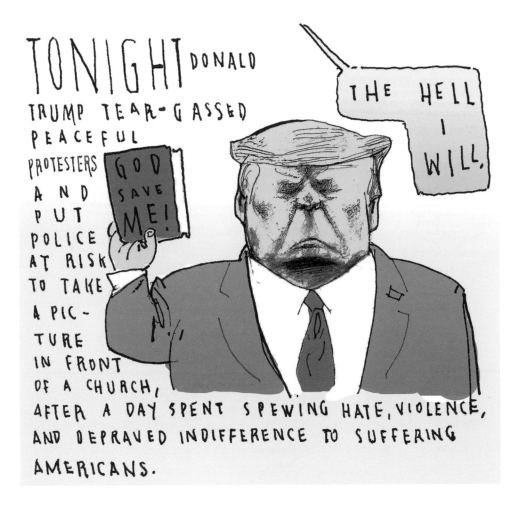

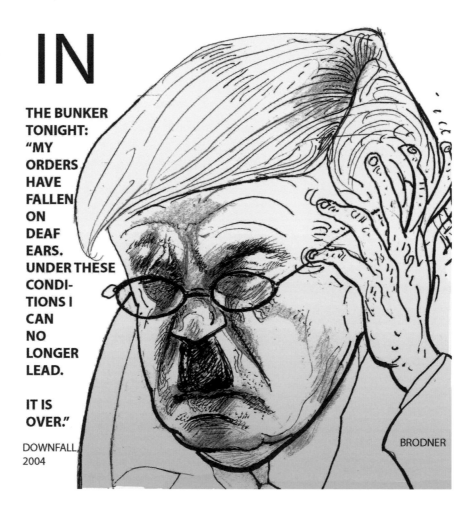

IN

THE BUNKER
TONIGHT:
"MY
ORDERS
HAVE
FALLEN
ON
DEAF
EARS.
UNDER THESE
CONDI-
TIONS I
CAN
NO
LONGER
LEAD.

IT IS
OVER."

DOWNFALL,
2004

BRODNER

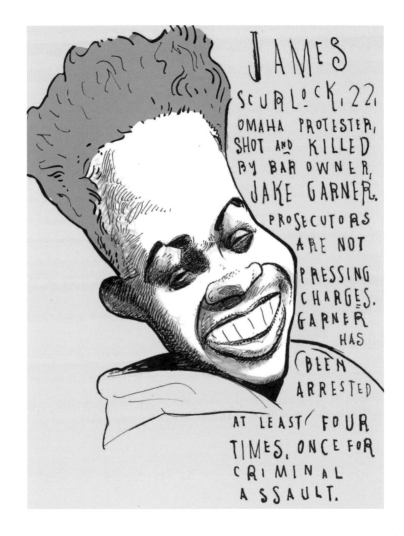

JAMES SCURLOCK, 22, OMAHA PROTESTER, SHOT AND KILLED BY BAR OWNER, JAKE GARDNER. PROSECUTORS ARE NOT PRESSING CHARGES. GARDNER HAS BEEN ARRESTED AT LEAST FOUR TIMES, ONCE FOR CRIMINAL ASSAULT.

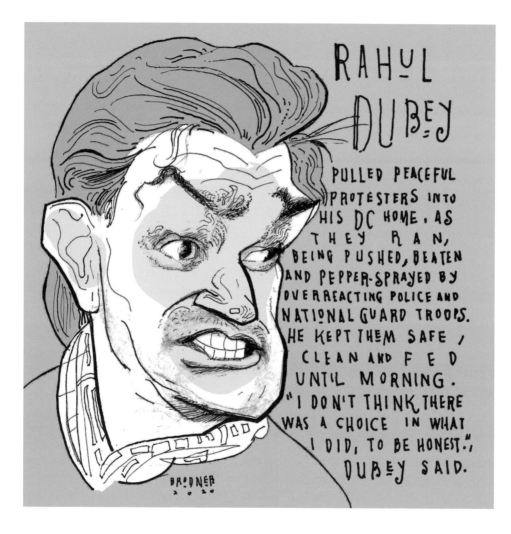

RAHUL DUBEY

PULLED PEACEFUL PROTESTERS INTO HIS DC HOME. AS THEY RAN, BEING PUSHED, BEATEN AND PEPPER-SPRAYED BY OVERREACTING POLICE AND NATIONAL GUARD TROOPS. HE KEPT THEM SAFE, CLEAN AND FED UNTIL MORNING. "I DON'T THINK THERE WAS A CHOICE IN WHAT I DID, TO BE HONEST.", DUBEY SAID.

THREE DOZEN FORMER FACEBOOK EMPLOYEES CALLED OUT MARK ZUCKERBERG'S DECISION TO ALLOW TRUMP'S FALSE AND DANGEROUS POSTS UNALTERED.

"THIS IS A BETRAYAL OF THE IDEALS FACEBOOK CLAIMS... ...FACT-CHECKING IS NOT CENSORSHIP. LABELING A CALL TO VIOLENCE IS NOT AUTHORITARIANISM."

MANUEL ELLIS WAS SUFFO-CATED TO DEATH IN CUSTODY IN TACOMA, WASHINGTON IN MARCH. HE WAS FATHER OF TWO YOUNG CHILDREN. HE WAS 33. "I CAN'T BREATHE" HE SAID.

MAURICE GORDON

28-YEARS OLD, WAS KILLED BY NJ STATE TROOPER AT A TRAFFIC STOP IN BASS RIVER, NJ, TWO DAYS BEFORE THE KILLING OF GEORGE FLOYD.

JAVIER AMBLER.
40, DIED IN CUSTODY, IN
AUSTIN TEXAS,
MAR. 28,
2019.
AS
THE POLICE
CHARGED HIM WITH
RESISTING
ARREST. HE
SAID, "I
HAVE
CONGESTIVE HEART
FAILURE. I CAN'T
BREATHE." THE VIDEO
WAS ONLY RELEASED
YESTERDAY.

TRUCK DRIVER
ANTONIO
VALENZUELA
DIED AFTER BEING PLACED IN A VASCULAR NECK HOLD BY POLICE, FEB. 29, LAS CRUCES, N.M. IT HAS BEEN RULED A HOMICIDE. HE WAS 40.

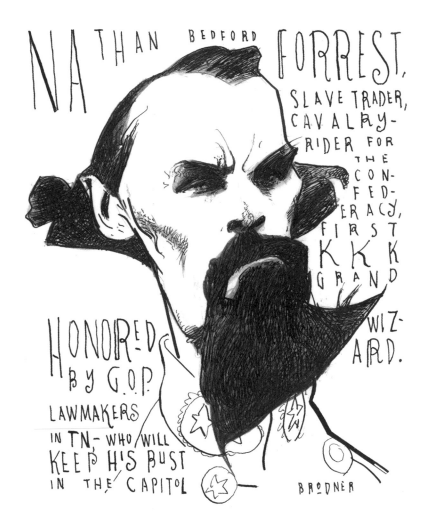

NATHAN BEDFORD FORREST, SLAVE TRADER, CAVALRY-RIDER FOR THE CONFEDERACY, FIRST KKK GRAND WIZARD.

HONORED BY G.O.P. LAWMAKERS IN TN — WHO WILL KEEP HIS BUST IN THE CAPITOL

BRODNER

AIMEE
STEPHENS,
TRANSGENDER
WOMAN
WHOSE
LAWSUIT
RESULTED IN
THE SUPREME
COURT'S
DECISION
TO PROTECT
LGBTQ RIGHTS.
SHE DIED LAST
MONTH. HER PARTNER
RESPONDED TO THE
DECISION: "WE WON."

BRODNER

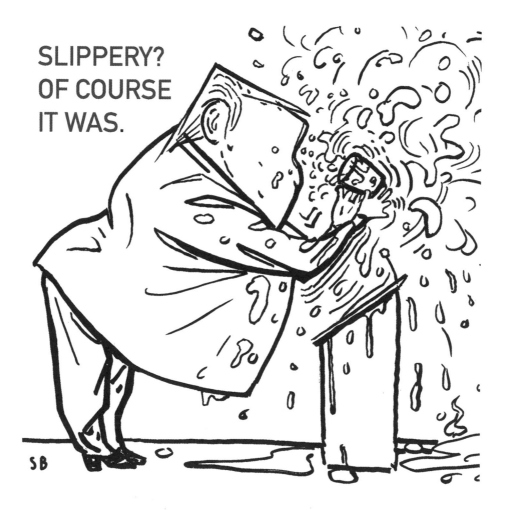

SLIPPERY?
OF COURSE
IT WAS.

Donald Trump struggles to lift a water glass at
a rally, later blaming a "slippery" stage.

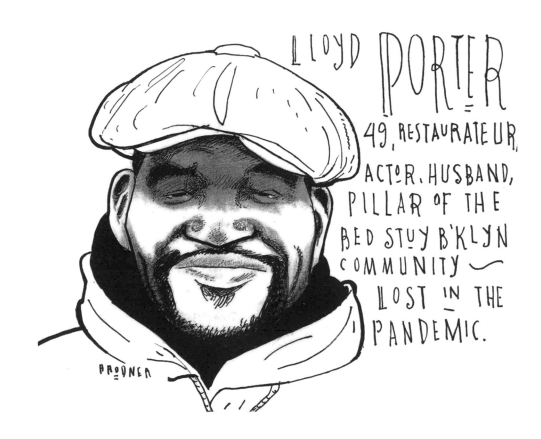

LLOYD PORTER

49, RESTAURATEUR,
ACTOR, HUSBAND,
PILLAR OF THE
BED STUY B'KLYN
COMMUNITY —
LOST IN THE
PANDEMIC.

BROONER

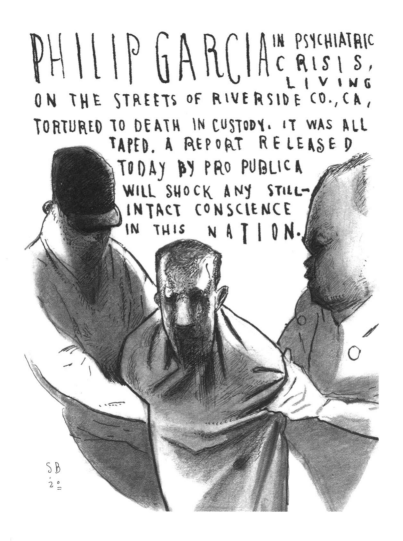

PHILIP GARCIA IN PSYCHIATRIC CRISIS, LIVING ON THE STREETS OF RIVERSIDE CO., CA, TORTURED TO DEATH IN CUSTODY. IT WAS ALL TAPED. A REPORT RELEASED TODAY BY PRO PUBLICA WILL SHOCK ANY STILL-INTACT CONSCIENCE IN THIS NATION.

SB
20

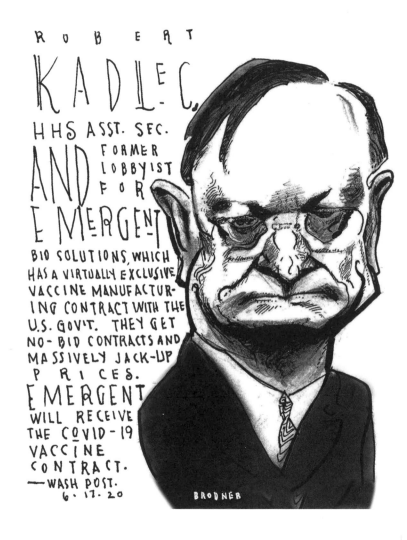

ROBERT
KADLEC.
HHS ASST. SEC.
AND FORMER LOBBYIST FOR EMERGENT BIO SOLUTIONS, WHICH HAS A VIRTUALLY EXCLUSIVE VACCINE MANUFACTURING CONTRACT WITH THE U.S. GOV'T. THEY GET NO-BID CONTRACTS AND MASSIVELY JACK-UP PRICES. EMERGENT WILL RECEIVE THE COVID-19 VACCINE CONTRACT.
—WASH POST.
6·17·20

BRODNER

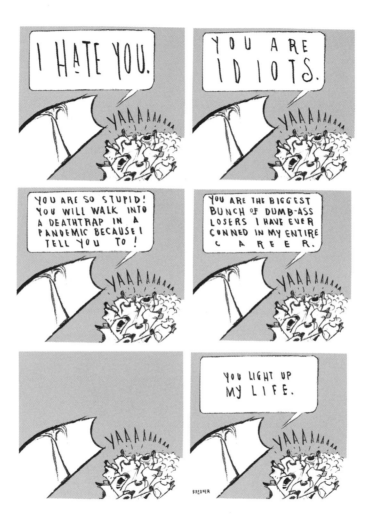

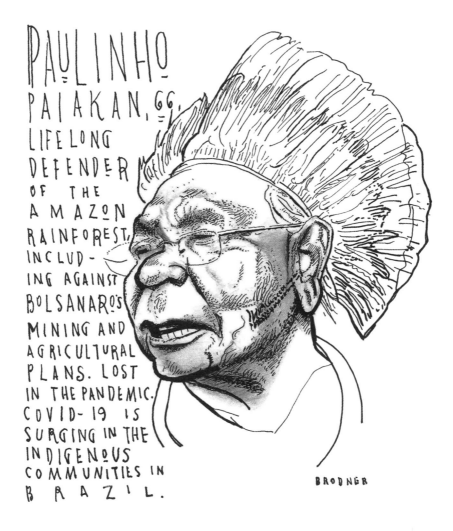

PAULINHO PAIAKAN, 66, LIFELONG DEFENDER OF THE AMAZON RAINFOREST, INCLUDING AGAINST BOLSANARO'S MINING AND AGRICULTURAL PLANS. LOST IN THE PANDEMIC. COVID-19 IS SURGING IN THE INDIGENOUS COMMUNITIES IN BRAZIL.

BRODNER

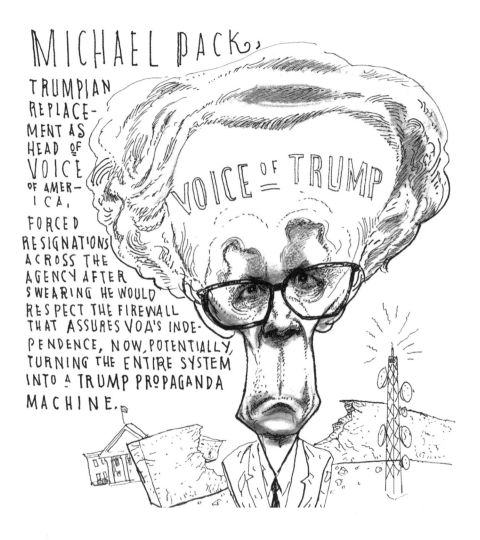

MICHAEL PACK,

TRUMPIAN REPLACE-MENT AS HEAD OF VOICE OF AMER-ICA,

FORCED RESIGNATIONS ACROSS THE AGENCY AFTER SWEARING HE WOULD RESPECT THE FIREWALL THAT ASSURES VOA'S INDE-PENDENCE, NOW, POTENTIALLY, TURNING THE ENTIRE SYSTEM INTO A TRUMP PROPAGANDA MACHINE.

VOICE OF TRUMP

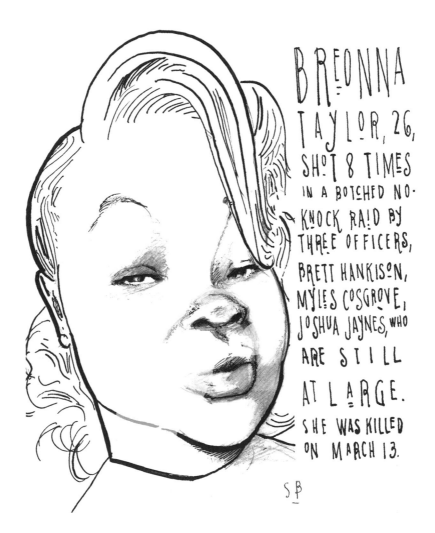

BREONNA TAYLOR, 26, SHOT 8 TIMES IN A BOTCHED NO-KNOCK RAID BY THREE OFFICERS, BRETT HANKISON, MYLES COSGROVE, JOSHUA JAYNES, WHO ARE STILL AT LARGE. SHE WAS KILLED ON MARCH 13.

SB

SEN. MITCH McCONNELL WON HIS PRIMARY IN KENTUCKY, WHERE 95% OF THE POLLING PLACES WERE CLOSED. IN (BLACK) LOUISVILLE, ONLY ONE WAS OPEN. HE HAS ARDENTLY OPPOSED VOTING RIGHTS AND ACCESS BILLS AS MAJORITY LEADER.

BRODNER

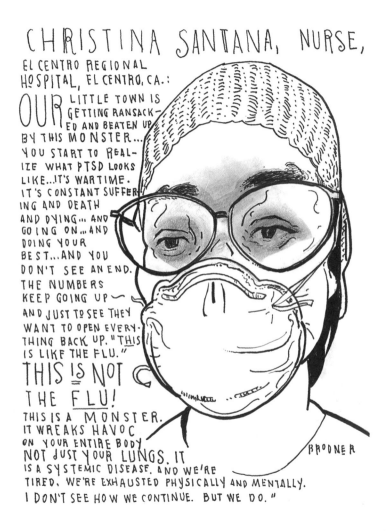

CHRISTINA SANTANA, NURSE,

EL CENTRO REGIONAL HOSPITAL, EL CENTRO, CA.: OUR LITTLE TOWN IS GETTING RANSACKED AND BEATEN UP BY THIS MONSTER... YOU START TO REALIZE WHAT PTSD LOOKS LIKE...IT'S WARTIME. IT'S CONSTANT SUFFERING AND DEATH AND DYING... AND GOING ON... AND DOING YOUR BEST...AND YOU DON'T SEE AN END. THE NUMBERS KEEP GOING UP AND JUST TO SEE THEY WANT TO OPEN EVERYTHING BACK UP. "THIS IS LIKE THE FLU."

THIS IS NOT THE FLU! THIS IS A MONSTER. IT WREAKS HAVOC ON YOUR ENTIRE BODY NOT JUST YOUR LUNGS. IT IS A SYSTEMIC DISEASE. AND WE'RE TIRED. WE'RE EXHAUSTED PHYSICALLY AND MENTALLY. I DON'T SEE HOW WE CONTINUE. BUT WE DO. "

BRODNER

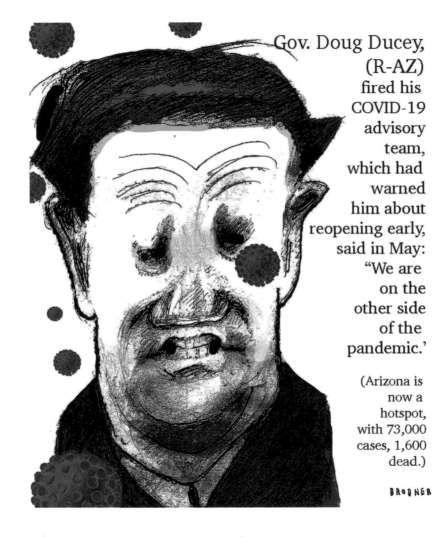

Gov. Doug Ducey, (R-AZ) fired his COVID-19 advisory team, which had warned him about reopening early, said in May: "We are on the other side of the pandemic.'

(Arizona is now a hotspot, with 73,000 cases, 1,600 dead.)

BRODNER

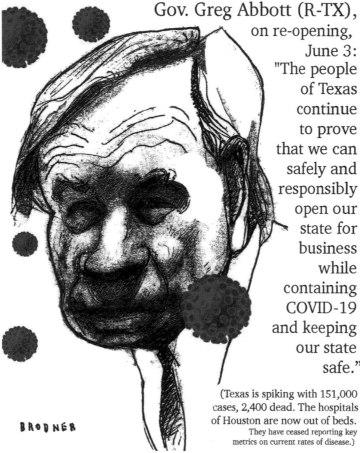

Gov. Greg Abbott (R-TX), on re-opening, June 3: "The people of Texas continue to prove that we can safely and responsibly open our state for business while containing COVID-19 and keeping our state safe."

(Texas is spiking with 151,000 cases, 2,400 dead. The hospitals of Houston are now out of beds. They have ceased reporting key metrics on current rates of disease.)

BRODNER

CARLOS
INGRAM
LOPEZ
IN PSYCHO-
LOGICAL
DISTRESS,
HAND-
CUFFED
AND
SMOTHERED
IN CUSTODY
IN TUCSON.
" I CAN'T
BREATHE."
HE SAID.

Gov. Ron DeSantis, (R-FL):

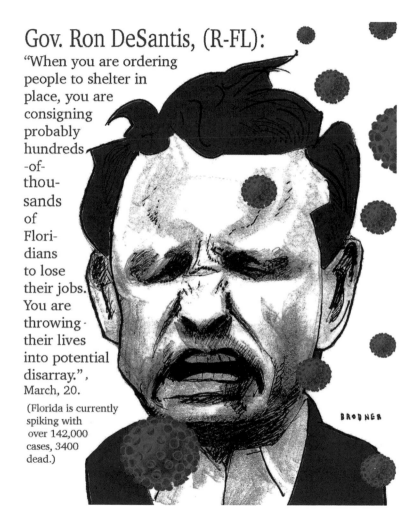

"When you are ordering people to shelter in place, you are consigning probably hundreds -of- thou- sands of Flori- dians to lose their jobs. You are throwing their lives into potential disarray.", March, 20.

(Florida is currently spiking with over 142,000 cases, 3400 dead.)

BRODNER

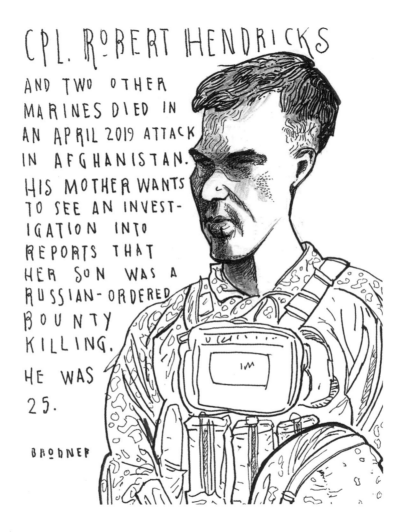

CPL. ROBERT HENDRICKS AND TWO OTHER MARINES DIED IN AN APRIL 2019 ATTACK IN AFGHANISTAN. HIS MOTHER WANTS TO SEE AN INVESTIGATION INTO REPORTS THAT HER SON WAS A RUSSIAN-ORDERED BOUNTY KILLING. HE WAS 25.

BRODNER

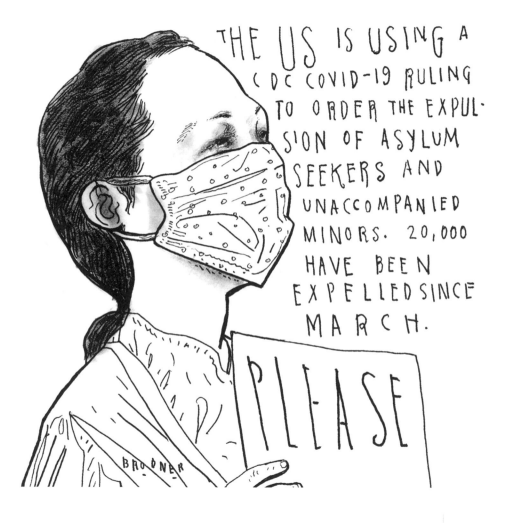

THE US IS USING A CDC COVID-19 RULING TO ORDER THE EXPULSION OF ASYLUM SEEKERS AND UNACCOMPANIED MINORS. 20,000 HAVE BEEN EXPELLED SINCE MARCH.

PLEASE

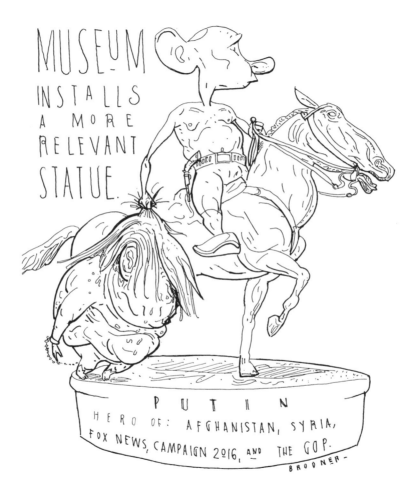

MUSEUM
INSTALLS
A MORE
RELEVANT
STATUE.

PUTIN
HERO OF: AFGHANISTAN, SYRIA,
FOX NEWS, CAMPAIGN 2016, AND THE GOP.
BROONER-

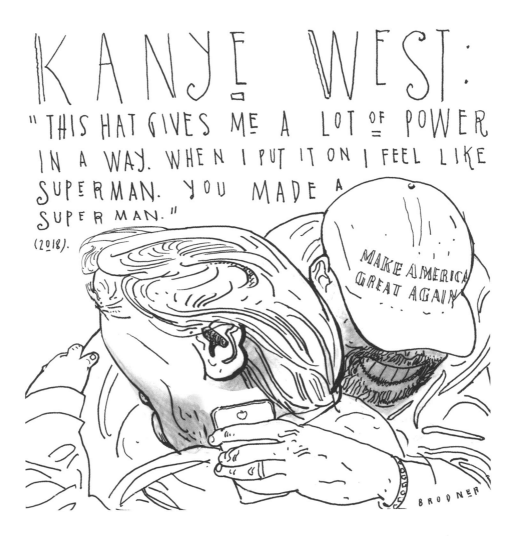

KANJE WEST:

"THIS HAT GIVES ME A LOT OF POWER IN A WAY. WHEN I PUT IT ON I FEEL LIKE SUPERMAN. YOU MADE A SUPER MAN."

(2018).

MAKE AMERICA GREAT AGAIN

BROONER

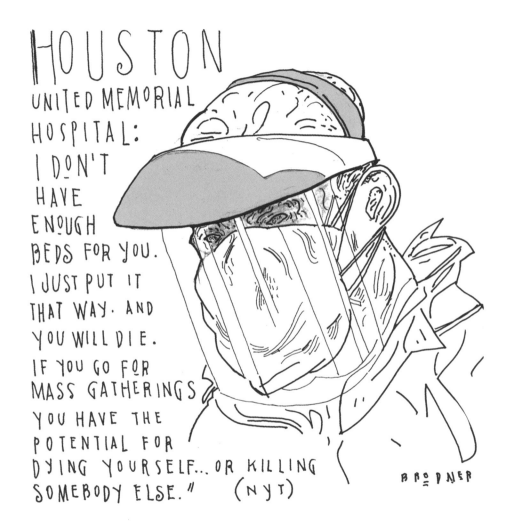

HOUSTON

UNITED MEMORIAL
HOSPITAL:
I DON'T
HAVE
ENOUGH
BEDS FOR YOU.
I JUST PUT IT
THAT WAY. AND
YOU WILL DIE.
IF YOU GO FOR
MASS GATHERINGS
YOU HAVE THE
POTENTIAL FOR
DYING YOURSELF... OR KILLING
SOMEBODY ELSE." (NYT)

BRODNER

HOUSTON RODEO:
"I'M AN AMERICAN AND I FEEL I SHOULD BE ABLE TO DO WHAT I WANT TO DO. I PAY MY TAXES. I LIVE FREE AND I WANT TO BE FREE."

(PBS)

HOUSTON
RODEO:
"IT'S AGAINST
OUR CON-
STITUTIONAL
RIGHTS.
THEY SHOULDN'T
BE ABLE TO
DICTATE WHAT
I WEAR."
(PBS)

BRODNER

98 JULY 09, 2020

NICK
CORDERO, BROADWAY STAR, "ALWAYS MORE CONCERNED WITH OTHERS THAN HIMSELF." (JUSTIN SQUIGS ROBERTSON.) LOST IN THE PANDEMIC. HIS AGE, 41, CHALLENGED THE PERCEPTION THAT COVID-19 WAS A DISEASE OF THE ELDERLY.

BROONER

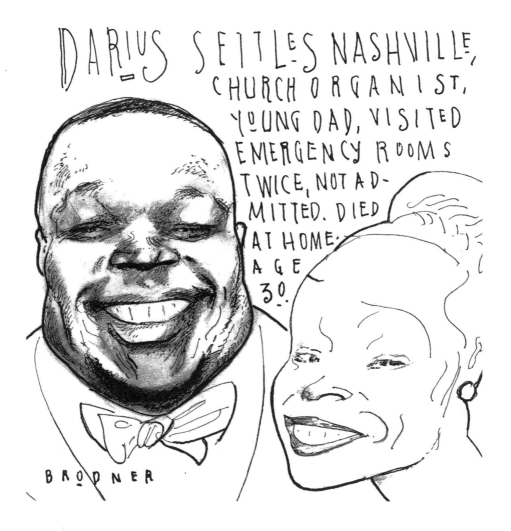

DARIUS SETTLES NASHVILLE, CHURCH ORGANIST, YOUNG DAD, VISITED EMERGENCY ROOMS TWICE, NOT ADMITTED. DIED AT HOME, AGE 30.

BRODNER

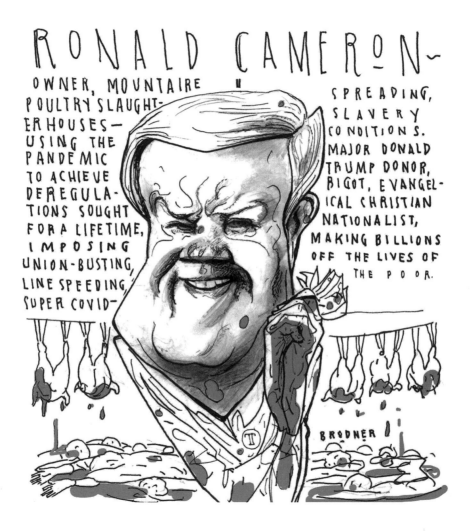

RONALD CAMERON-

OWNER, MOUNTAIRE POULTRY SLAUGHTER HOUSES— USING THE PANDEMIC TO ACHIEVE DEREGULATIONS SOUGHT FOR A LIFETIME, IMPOSING UNION-BUSTING, LINE SPEEDING, SUPER COVID— SPREADING, SLAVERY CONDITIONS. MAJOR DONALD TRUMP DONOR, BIGOT, EVANGELICAL CHRISTIAN NATIONALIST, MAKING BILLIONS OFF THE LIVES OF THE POOR.

BRODNER

BALIN BRAKE, 21.

ON MAY 30

FORT WAYNE, IND., PROTESTER, LOST VISION IN ONE EYE, HIT BY A GAS CANISTER FIRED BY POLICE, WHO CLAIM HE WAS ATTACKING THEM. FOOTAGE SHOWS NO SUCH THING.

ON MAY 30

"I WANT YOU TO LOOK ME IN THE EYE AND SAY YOU STAND BY THE POLICE AND WHAT THEY DID."

8 SUCH INJURIES WERE INFLICTED ACROSS THE COUNTRY.

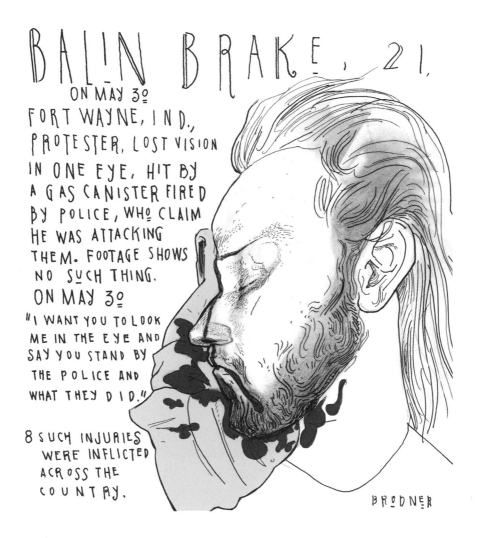

BRODNER

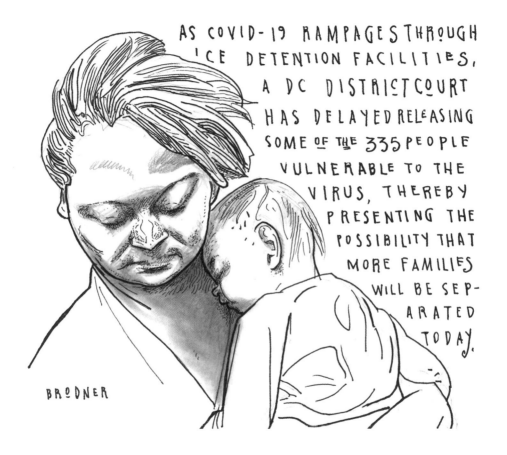

AS COVID-19 RAMPAGES THROUGH ICE DETENTION FACILITIES, A DC DISTRICT COURT HAS DELAYED RELEASING SOME OF THE 335 PEOPLE VULNERABLE TO THE VIRUS, THEREBY PRESENTING THE POSSIBILITY THAT MORE FAMILIES WILL BE SEPARATED TODAY.

BRODNER

PORTLAND, OR.

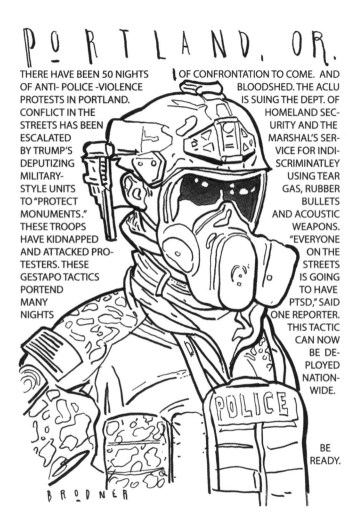

THERE HAVE BEEN 50 NIGHTS OF ANTI-POLICE-VIOLENCE PROTESTS IN PORTLAND. CONFLICT IN THE STREETS HAS BEEN ESCALATED BY TRUMP'S DEPUTIZING MILITARY-STYLE UNITS TO "PROTECT MONUMENTS." THESE TROOPS HAVE KIDNAPPED AND ATTACKED PROTESTERS. THESE GESTAPO TACTICS PORTEND MANY NIGHTS OF CONFRONTATION TO COME. AND BLOODSHED. THE ACLU IS SUING THE DEPT. OF HOMELAND SECURITY AND THE MARSHAL'S SERVICE FOR INDISCRIMINATLEY USING TEAR GAS, RUBBER BULLETS AND ACOUSTIC WEAPONS. "EVERYONE ON THE STREETS IS GOING TO HAVE PTSD," SAID ONE REPORTER. THIS TACTIC CAN NOW BE DEPLOYED NATIONWIDE.

BE READY.

BRODNER

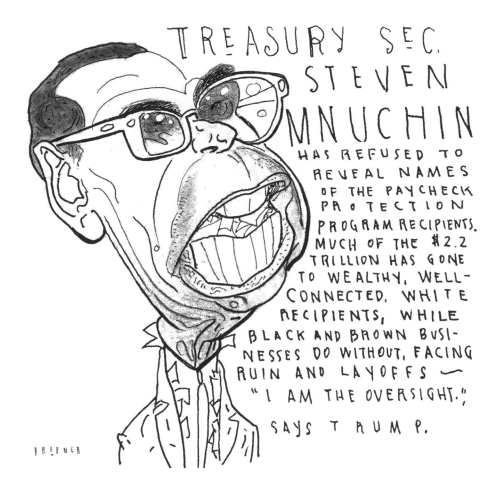

TREASURY SEC. STEVEN MNUCHIN HAS REFUSED TO REVEAL NAMES OF THE PAYCHECK PROTECTION PROGRAM RECIPIENTS. MUCH OF THE #2.2 TRILLION HAS GONE TO WEALTHY, WELL-CONNECTED, WHITE RECIPIENTS, WHILE BLACK AND BROWN BUSINESSES DO WITHOUT, FACING RUIN AND LAYOFFS — "I AM THE OVERSIGHT." SAYS TRUMP.

BRODNER

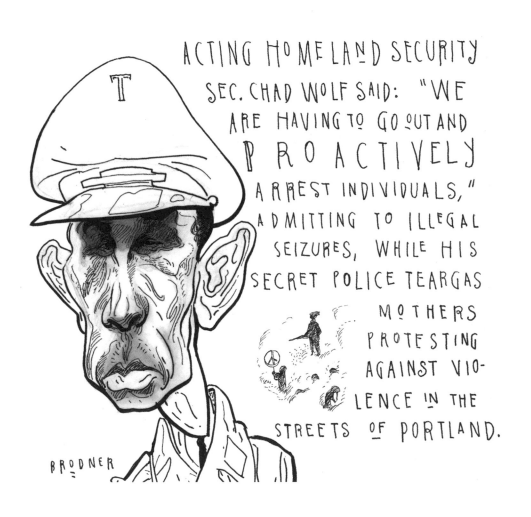

ACTING HOMELAND SECURITY SEC. CHAD WOLF SAID: "WE ARE HAVING TO GO OUT AND PROACTIVELY ARREST INDIVIDUALS," ADMITTING TO ILLEGAL SEIZURES, WHILE HIS SECRET POLICE TEARGAS MOTHERS PROTESTING AGAINST VIOLENCE IN THE STREETS OF PORTLAND.

BRODNER

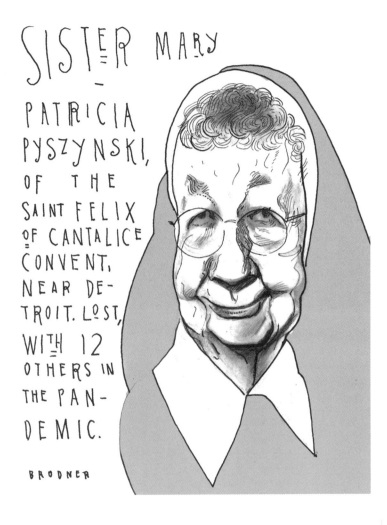

SISTER MARY
PATRICIA
PYSZYNSKI,
OF THE
SAINT FELIX
OF CANTALICE
CONVENT,
NEAR DE-
TROIT. LOST,
WITH 12
OTHERS IN
THE PAN-
DEMIC.

BRODNER

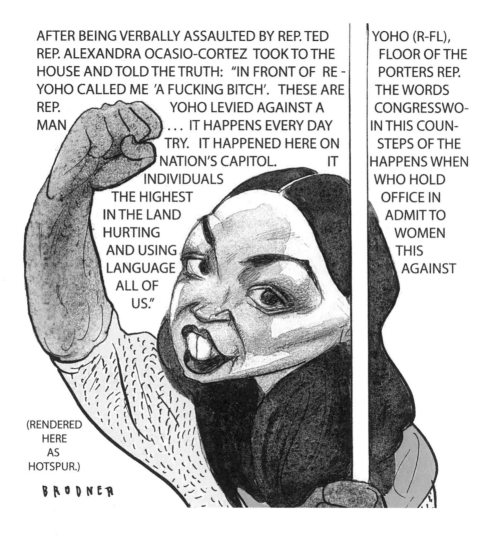

TRUMP'S SECRET POLICE SHOT PEPPER SPRAY DIRECTLY INTO THE FACE OF A SEATTLE NURSE WHO WAS STOPPING TO HELP A MAN KNOCKED DOWN BY THESE "TROOPS," WHERE PROTESTERS GATHERED IN RESPONSE TO THEIR PRESENCE.

PROTESTERS WERE GASSED WITHOUT PROVOCATION.

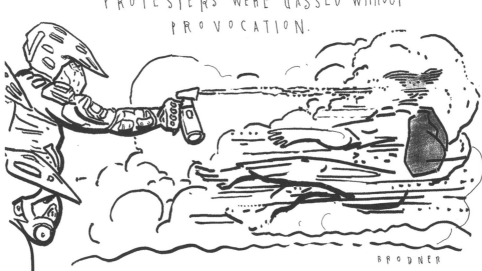

BRODNER

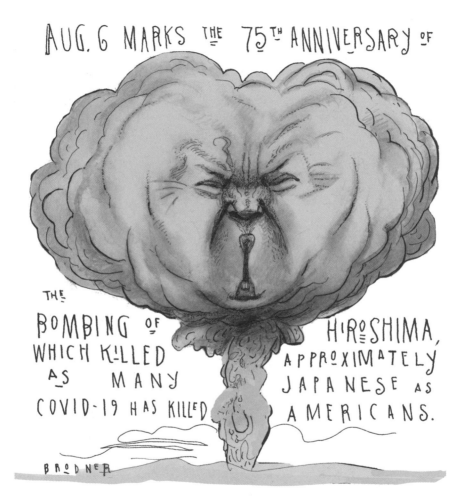

AUG. 6 MARKS THE 75TH ANNIVERSARY OF THE BOMBING OF HIROSHIMA, WHICH KILLED AS MANY APPROXIMATELY JAPANESE AS COVID-19 HAS KILLED AMERICANS.

BRODNER

BRODNER

TONY GREEN,

HOST OF A DALLAS PARTY, ON JUNE 13, IN WHICH 14 PEOPLE GOT SICK; HIMSELF, SO HARD HIT, THAT HE BARELY ESCAPED A STROKE. " I BELIEVED IT TO BE A HOAX . . . MY FATHER-IN-LAW AND I WENT TO THE HOSPITAL ON JUNE 24. HIS MOTHER WAS ADMITTED THE NEXT DAY AND ON JULY 1, SHE DIED. YOU CANNOT IMAGINE THE GUILT I FEEL, KNOWING THAT I HAVE BEEN A DENIER, CARELESSLY SHUFFLING THROUGH THIS PANDEMIC. MAKING FUN OF THOSE WEARING MASKS I AM CALLING MYSELF OUT FIRST. IF WE CONTINUE TO BE MORE WORRIED ABOUT THE DISRUPTION OF OUR LIVES THAN WE ARE ABOUT STOPPING THIS VIRUS, NOT ONE AMERICAN WILL BE SPARED."

JOHN LEWIS, HIS LAST WORDS, RELEASED ON THE DAY OF HIS FUNERAL:

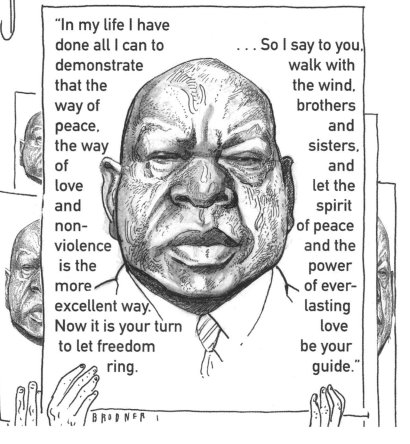

"In my life I have done all I can to demonstrate that the way of peace, the way of love and non-violence is the more excellent way. Now it is your turn to let freedom ring. . . . So I say to you, walk with the wind, brothers and sisters, and let the spirit of peace and the power of ever-lasting love be your guide."

BRODNER

LOUIS DeJOY

TWO MILLION-DOLLAR
TRUMP DONOR-TURNED
POSTMASTER GENERAL,
HAS IMPLEMENTED
"CHANGES" THAT ARE
SLOWING DOWN THE
MAILS, CAUSING BACK-
LOGS. THIS COMES
AS TRUMP CONTIN-
UALLY ATTACKS THE
POST OFFICE.
SHIPPING DATES ARE
NOW NOT BEING MET.
BASED ON THESE PRACTICES,
MAIL-IN BALLOTS WILL BE
PROCESSED DAYS AFTER THE
ELECTION. TRUMP HAS REPEATED
THAT A DELAY WOULD, TO HIM,
SIGNAL "FRAUD."

BRODNER

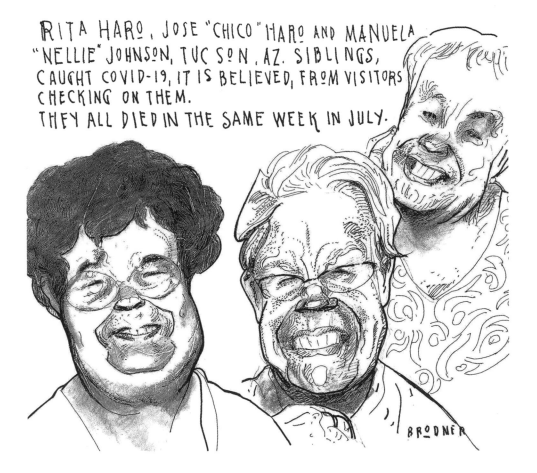

RITA HARO, JOSE "CHICO" HARO AND MANUELA "NELLIE" JOHNSON, TUCSON, AZ. SIBLINGS, CAUGHT COVID-19, IT IS BELIEVED, FROM VISITORS CHECKING ON THEM.
THEY ALL DIED IN THE SAME WEEK IN JULY.

BRODNER

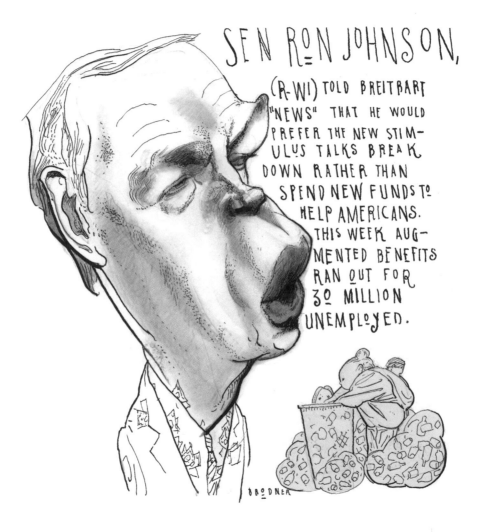

SEN RON JOHNSON, (R-WI) TOLD BREITBART "NEWS" THAT HE WOULD PREFER THE NEW STIMULUS TALKS BREAK DOWN RATHER THAN SPEND NEW FUNDS TO HELP AMERICANS. THIS WEEK AUGMENTED BENEFITS RAN OUT FOR 30 MILLION UNEMPLOYED.

BRODNER

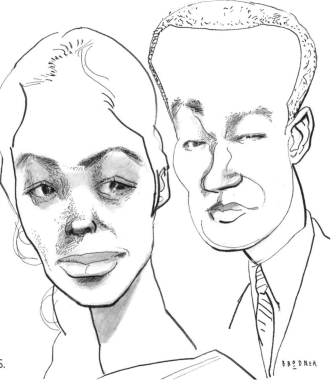

SHYAMALA GOPALAN AND DONALD HARRIS.

GOPALAN, DAUGHTER OF A
TAMIL INDIAN DIPLOMAT AND
WOMEN'S RIGHTS ADVOCATE,
MOVED TO THE US AT 19, EVEN-
TUALLY BECOMING A BREAST
CANCER RESEARCHER. HARRIS
EMIGRATED FROM THE WEST
INDIES TO STUDY AT BERKELEY,
LATER BECOMING A PROFESSOR
OF ECONOMICS AT STANFORD.
THEY MET DURING CIVIL RIGHTS
ACTIVISM.
IN 1964 THEY BECAME
THE PARENTS OF KAMALA HARRIS.

MARJORIE
TAYLOR GREENE

WON HER GOP PRIMARY IN
GEORGIA'S 14TH DISTRICT. SHE IS
A DEVOTEE OF QANON, A WEB-
BASED CONSPIRACY BELIEF
SYSTEM, WHICH CONTENDS THAT
UNIDENTIFIED GOVERNMENT
OFFICIALS ARE SEX TRAFFICKING
(AND EATING) CHILDREN; THAT
THE CORONAVIRUS IS A PLOT;
THAT HILLARY CLINTON AND THE
"MEDIA" ARE BEHIND THIS; AND
THAT TRUMP IS HEROICALLY
WORKING TO SAVE AMERICA
FROM THEM. (THEY ARE ALSO
HIJACKING THE #SAVETHE
CHILDREN CHARITY).

TRUMP: "Congratulations to future
Republican Star Marjorie Taylor
Greene on a big Congressional
primary win in Georgia against
a very tough and smart opponent.
Marjorie is strong on everything
and never gives up -
a real WINNER!"

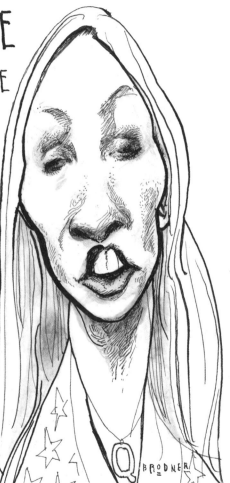

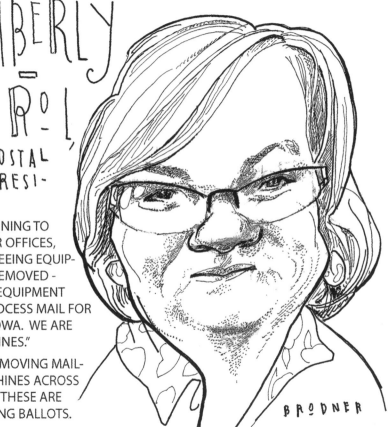

KIMBERLY KAROL,

IOWA POSTAL UNION PRESIDENT:

"MAIL IS BEGINNING TO PILE UP IN OUR OFFICES, AND WE ARE SEEING EQUIPMENT BEING REMOVED - THE SORTING EQUIPMENT WE USE TO PROCESS MAIL FOR DELIVERY IN IOWA. WE ARE LOSING MACHINES."

THE USPS IS REMOVING MAIL-SORTING MACHINES ACROSS THE COUNTRY; THESE ARE USED IN SORTING BALLOTS.

BRODNER

JOHN EASTMAN

IS THE AUTHOR OF THE
NEWSWEEK OPINION
PIECE THAT KICK-
STARTED THE KAMALA HARRIS
BIRTHER THEORY, WHICH
SOON WENT VIRAL AND INTO
TRUMP-WORLD MEDIA.

MR. EASTMAN IS AN ANTI-LGBTQ
ACTIVIST AND ANTI-IMMIGRANT BIGOT.
NEWSWEEK EDITOR JOSH HAMMER
LATER APOLOGIZED, STATING, IN
EFFECT, THAT HE DIDN'T RECOGNIZE
A RACIST LIE WHEN HE SAW IT.

BRODNER

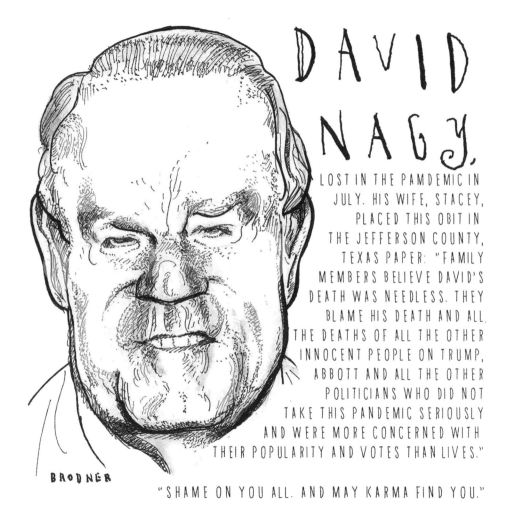

DAVID NAGY,

LOST IN THE PAMDEMIC IN JULY. HIS WIFE, STACEY, PLACED THIS OBIT IN THE JEFFERSON COUNTY, TEXAS PAPER: "FAMILY MEMBERS BELIEVE DAVID'S DEATH WAS NEEDLESS. THEY BLAME HIS DEATH AND ALL THE DEATHS OF ALL THE OTHER INNOCENT PEOPLE ON TRUMP, ABBOTT AND ALL THE OTHER POLITICIANS WHO DID NOT TAKE THIS PANDEMIC SERIOUSLY AND WERE MORE CONCERNED WITH THEIR POPULARITY AND VOTES THAN LIVES."

"SHAME ON YOU ALL. AND MAY KARMA FIND YOU."

BRODNER

ELIJAH McCLAIN, 23,

KILLED IN AURORA, COLORADO
POLICE CUSTODY IN 2019.
FOOTAGE SHOWS HIM BEING
TORTURED AND INJECTED WITH
A SEDATIVE, LEADING TO HEART
FAILURE AND HIS DEATH.
NO CHARGES HAVE BEEN FILED
AGAINST THE RESPONSIBLE
OFFICERS. HIS FAMILY IS SUING THE
CITY TO HOLD THEM ACCOUNTABLE.

"I CAN'T BREATHE.", HE SAID.

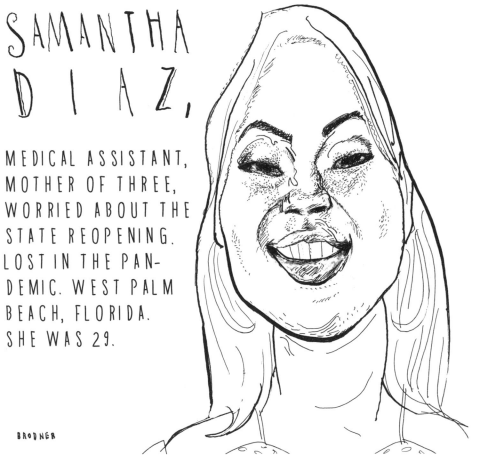

SAMANTHA DIAZ,

MEDICAL ASSISTANT, MOTHER OF THREE, WORRIED ABOUT THE STATE REOPENING. LOST IN THE PANDEMIC. WEST PALM BEACH, FLORIDA. SHE WAS 29.

BRODNER

DAVID C. WILLIAMS

FORMER VICE CHAIRMAN
OF THE US POSTAL SERVICE,
CLAIMS HE'D RESIGNED AS
STEPHEN MNUCHIN MOUNTED
A HOSTILE TAKEOVER OF THE
USPS ON BEHALF OF TRUMP,
CHANGING THE RULES IN
ORDER TO DESTROY THE
SYSTEM. LOUIS DEJOY,
THE CURRENT POSTMASTER
GENERAL, HE SAYS,
WAS NOT PROPERLY
INVESTIGATED WHILE INFO ABOUT SERIOUS
CONFLICTS OF INTEREST EMERGED.

BRODNER

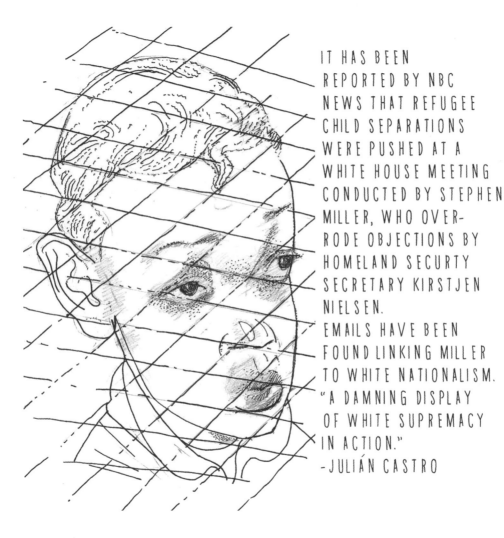

IT HAS BEEN
REPORTED BY NBC
NEWS THAT REFUGEE
CHILD SEPARATIONS
WERE PUSHED AT A
WHITE HOUSE MEETING
CONDUCTED BY STEPHEN
MILLER, WHO OVER-
RODE OBJECTIONS BY
HOMELAND SECURTY
SECRETARY KIRSTJEN
NIELSEN.
EMAILS HAVE BEEN
FOUND LINKING MILLER
TO WHITE NATIONALISM.
"A DAMNING DISPLAY
OF WHITE SUPREMACY
IN ACTION."
-JULIÁN CASTRO

STEPHEN HAHN

RECENTLY APPOINT-
ED FDA COMMIS-
SIONER, WALKED
BACK STATEMENTS
SUPPORTING BLOOD
PLASMA THERAPY
FOR COVID-19 PATIENTS
IN SUPPORT OF TRUMP'S
ASSERTIONS. NEITHER HE
NOR HIS ADVISORS HAVE
SIGNIFICANT FDA EXPER-
IENCE. "EITHER HE IS A
CHEERLEADER FOR THE
PRESIDENT OR HE'S DOING HIS BEST
IMPRESSION OF ONE."
JOSHUA SHARFSTEIN, COMMISSIONER, 2009-11.

BRODNER

DR. BRITTNEY COOPER,
COMMENTING ON MURDERS IN KENOSHA:

"Let's not forget that on the first night of the convention we had a white couple that had been brandishing guns at protesters so in Wisconsin last night we had a 17-year-old kid who finished the threat that those white people started in St. Louis, that we will "bring out our guns and shoot you for successfully exercising your right to peacefully protest."

"White people fear that black people are coming to take their power. This is the thing the RNC is actually promoting this week."

DR. AMY ACTON,

DIRECTOR OF THE OHIO DEPARTMENT OF HEALTH, RESIGNED IN JUNE BECAUSE OF THREATS TO HER SAFETY. TO DATE, 30 HEALTH OFFICIALS ACROSS THE COUNTRY HAVE RESIGNED UNDER THREATS. DR. ANTHONY FAUCI HAS REVEALED THAT HE AND HIS FAMILY HAVE NEEDED EXTRA SECURITY FOR THIS REASON.

BRODNER

MARY TRUMP:

Reacting to Trump's RNC Speech:
"If you listen to him you'd think that Biden is president now. But if the country is a place of division and decadence, that's down to HIM, as he is currently in the Oval Office."

BRODNER

TERRORIST 1: SHOOTER OF JACOB BLAKE, AUG. 23, KENOSHA, WI. IN ONGOING RACIST POLICE ACTION.

TERRORIST 2: SHOOTER OF THREE, KILLER OF TWO, AUG. 25, FOLLOW-ER OF TRUMP, KENOSHA, WI.

TERRORIST 3: KILLER OF PRO-TRUMPER, AUG. 29, PORTLAND.

TRUMP, THE WHITE HOUSE, 2020.

BRODNER

**CHERYL &
CORRINA
THINN,**
SISTERS WHO
WORKED TOGETH-
ER AT TUBA
CITY REGIONAL
HEALTH CARE IN
ARIZONA. CHERYL
CONDUCTED PATIENT
REVIEWS AND CORRINA
WAS A SOCIAL WORKER.
THEY LIVED WITH THEIR
MOTHER AND HELPED
RAISE EACH OTHER'S
CHILDREN. AMONG 500
OF THEIR NAVAJO RESERV-
ATION LOST IN THE
PANDEMIC. THEY WERE 44 AND 40.

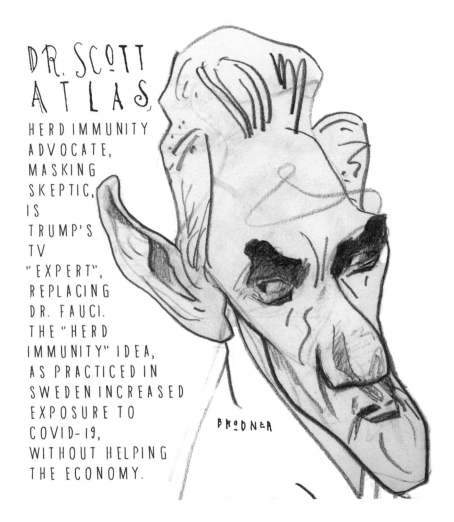

DR. SCOTT ATLAS,

HERD IMMUNITY ADVOCATE, MASKING SKEPTIC, IS TRUMP'S TV "EXPERT", REPLACING DR. FAUCI. THE "HERD IMMUNITY" IDEA, AS PRACTICED IN SWEDEN INCREASED EXPOSURE TO COVID-19, WITHOUT HELPING THE ECONOMY.

BRODNER

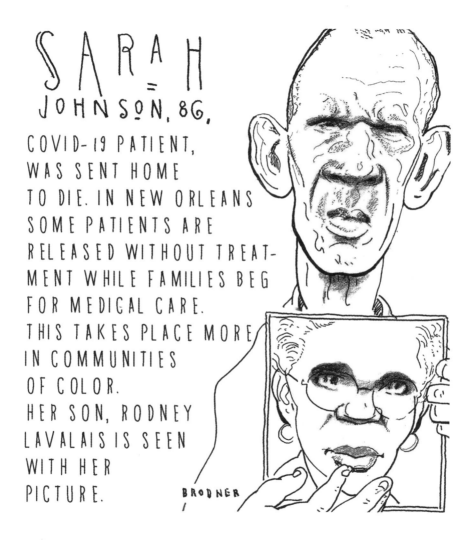

SARAH
JOHNSON, 86,

COVID-19 PATIENT,
WAS SENT HOME
TO DIE. IN NEW ORLEANS
SOME PATIENTS ARE
RELEASED WITHOUT TREAT-
MENT WHILE FAMILIES BEG
FOR MEDICAL CARE.
THIS TAKES PLACE MORE
IN COMMUNITIES
OF COLOR.
HER SON, RODNEY
LAVALAIS IS SEEN
WITH HER
PICTURE.

BRODNER

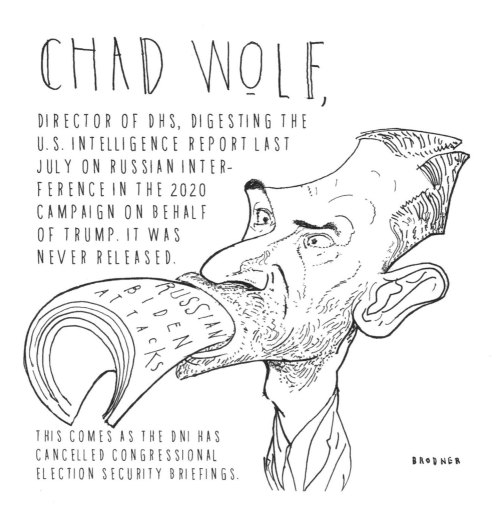

CHAD WOLF,

DIRECTOR OF DHS, DIGESTING THE
U.S. INTELLIGENCE REPORT LAST
JULY ON RUSSIAN INTER-
FERENCE IN THE 2020
CAMPAIGN ON BEHALF
OF TRUMP. IT WAS
NEVER RELEASED.

RUSSIAN BIDEN ATTACKS

THIS COMES AS THE DNI HAS
CANCELLED CONGRESSIONAL
ELECTION SECURITY BRIEFINGS.

BRODNER

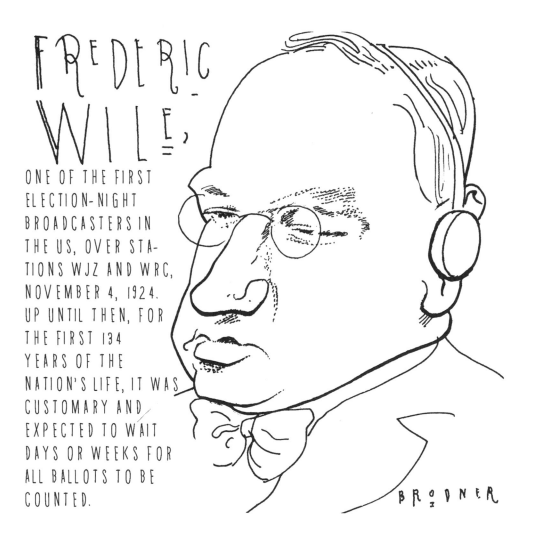

FREDERIC WILE,

ONE OF THE FIRST
ELECTION-NIGHT
BROADCASTERS IN
THE US, OVER STA-
TIONS WJZ AND WRC,
NOVEMBER 4, 1924.
UP UNTIL THEN, FOR
THE FIRST 134
YEARS OF THE
NATION'S LIFE, IT WAS
CUSTOMARY AND
EXPECTED TO WAIT
DAYS OR WEEKS FOR
ALL BALLOTS TO BE
COUNTED.

BRODNER

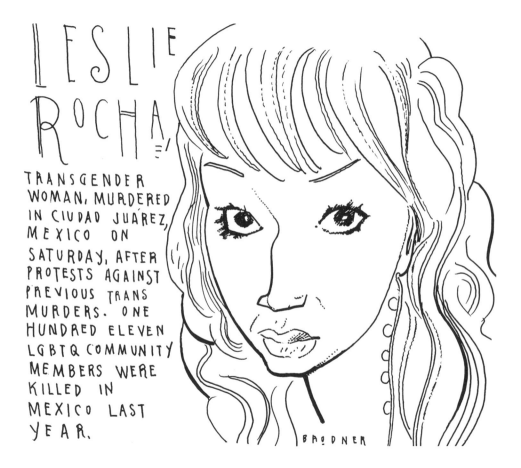

LESLIE ROCHA

TRANSGENDER WOMAN, MURDERED IN CIUDAD JUÁREZ, MEXICO ON SATURDAY, AFTER PROTESTS AGAINST PREVIOUS TRANS MURDERS. ONE HUNDRED ELEVEN LGBTQ COMMUNITY MEMBERS WERE KILLED IN MEXICO LAST YEAR.

BRODNER

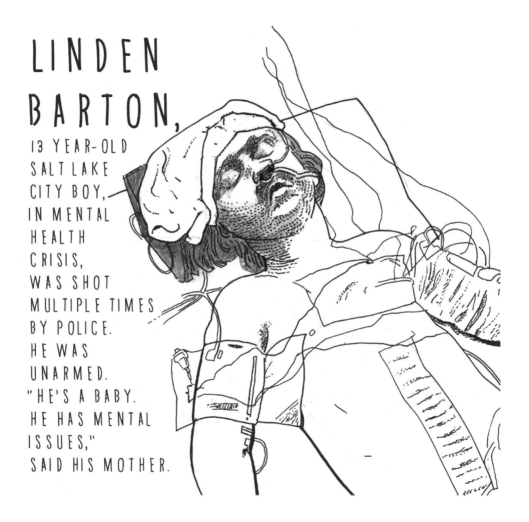

LINDEN BARTON,

13 YEAR-OLD SALT LAKE CITY BOY, IN MENTAL HEALTH CRISIS, WAS SHOT MULTIPLE TIMES BY POLICE. HE WAS UNARMED. "HE'S A BABY. HE HAS MENTAL ISSUES," SAID HIS MOTHER.

Demetria "Demi" Bannister, third grade teacher in SC, is one of three teachers who have died of Covid-19 so far this term. She was a gifted singer and a devoted educator. She had been teaching online but visited her school in late August. She was 28 years old.

BRODNER

ON AUGUST 10, A MOTORCYCLE RALLY DREW 460,000 ATTENDEES IN STURGIS, S.D. ~ RESEARCHERS HAVE ESTIMATED THAT 266,796 CASES CAN BE LINKED TO THAT RALLY. THE PUBLIC HEALTH COST, $12.2 BILLION, IS ENOUGH TO HAVE PAID EACH PERSON $26,000 TO STAY HOME.

BRODNER

CALIFORNIA DIRECTOR OF NATURAL RESOURCES, WADE CROWFOOT: "IF WE IGNORE THE SCIENCE WE'RE NOT GOING TO SUCCEED TOGETHER IN PROTECTING CALIFORNIANS."
TRUMP: "IT WILL START GETTING COOLER. YOU JUST WATCH." CROWFOOT: "I WISH THE SCIENCE AGREED WITH THAT."
TRUMP: (CHUCKLES) "I DON'T THINK SCIENCE KNOWS, ACTUALLY."

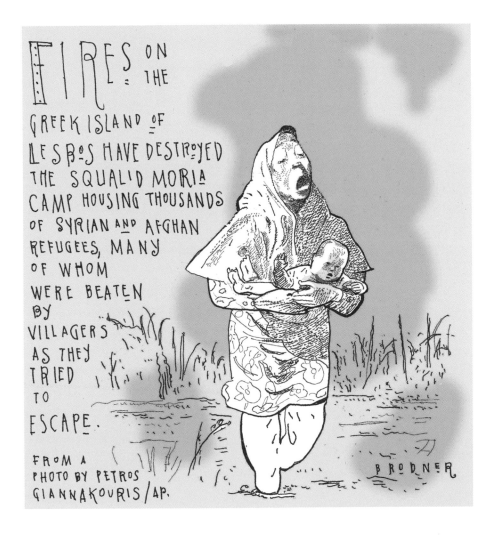

FIRES ON THE GREEK ISLAND OF LESBOS HAVE DESTROYED THE SQUALID MORIA CAMP HOUSING THOUSANDS OF SYRIAN AND AFGHAN REFUGEES, MANY OF WHOM WERE BEATEN BY VILLAGERS AS THEY TRIED TO ESCAPE.

FROM A PHOTO BY PETROS GIANNAKOURIS/AP.

BRODNER

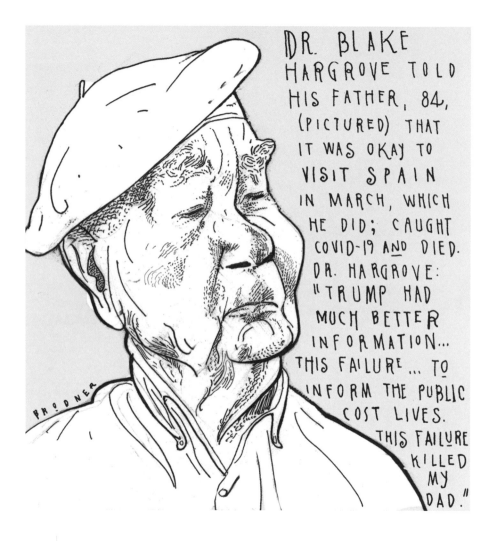

DR. BLAKE HARGROVE TOLD HIS FATHER, 84, (PICTURED) THAT IT WAS OKAY TO VISIT SPAIN IN MARCH, WHICH HE DID; CAUGHT COVID-19 AND DIED. DR. HARGROVE: "TRUMP HAD MUCH BETTER INFORMATION... THIS FAILURE... TO INFORM THE PUBLIC COST LIVES. THIS FAILURE KILLED MY DAD."

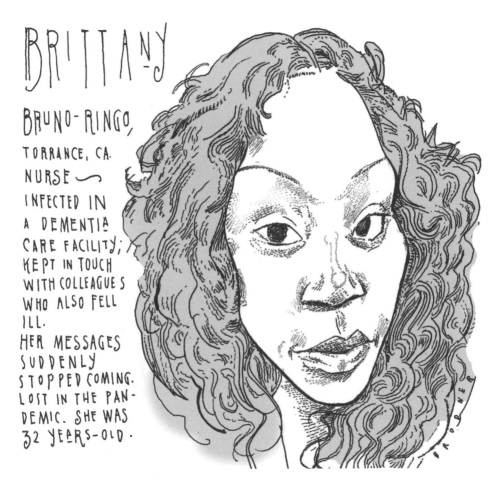

BRITTANY

BRUNO-RINGO,
TORRANCE, CA.
NURSE
INFECTED IN
A DEMENTIA
CARE FACILITY;
KEPT IN TOUCH
WITH COLLEAGUES
WHO ALSO FELL
ILL.
HER MESSAGES
SUDDENLY
STOPPED COMING.
LOST IN THE PAN-
DEMIC. SHE WAS
32 YEARS-OLD.

"I want you to use my words against me. If there's a Republican president in 2016 and a vacancy occurs in the last year of the first term, you can say Lindsey Graham said let's let the next president, whoever it might be, make that nomination."
Sen. Lindsey Graham, March, 2016.

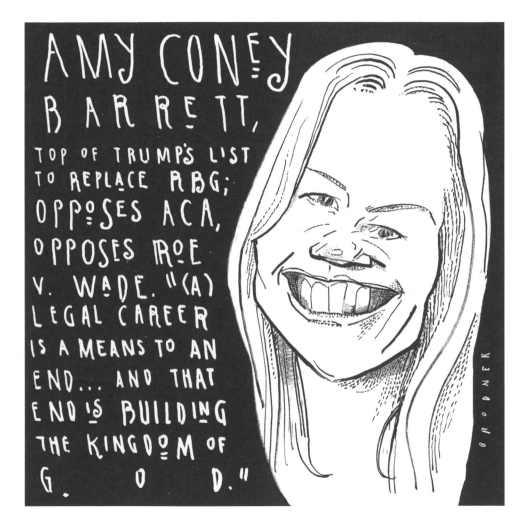

AMY CONEY BARRETT, TOP OF TRUMP'S LIST TO REPLACE RBG; OPPOSES ACA, OPPOSES ROE V. WADE. "(A) LEGAL CAREER IS A MEANS TO AN END... AND THAT END IS BUILDING THE KINGDOM OF G. O. D."

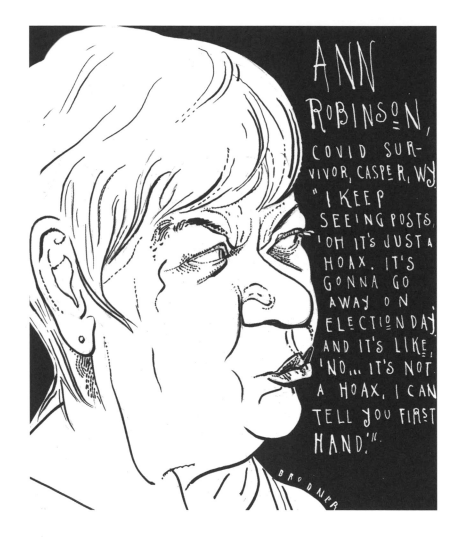

ANN ROBINSON, COVID SURVIVOR, CASPER, WY. "I KEEP SEEING POSTS, 'OH IT'S JUST A HOAX. IT'S GONNA GO AWAY ON ELECTION DAY,' AND IT'S LIKE, 'NO... IT'S NOT A HOAX, I CAN TELL YOU FIRST HAND.'"

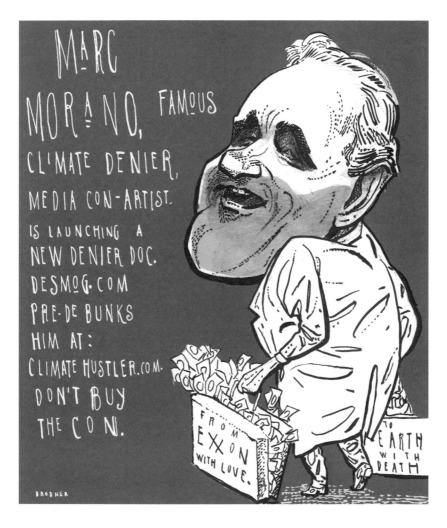

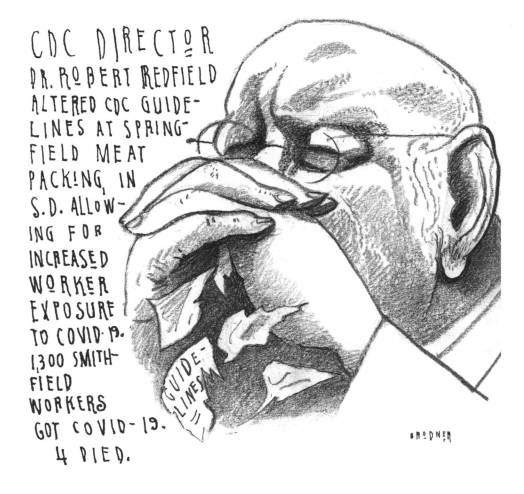

CDC DIRECTOR DR. ROBERT REDFIELD ALTERED CDC GUIDE-LINES AT SPRING-FIELD MEAT PACKING, IN S.D. ALLOW-ING FOR INCREASED WORKER EXPOSURE TO COVID-19. 1,300 SMITHFIELD WORKERS GOT COVID-19. 4 DIED.

GUIDE-LINES

BRODNER

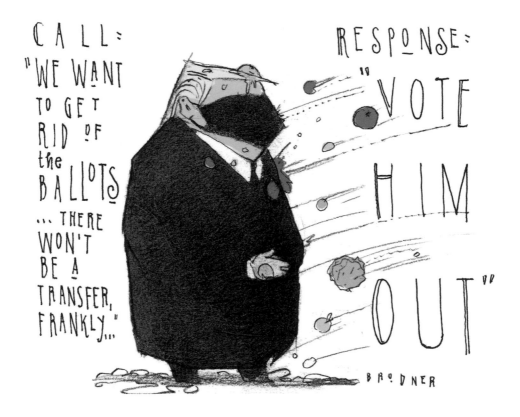

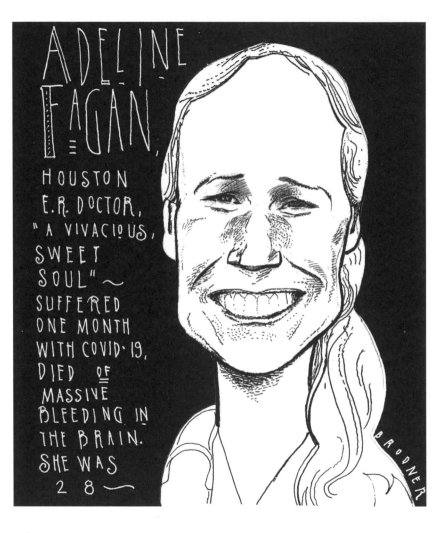

ADELINE FAGAN,
HOUSTON E.R. DOCTOR, "A VIVACIOUS, SWEET SOUL" ~ SUFFERED ONE MONTH WITH COVID·19, DIED OF MASSIVE BLEEDING IN THE BRAIN. SHE WAS 28 ~

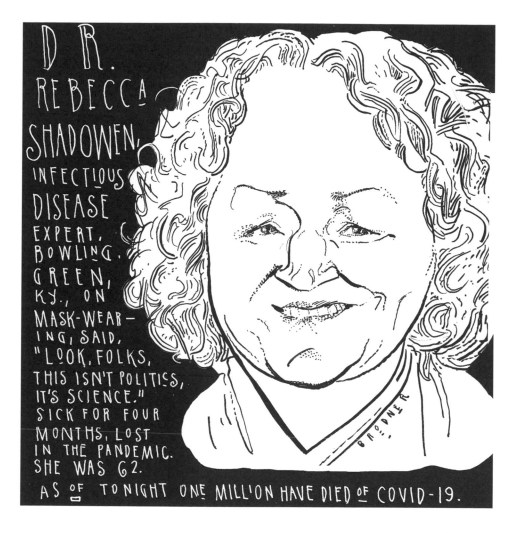

DR. REBECCA SHADOWEN, INFECTIOUS DISEASE EXPERT, BOWLING GREEN, KY., ON MASK-WEARING, SAID, "LOOK, FOLKS, THIS ISN'T POLITICS, IT'S SCIENCE." SICK FOR FOUR MONTHS, LOST IN THE PANDEMIC. SHE WAS 62. AS OF TONIGHT ONE MILLION HAVE DIED OF COVID-19.

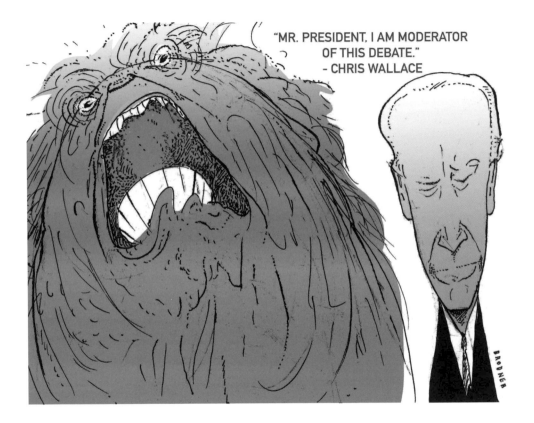

"MR. PRESIDENT, I AM MODERATOR OF THIS DEBATE."
- CHRIS WALLACE

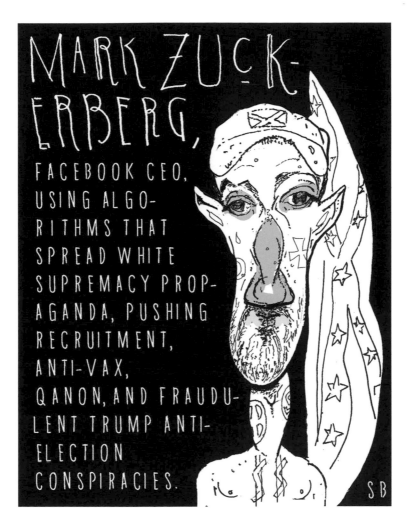

MARK ZUCK-ERBERG, FACEBOOK CEO, USING ALGO-RITHMS THAT SPREAD WHITE SUPREMACY PROP-AGANDA, PUSHING RECRUITMENT, ANTI-VAX, QANON, AND FRAUDU-LENT TRUMP ANTI-ELECTION CONSPIRACIES.

SB

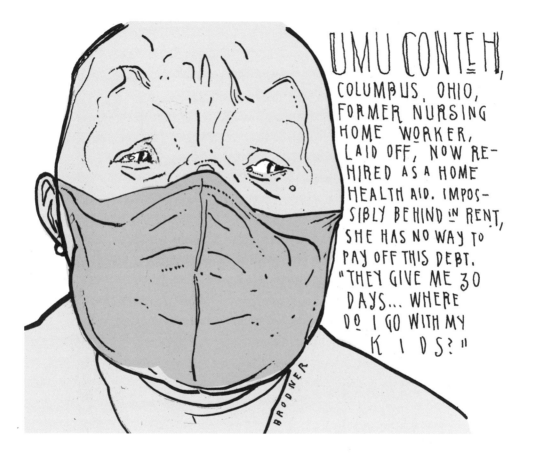

UMU CONTEH, COLUMBUS, OHIO, FORMER NURSING HOME WORKER, LAID OFF, NOW RE-HIRED AS A HOME HEALTH AID. IMPOSSIBLY BEHIND IN RENT, SHE HAS NO WAY TO PAY OFF THIS DEBT. "THEY GIVE ME 30 DAYS... WHERE DO I GO WITH MY KIDS?"

NYT: Documents reveal that Jeff Sessions and Rod Rosenstein engineered the brutal child separations at the border in 2018. Attorney General Sessions: "We need to take away children." Rosenstein, deputy AG ruled: It did not matter how young the children were. Lawyers should not stop prosecutions because the children were barely more than infants. Thousands have been incarcerated. And many have been sexually abused. All traumatized, perhaps, for life.

Bennie
Henley,
Covid patient
at Tampa
General,
in the after-
math of
Florida's
re-opening.
Ten patients
were on
ventilators.
"More than a
dozen others
with non-critical
 cases filled
beds in a dedi-
cated ward. In the
emergency room,
someone sick with
the virus showed up about every hour.
This is what a lull looks like." The Washington Post

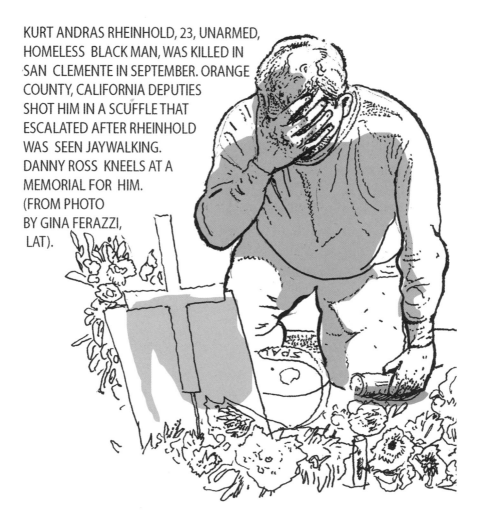

KURT ANDRAS RHEINHOLD, 23, UNARMED, HOMELESS BLACK MAN, WAS KILLED IN SAN CLEMENTE IN SEPTEMBER. ORANGE COUNTY, CALIFORNIA DEPUTIES SHOT HIM IN A SCUFFLE THAT ESCALATED AFTER RHEINHOLD WAS SEEN JAYWALKING. DANNY ROSS KNEELS AT A MEMORIAL FOR HIM. (FROM PHOTO BY GINA FERAZZI, LAT).

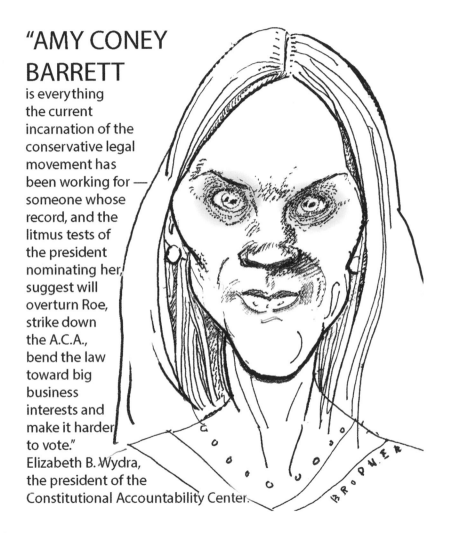

"AMY CONEY BARRETT is everything the current incarnation of the conservative legal movement has been working for — someone whose record, and the litmus tests of the president nominating her, suggest will overturn Roe, strike down the A.C.A., bend the law toward big business interests and make it harder to vote."
Elizabeth B. Wydra, the president of the Constitutional Accountability Center.

AMY
CONEHEAD
PARROT
=T

SB

SEN. SHELDON WHITE-
HOUSE UNMASKED AMY
CONEY BARRETT AS A
GUIDED MISSILE AIMED
AT HEALTH, ABORTION,
LGBTQ RIGHTS. IN
EXQUISITE DETAIL HE
REVEALED HER TO BE
THE KOCH NETWORK
IN A RED DRESS.
"AND WHO WINS IN
DARK MONEY
POLITICS? A VERY
SMALL GROUP. THE
ONES WHO HAVE
UNLIMITED MONEY TO
SPEND, AND A MOTIVE TO
SPEND IT IN POLITICS."
THEIR AGENDA:
1. USE UNLIMITED DARK MONEY.
2. DIMINISH THE CIVIL JURY.
3. WEAKEN REGULATORY
AGENCIES (FAVORED BY
 POLLUTERS LIKE KOCH
INDUSTRIES).
4. SUPPRESS VOTING.
5. ETC.

MS. CONEY-BARRETT

MICHAEL REINOEHL, ACTIVIST,
SUSPECT IN THE KILLING OF
A FAR RIGHT TRUMP SUP-
PORTER IN PORTLAND, WAS
KILLED IN A HAIL OF
GUNFIRE SEPT. 3.
21 WITNESSES HAVE
NOW STATED THAT
POLICE DID NOT
INFORM HIM OF HIS
ARREST, BUT ENGAGED
IN AN EXTRA-JUDICIAL
KILLING. HE WAS
UNARMED.
 "I said, 'Why the hell haven't they
arrested him?' And they knew who he
was. And we sent in the U.S. Marshals.
And in 15 minutes it was all over.
That was the end of it.", Trump.

BRODNER

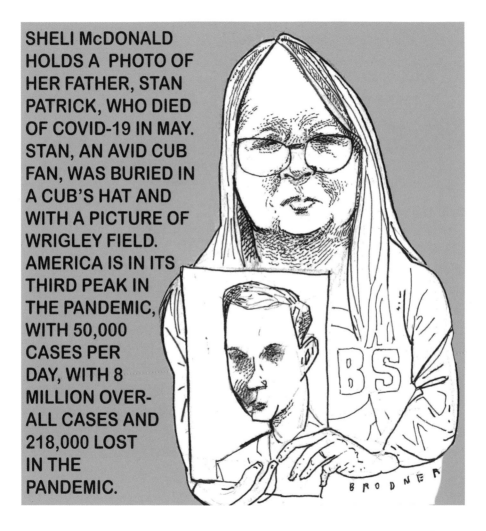

SHELI McDONALD HOLDS A PHOTO OF HER FATHER, STAN PATRICK, WHO DIED OF COVID-19 IN MAY. STAN, AN AVID CUB FAN, WAS BURIED IN A CUB'S HAT AND WITH A PICTURE OF WRIGLEY FIELD. AMERICA IS IN ITS THIRD PEAK IN THE PANDEMIC, WITH 50,000 CASES PER DAY, WITH 8 MILLION OVER-ALL CASES AND 218,000 LOST IN THE PANDEMIC.

Thomas J. Donohue, CEO, US Chamber of Commerce.

In 2019 the Chamber devoted a new section to its website recognizing Climate Change, after years of opposing the science. A new report reveals that they continue to lobby for the fossil fuel industry. They have also poured thousands of dollars into the campaigns of Susan Collins, Cory Gardner, Thom Tillis, Joni Ernst, and Roger Marshall. There have been 57 separate lobbying efforts in the last year.

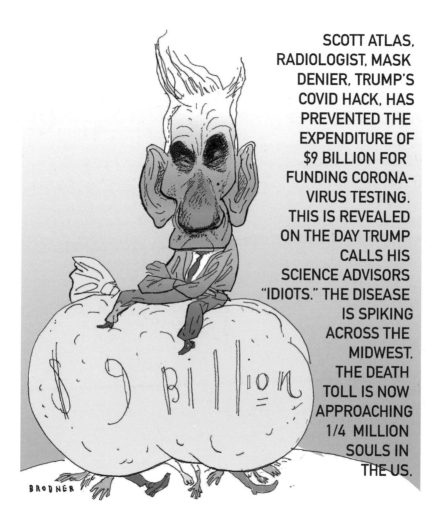

SCOTT ATLAS, RADIOLOGIST, MASK DENIER, TRUMP'S COVID HACK, HAS PREVENTED THE EXPENDITURE OF $9 BILLION FOR FUNDING CORONAVIRUS TESTING. THIS IS REVEALED ON THE DAY TRUMP CALLS HIS SCIENCE ADVISORS "IDIOTS." THE DISEASE IS SPIKING ACROSS THE MIDWEST. THE DEATH TOLL IS NOW APPROACHING 1/4 MILLION SOULS IN THE US.

BRUCE GOLDING, WRITER
OF THE DISCREDITED
HUNTER BIDEN
NY POST ARTICLE,
WAS REPORTEDLY
TOO EMBAR-
RASSED
TO SIGN IT.
THE FBI IS
NOW INVEST-
IGATING THE
GIULIANI
RUSSIA-
TO-TRUMP
DISINFORMA-
TION
PIPELINE.

PARENTS OF 545 MIGRANT CHILDREN KIDNAPPED BY TRUMP AGENTS HAVE NOT BEEN FOUND AND MAY BE UNREACH-ABLE. GOD MAY RESERVE A PLACE IN HELL FOR THE TRUMP MOB. BUT SWIFT JUSTICE MUST COME FOR THEM IN THE U.S.

BRODNER

ANGELA SETTLES, OF
NASHVILLE. HER
HUSBAND, DARIUS, 30,
DIED OF COVID-19
IN JULY AFTER
BEING SENT HOME
FROM THE E.R.
UNINSURED, HE
WAS WORRIED
ABOUT THE
HIGH COST OF
HIS HOSPITAL-
IZATION. HE,
ALONG WITH
HUNDREDS
OF OTHERS, WAS
NEVER TOLD THAT THE
FEDERAL GOVERNMENT
WOULD HAVE PAID
HIS BILLS.
ANGELA WAS LATER SENT A
BILL FOR HER HUSBAND'S
CARE THAT THE HOSPITAL
HAS SINCE SAID WAS
SENT IN ERROR.

MIKE PENCE CONTINUES TO HOLD RALLIES AS COVID-19 SWEEPS
THROUGH HIS OFFICE, INFECTING HIS CHIEF OF STAFF AND FOUR
OTHERS (HE IS NOT QUARANTINING, IN VIOLATION OF CDC GUIDELINES),
ON A DAY WHEN THE ADMINISTRATION'S "HERD IMMUNITY" STRATEGY
WAS, AT LAST, ELUCIDATED BY MARK MEADOWS, TRUMP'S
CHIEF OF STAFF:

"WE ARE NOT GOING TO
CONTROL THIS
PANDEMIC."

ALSO
WALL STREET
CRATERED AS
IT BECAME CLEAR
THAT REPUBLICANS WILL BLOCK
PANDEMIC RELIEF.

As of today, at least 69 million have already cast their ballots. This number equals half the total 2016 vote. For the first time, most will be cast before Election Day.

(line in Wisconsin.)

People are waiting for hours, confounding attempts

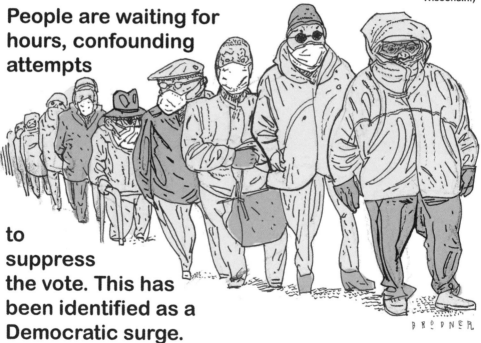

to suppress the vote. This has been identified as a Democratic surge.

OCTOBER 28, 2020

WALTER WALLACE JR., 27, WAS KILLED IN HAIL A OF GUNFIRE IN PHILADELPHIA BY POLICE ILL-EQUIPPED TO HANDLE HIS MENTAL HEALTH EMERGENCY. THE CITY HAS BEEN EXPERIENC- ING WIDE- SPREAD PROTEST SINCE MONDAY.

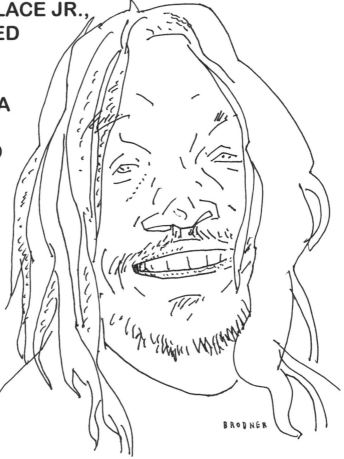

BRODNER

Donald Trump Jr. said that Covid-19 deaths are "down to nothing." on the day when 1,000 Americans died of the virus.

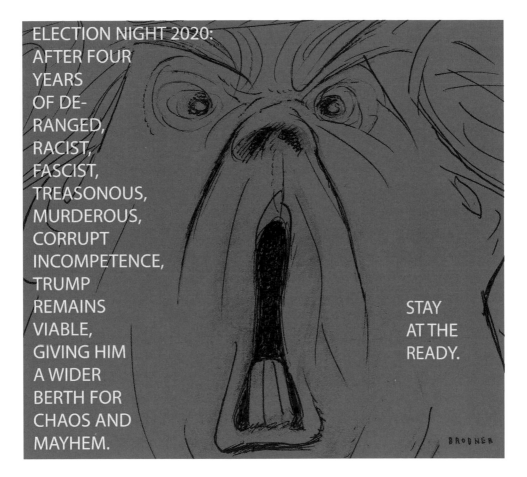

ELECTION NIGHT 2020: AFTER FOUR YEARS OF DE-RANGED, RACIST, FASCIST, TREASONOUS, MURDEROUS, CORRUPT INCOMPETENCE, TRUMP REMAINS VIABLE, GIVING HIM A WIDER BERTH FOR CHAOS AND MAYHEM.

STAY AT THE READY.

THE MOB OUTSIDE MARICOPA VOTE COUNTING SITE LAST NIGHT.
Sean HannitY: 'Do you trust what happened in this election? Do you
believe these election results are accurate? Do you believe this was
a free and fair election?' He said he didn't trust what was happening
in Philly and Detroit.
And Tucker Carlson
said many people
"will never again
accept the results
of a presidential
election'again after
2020."

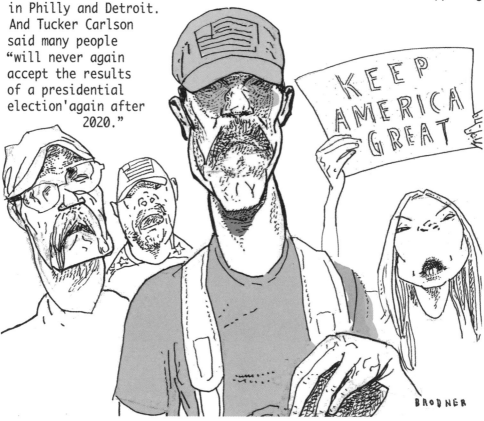

"That is the President of the United States. That is the most powerful person in the world and we see him like an obese turtle on his back flailing in the hot sun realizing his time is over."
— Anderson Cooper, on CNN.

BRODNER

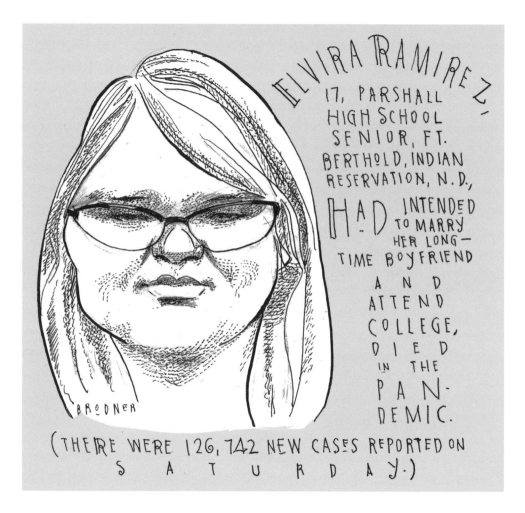

ELVIRA RAMIREZ, 17, PARSHALL HIGH SCHOOL SENIOR, FT. BERTHOLD, INDIAN RESERVATION, N.D., HAD INTENDED TO MARRY HER LONG-TIME BOYFRIEND AND ATTEND COLLEGE, DIED IN THE PANDEMIC.

(THERE WERE 126,742 NEW CASES REPORTED ON SATURDAY.)

BRODNER

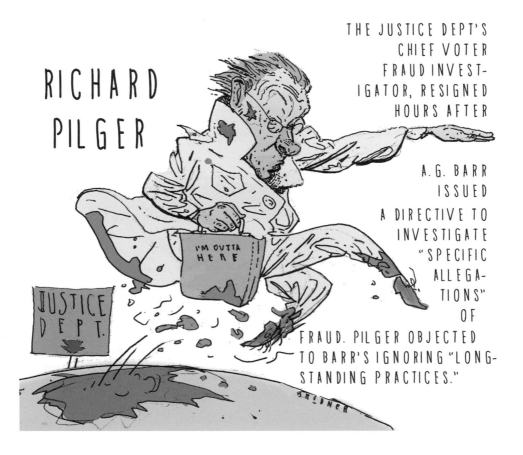

RICHARD
PILGER

THE JUSTICE DEPT'S
CHIEF VOTER
FRAUD INVEST-
IGATOR, RESIGNED
HOURS AFTER

A.G. BARR
ISSUED
A DIRECTIVE TO
INVESTIGATE
"SPECIFIC
ALLEGA-
TIONS"
OF
FRAUD. PILGER OBJECTED
TO BARR'S IGNORING "LONG-
STANDING PRACTICES."

I'M OUTTA HERE

JUSTICE DEPT.

BRODNER

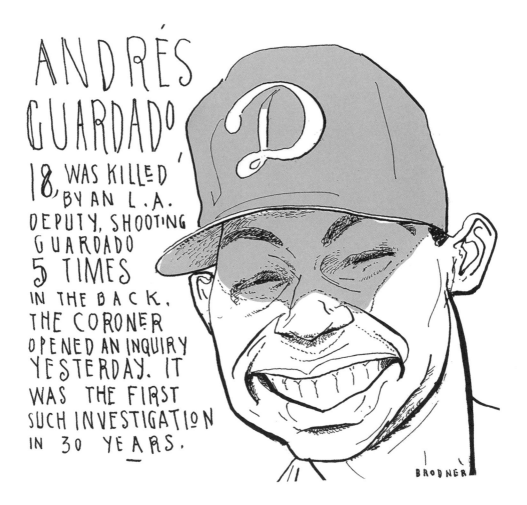

ANDRÉS GUARDADO, 18, WAS KILLED BY AN L.A. DEPUTY, SHOOTING GUARDADO 5 TIMES IN THE BACK, THE CORONER OPENED AN INQUIRY YESTERDAY. IT WAS THE FIRST SUCH INVESTIGATION IN 30 YEARS.

BRODNER

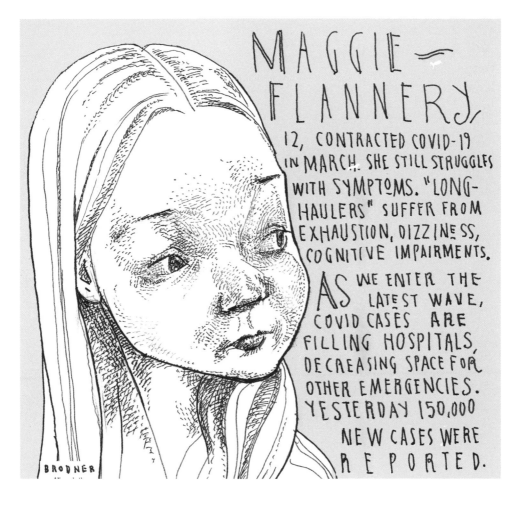

MAGGIE — FLANNERY, 12, CONTRACTED COVID-19 IN MARCH. SHE STILL STRUGGLES WITH SYMPTOMS. "LONG-HAULERS" SUFFER FROM EXHAUSTION, DIZZINESS, COGNITIVE IMPAIRMENTS.

AS WE ENTER THE LATEST WAVE, COVID CASES ARE FILLING HOSPITALS, DECREASING SPACE FOR OTHER EMERGENCIES. YESTERDAY 150,000 NEW CASES WERE REPORTED.

BRODNER

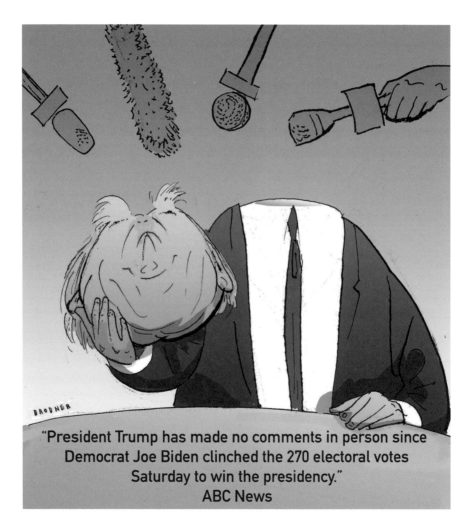

"President Trump has made no comments in person since Democrat Joe Biden clinched the 270 electoral votes Saturday to win the presidency."
ABC News

BRAD RAFFENS-PERGER,

GEORGIA SECRETARY OF STATE, RECEIVED A CALL FRIDAY FROM LINDSEY GRAHAM, SUGGESTING HE THROW OUT LEGAL MAIL-IN BALLOTS. A STAFFER, WHO WAS ON THE CALL, COR-ROBORATED THIS STORY TODAY.

BRODNER

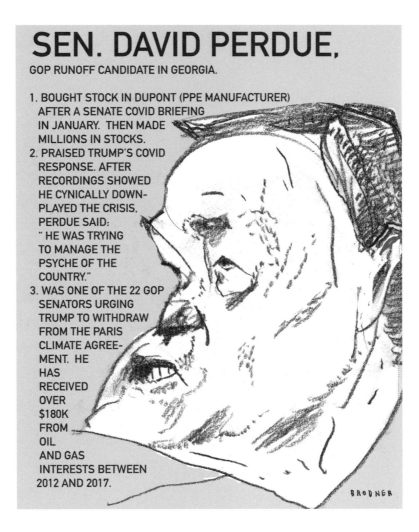

SEN. DAVID PERDUE,

GOP RUNOFF CANDIDATE IN GEORGIA.

1. BOUGHT STOCK IN DUPONT (PPE MANUFACTURER) AFTER A SENATE COVID BRIEFING IN JANUARY. THEN MADE MILLIONS IN STOCKS.
2. PRAISED TRUMP'S COVID RESPONSE. AFTER RECORDINGS SHOWED HE CYNICALLY DOWN-PLAYED THE CRISIS, PERDUE SAID: " HE WAS TRYING TO MANAGE THE PSYCHE OF THE COUNTRY."
3. WAS ONE OF THE 22 GOP SENATORS URGING TRUMP TO WITHDRAW FROM THE PARIS CLIMATE AGREE-MENT. HE HAS RECEIVED OVER $180K FROM OIL AND GAS INTERESTS BETWEEN 2012 AND 2017.

BRODNER

THE MORGUE IN EL PASO, TEXAS IS SO OVERWHELMED WITH PEOPLE DYING OF COVID-19 THAT LOCAL PRISON INMATES ARE BEING BROUGHT IN TO ASSIST WITH THE OVERFLOW OF BODIES AWAITING AUTOPSY.

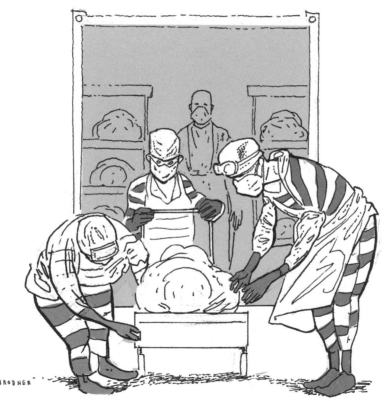

"Everyone should get to know the name of General Services Administrator Emily Murphy. Her Wikipedia page will change forever as the person who stood in the way, obstructed the incoming president and administration and, as a result, Americans died because Emily Murphy refused to do her job. And Donald Trump is rewarding her for it."
Donna Edwards

Pennsylvania District Court Judge Matthew W. Brann, in deciding against the Trump Campaign's appeal to cancel votes. "In the United States of America, this cannot justify the disenfranchisement of a single voter, let alone all the voters of its sixth most populated state. Our people, laws, and institutions demand more. At bottom, Plaintiffs have failed to meet their burden to state a claim upon which relief may be granted. Therefore, I grant Defendants' motions and dismiss Plaintiffs' action with prejudice."

BRODNER

Christian Robbins,

14, Richland WA, committed suicide one month into the pandemic. The US suicide prevention system is so broken that there isn't accurate national data on the problem. Between 2007-2018 suicides increased by 56% among teens and young adults. The pandemic is elevating this crisis.

National Suicide Prevention Lifeline: 800-273-TALK. (8255).
Crisis Text Line: 741741.

Jade Carahajal-Richter, Kearney Charity Hospital, Lakin, KS, is part of the overwhelmed Midwest health system, lacking in equipment and staff. These are states where bars, restaurants, gatherings (and Trump rallies) have been unregulated. "Everyone is continuing to go about their lives." said one doctor. "But we sort of feel like we're drowning."

BRODNER

Al Howard, NYC police officer, who saved Dr. Martin Luther King's life after a 1958 stabbing at a Harlem department store, by stopping someone from removing the blade from Dr. King's chest, called Harlem Hospital and then diverted a large crowd form the entrance, making a path for the ambulance, died in pandemic.

IN AMERICA

One in eight people (24 million) are hungry, as
the senate takes recess and refuses to act. By year-end
50 million are predicted to be food insecure.
Food pantries are being overwhelmed.
Evictions will exceed the Great Recession levels,
displacing 20 million. On Giving Tuesday please
help Feedingamerica.org and your local
foodbank.

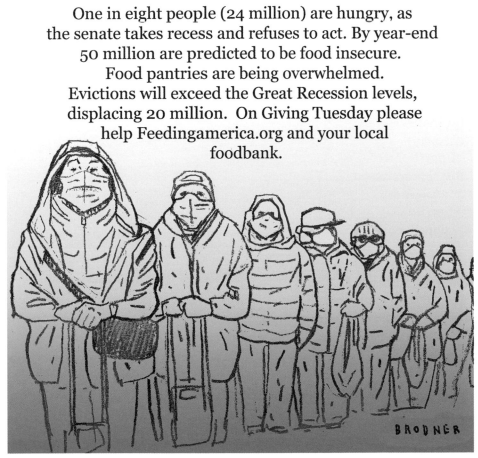

Greg Cruey, middle school social studies teacher in West Virginia. Enraged parents force kids to hang up on his zoom class and phone the school, complaining when he teaches civics, especially lessons on the election, so deeply entrenched is partisan misinformation there. Children are confused about what is true. It is a deeply poor district. He worries most for his students' safety now.

BRODNER

Gabriel Sterling,

Georgia elections official, denounced threats of violence directed at election workers (in particular at his boss Brad Raffensperger, from candidates Loeffler and Perdue.) Trump lawyer Joseph di Genova had said that fired security official Christopher Krebs "should be shot." A contractor for a voting system company was targeted by someone who hung a noose and said he should be "hung for treason." "This is elections," Mr. Sterling said. "This is the backbone of democracy, and all of you who have not said a damn word are complicit in this. It's too much." "I can't begin to explain the level of anger I have right now over this. And every American . . . should have that same level of anger."

Dr. Robert Redfield, CDC Director: "December and January are going to be the most difficult in the public health history of this nation, largely because of the stress put on our healthcare system." The death toll could reach 450,000 by February. Yesterday, 200,000 new infections were reported. Hospitals are at a breaking point. Over 350K now seen as lost in the pandemic.

Brandie Kopsas-Kingsley, Indiana University Health ICU nurse:
"I can't touch numbers. I can't understand what 230,000 or
245,000 deaths look like. But as a frontline healthcare worker
I can understand the sound the zipper on a bodybag makes.
I know the feeling of my hand on a chest. And the feeling of
two minutes of CPA before the next pulse check. I can
understand the humans behind those numbers. And that
every single one was a life. A person that mattered."

Poor GA Gov. Brian Kemp got viciously Trump-bombed today over telling the truth about the election. The thanks he gets for being the most loyal election-fixing GOP hack on Earth.

BRODNER

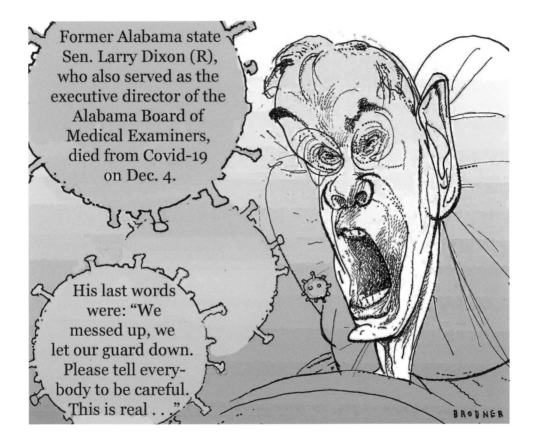

Robert Reich: "Reminder: Sen. Kelly Loeffler and her husband sold off stock after a private briefing on the coronavirus pandemic. They then purchased stock in remote-work technologies. If this doesn't disqualify her from office, then I don't know what would."

BRODNER

SCENES FROM AN INFODEMIC:

•Armed demonstrators hold a rally outside MI AG's home.
• Georgia election officials receive death threats as Trump loses two recounts.
•Kelli Ward, AZ GOP leader, tells governor to "shut the hell up" after
he acknowledges Biden's win.
• Ken Paxton, TX AG, sues PA, WI, MI and GA in the Supreme Court to
invalidate their votes.
•PA GOP legislators asked their House delegation to throw out votes.
•Etc.

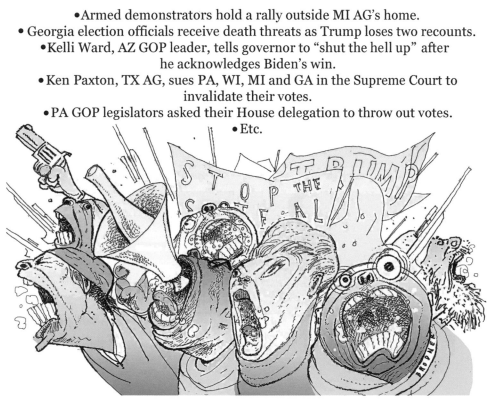

A week after the U.S. broke a daily record for coronavirus deaths set in April, it did so again.

At least **3,000** deaths were reported Wednesday.

BRODNER

New Hampshire House Speaker Dick Hinch (R) died from Covid-19, one week after being inaugurated at an outdoor ceremony with some 200, many unmasked, attendees. It has since been reported that a number had tested positive.

BRODNER

GOP Prayer Breakfast

Karl Rove: "Trump is acting like a sore loser."

CBS News poll: 62% say the election is settled.

Fox "News" poll: 52% say Trump is weakening the country.

"Proud Boys" at DC rally: "Destroy the GOP!"

Sen. Bill Cassidy, (R. LA.): "Biden won. the GOP is divided against itself."

Pillow man: "Fox is part of the anti-Trump conspiracy."

BRODNER

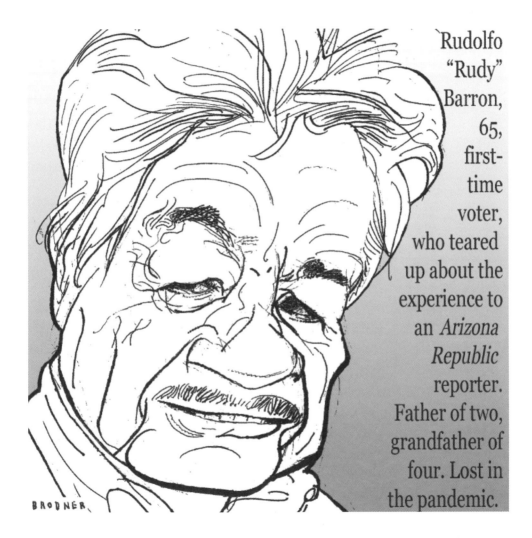

Rudolfo "Rudy" Barron, 65, first-time voter, who teared up about the experience to an *Arizona Republic* reporter. Father of two, grandfather of four. Lost in the pandemic.

BRODNER

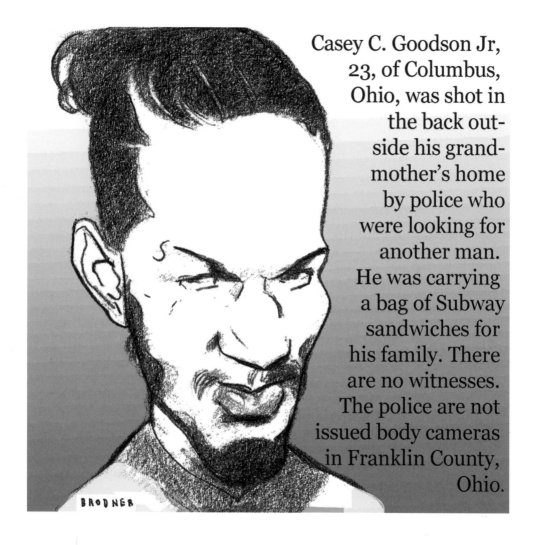

Casey C. Goodson Jr, 23, of Columbus, Ohio, was shot in the back outside his grandmother's home by police who were looking for another man. He was carrying a bag of Subway sandwiches for his family. There are no witnesses. The police are not issued body cameras in Franklin County, Ohio.

BRODNER

Jack Arends, 64, terminally ill Washington State elector, arrived at the Olympia Capitol on Monday in a wheelchair to cast his vote for Joe Biden and Kamala Harris. He said, "Today is the chance to begin the end of the Trump administration. I was glad to do my duty ... Had he won a second term, there is no limit to the damage he could have done to the world." Then, about two minutes into his speech, Arends broke the news to the chamber about his health condition, before abruptly ending his speech and setting his head down on his desk to weep.

BRODNER

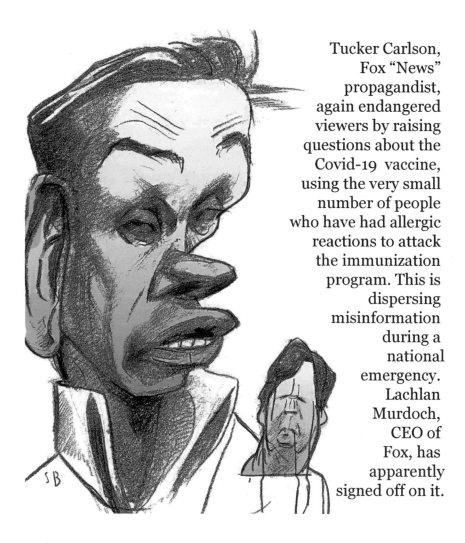

Tucker Carlson, Fox "News" propagandist, again endangered viewers by raising questions about the Covid-19 vaccine, using the very small number of people who have had allergic reactions to attack the immunization program. This is dispersing misinformation during a national emergency. Lachlan Murdoch, CEO of Fox, has apparently signed off on it.

CONVICTED FELON MICHAEL T. FLYNN APPEARED AT THE WHITE HOUSE FRIDAY AND PARTICIPATED IN A DISCUSSION OF A MILITARY TAKEOVER OF THE ELECTION.

TRUMP EXPRESSED INTEREST IN THE SEIZING OF VOTING MACHINES.

Yolanda Tominac, West Hills Hospital, L.A., critical care: "I can't tell you how many patients I have watched die, watched die alone, watched die behind a glass door. . . .We let the families in to say their goodbyes outside of that door. These patients are struggling to breathe. They are suffering. And if you don't want to see your family member like that, if you want to spend another Christmas with them, please be careful. Stay home, wash your hands, wear a mask, keep a safe distance. That is all we're asking." (California hospitals are now close to completely full.)

BRODNER

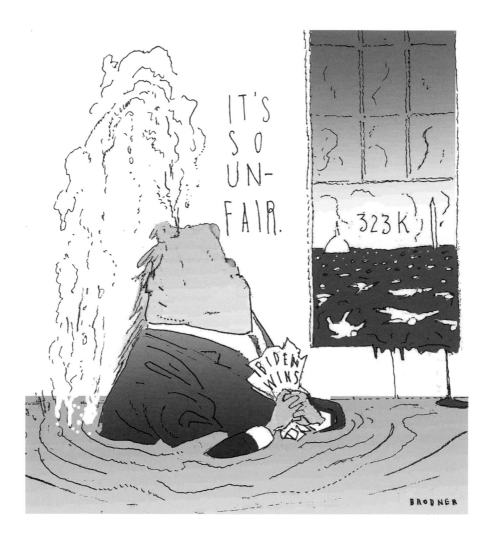

Ali Kinani, 9, killed in Iraq 2007 by Blackwater mercenaries who were pardoned by Trump last night.
Col. Gary Solis, military judge (ret.): " Throughout the Middle East, Al-Qaeda, Taliban, ISIS, we have now provided them with a hammer with which they can beat us every time we utter the words "fairness," "justice." And for what reason? . . . This is something that will be with us. And we'll be paying the price for this for a long time to come."

BRODNER

Trump leaving Washington (perhaps forever) as the country burns, without signing aid for millions of hungry and soon-to-be homeless Americans, showing care only for war criminals, traitors and corrupt politicians . . . like him- self.

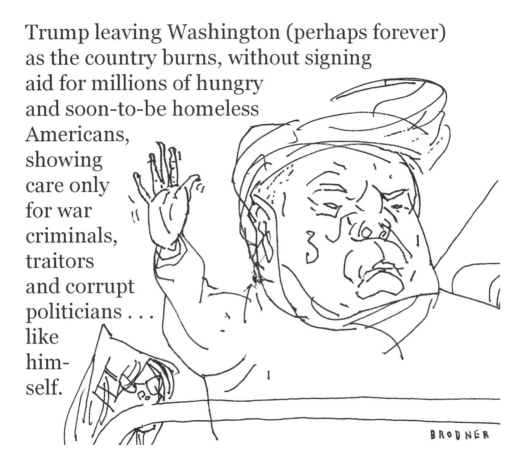

BRODNER

SOME OF THE DOZEN GOP SENATORS AND MEMBERS OF CONGRESS PLOTTING WITH TRUMP ON A JANUARY 6 STRATEGY FOR OVERTURNING THE ELECTION RESULTS: REP. JODY HICE (R-GA), REP. MO BROOKS (R-AL), REP. ANDY BIGGS (R-AZ), SEN. TOMMY TUBERVILLE (R-AL), REP. JIM JORDAN (R-OH), REP-ELECT MARJORIE TAYLOR GREENE (R-GA AND QANON). HICE WILL LEAD AN OBJECTION TO GA'S ELECTORS, THEREBY HUMILIATING THE GOP AT THE WHIM OF DONALD TRUMP ONE LAST TIME.

DR. SUSAN MOORE OF
INDIANA MADE A
VIDEO WHILE DYING
OF COVID-19,
DESCRIBING THE
RACIST TREATMENT
SHE HAD RECEIVED;
MEDICAL STAFF
WOULD NOT RESPOND
TO HER REQUESTS
FOR AID, AS SHE
LIE IN GREAT PAIN.
"I MAINTAIN THAT
IF I WERE WHITE
I WOULDN'T HAVE TO
GO THROUGH THAT.
THIS IS HOW BLACK
PEOPLE GET KILLED:
WHEN YOU SEND
THEM HOME AND THEY
DON'T KNOW HOW TO
FIGHT FOR
THEMSELVES."

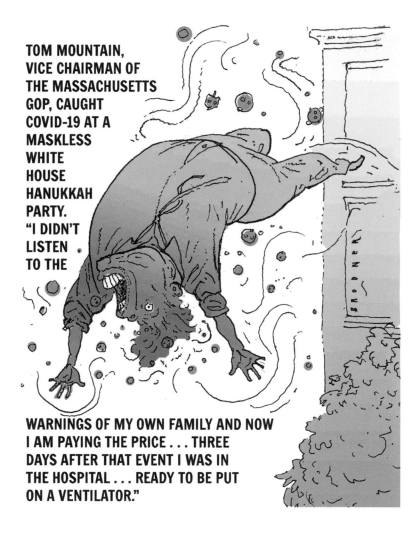

TOM MOUNTAIN, VICE CHAIRMAN OF THE MASSACHUSETTS GOP, CAUGHT COVID-19 AT A MASKLESS WHITE HOUSE HANUKKAH PARTY. "I DIDN'T LISTEN TO THE WARNINGS OF MY OWN FAMILY AND NOW I AM PAYING THE PRICE . . . THREE DAYS AFTER THAT EVENT I WAS IN THE HOSPITAL . . . READY TO BE PUT ON A VENTILATOR."

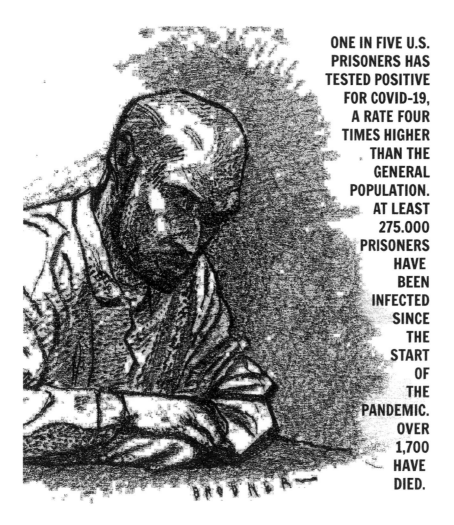

ONE IN FIVE U.S.
PRISONERS HAS
TESTED POSITIVE
FOR COVID-19,
A RATE FOUR
TIMES HIGHER
THAN THE
GENERAL
POPULATION.
AT LEAST
275.000
PRISONERS
HAVE
BEEN
INFECTED
SINCE
THE
START
OF
THE
PANDEMIC.
OVER
1,700
HAVE
DIED.

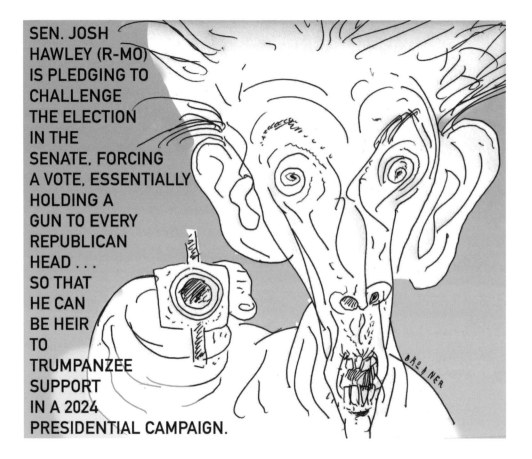

SEN. JOSH HAWLEY (R-MO) IS PLEDGING TO CHALLENGE THE ELECTION IN THE SENATE, FORCING A VOTE, ESSENTIALLY HOLDING A GUN TO EVERY REPUBLICAN HEAD . . . SO THAT HE CAN BE HEIR TO TRUMPANZEE SUPPORT IN A 2024 PRESIDENTIAL CAMPAIGN.

THE TREASON CAUCUS

TWELVE GOP ZOMBIES IN THE SENATE WHO WILL VOTE TO OVERTHROW THE ELECTION ON JANUARY 6.

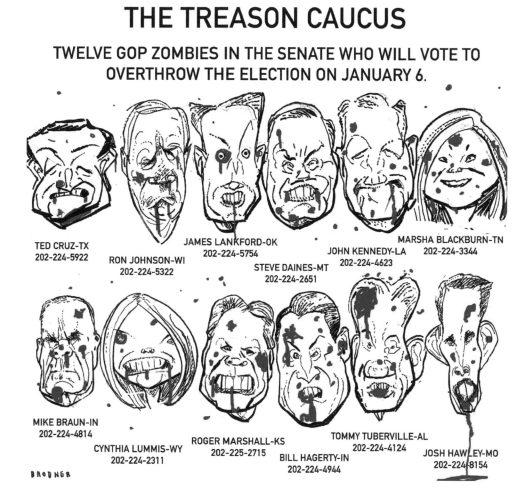

TED CRUZ-TX
202-224-5922

RON JOHNSON-WI
202-224-5322

JAMES LANKFORD-OK
202-224-5754

STEVE DAINES-MT
202-224-2651

JOHN KENNEDY-LA
202-224-4623

MARSHA BLACKBURN-TN
202-224-3344

MIKE BRAUN-IN
202-224-4814

CYNTHIA LUMMIS-WY
202-224-2311

ROGER MARSHALL-KS
202-225-2715

BILL HAGERTY-IN
202-224-4944

TOMMY TUBERVILLE-AL
202-224-4124

JOSH HAWLEY-MO
202-224-8154

BRODNER

Bismellah Adel
Aimag, 28 year
old radio
journalist from
Ghor province
was shot
to death
on Friday.
He is the 5th
media profes-
sional killed
in Afghanistan
in less than
two months.
No group
has claimed
responsibility
for the
killing.

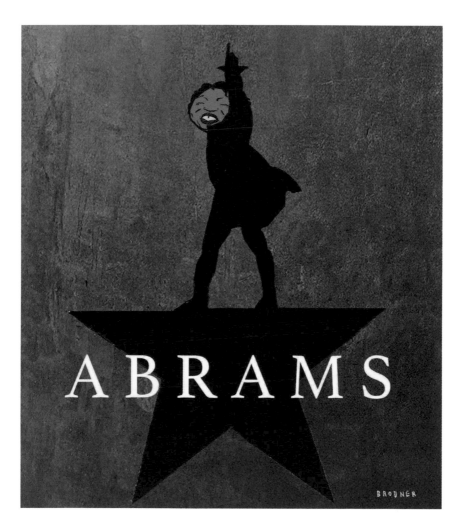

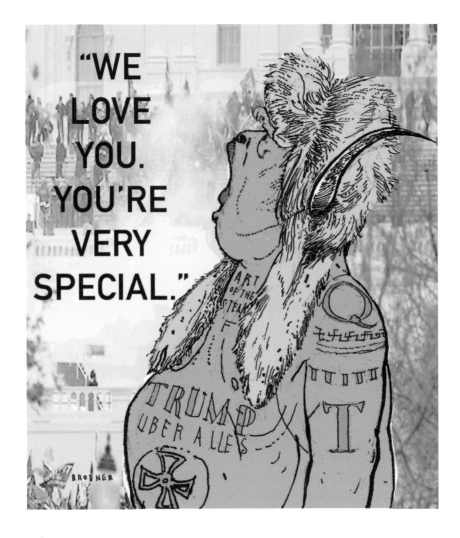

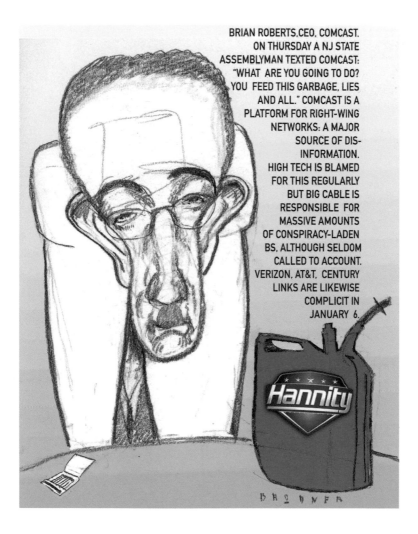

BRIAN ROBERTS, CEO, COMCAST. ON THURSDAY A NJ STATE ASSEMBLYMAN TEXTED COMCAST: "WHAT ARE YOU GOING TO DO? YOU FEED THIS GARBAGE, LIES AND ALL." COMCAST IS A PLATFORM FOR RIGHT-WING NETWORKS: A MAJOR SOURCE OF DIS-INFORMATION. HIGH TECH IS BLAMED FOR THIS REGULARLY BUT BIG CABLE IS RESPONSIBLE FOR MASSIVE AMOUNTS OF CONSPIRACY-LADEN BS, ALTHOUGH SELDOM CALLED TO ACCOUNT. VERIZON, AT&T, CENTURY LINKS ARE LIKEWISE COMPLICIT IN JANUARY 6.

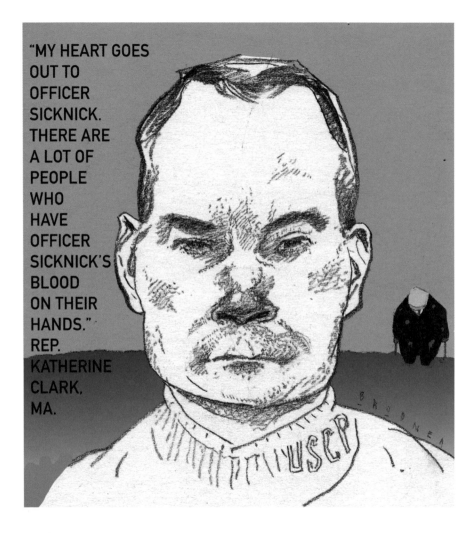

"MY HEART GOES OUT TO OFFICER SICKNICK. THERE ARE A LOT OF PEOPLE WHO HAVE OFFICER SICKNICK'S BLOOD ON THEIR HANDS." REP. KATHERINE CLARK, MA.

Working women accounted for all of the 140,000 job losses last month. Women of color working in restaurants, retail, other service sector jobs for poverty wages were disproportionately laid off in the lockdowns. About 40% of unemployed women in December had been out of work for 6 months or more, making finding a job more difficult.

IN-CELL

FORMER MICHIGAN GOV. RICK SNYDER WAS CHARGED WITH TWO COUNTS OF WILLFUL NEGLECT OF DUTY IN THE FLINT WATER CRISIS. TWELVE DIED. EIGHTY WERE SICKENED IN OUT-BREAKS OF DISEASE. THIRTY THOUSAND CHILD-REN WERE EXPOSED TO A NEUROTOXIN KNOWN TO BE DETRIMENTAL TO DEVELOPING BRAINS AND NERVOUS SYSTEMS.

While American terrorism is an urgent domestic threat there is no law outlawing it. While al-Qaida and ISIS are officially designated foreign terror organizations, the KKK is legal. "The Capitol invasion) was an act of of domestic terror in my opinion." Retired FBI agent Thomas O'Connor.

BRODNER

Steven Neher, 49, a nurse practitioner, worked at the Hillsborough County Falkenburg Road Jail in Tampa, a place, like any enclosed community, where viruses spread easily.
One day he lost his sense of smell. Testing positive, he asked for what he called the "Trump cocktail," all the medications he thought he needed. He got vitamins, antibiotics, steroids and an inhaler.

It wasn't enough.

BRODNER

Dustin Higgs was
executed on Saturday
in the Trump
Administration's
final
execution
spree,
in which 13
were rushed
to their deaths.
Justice Sonia
Sotomayor:
"To put this in
historical context,
the Federal
Government
will have executed
more than three times
as many people in the last
six months than it
had in the previous
six decades."

JANUARY 20, 2021

JANUARY 20, 2021 229

230 JANUARY 20, 2021

JANUARY 20, 2021 231

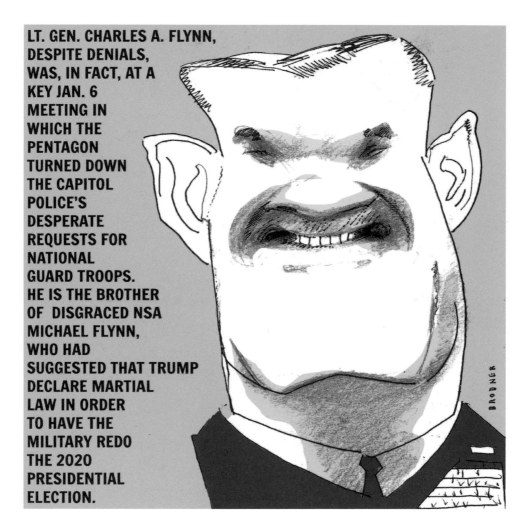

LT. GEN. CHARLES A. FLYNN, DESPITE DENIALS, WAS, IN FACT, AT A KEY JAN. 6 MEETING IN WHICH THE PENTAGON TURNED DOWN THE CAPITOL POLICE'S DESPERATE REQUESTS FOR NATIONAL GUARD TROOPS. HE IS THE BROTHER OF DISGRACED NSA MICHAEL FLYNN, WHO HAD SUGGESTED THAT TRUMP DECLARE MARTIAL LAW IN ORDER TO HAVE THE MILITARY REDO THE 2020 PRESIDENTIAL ELECTION.

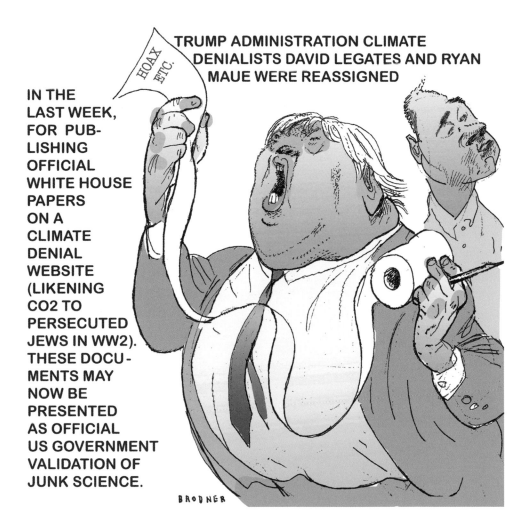

TRUMP ADMINISTRATION CLIMATE DENIALISTS DAVID LEGATES AND RYAN MAUE WERE REASSIGNED

IN THE LAST WEEK, FOR PUBLISHING OFFICIAL WHITE HOUSE PAPERS ON A CLIMATE DENIAL WEBSITE (LIKENING CO_2 TO PERSECUTED JEWS IN WW2). THESE DOCUMENTS MAY NOW BE PRESENTED AS OFFICIAL US GOVERNMENT VALIDATION OF JUNK SCIENCE.

HOAX ETC.

BRODNER

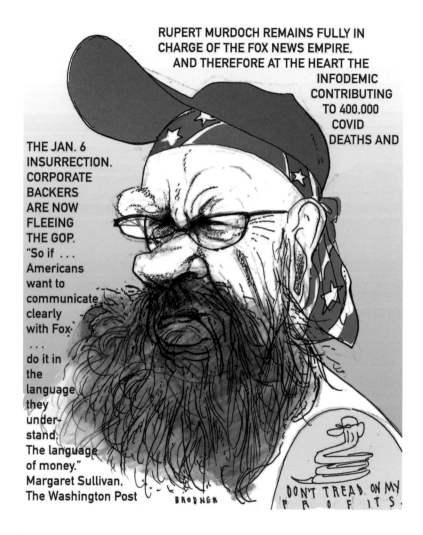

RUPERT MURDOCH REMAINS FULLY IN CHARGE OF THE FOX NEWS EMPIRE, AND THEREFORE AT THE HEART THE INFODEMIC CONTRIBUTING TO 400,000 COVID DEATHS AND THE JAN. 6 INSURRECTION. CORPORATE BACKERS ARE NOW FLEEING THE GOP. "So if . . . Americans want to communicate clearly with Fox . . . do it in the language they under-stand. The language of money." Margaret Sullivan, The Washington Post

BRODNER

DON'T TREAD ON MY PROFITS.

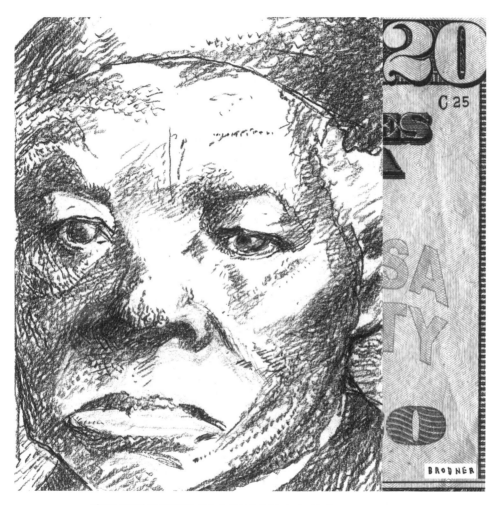

After Harriet Tubman was removed from a revised
$20 bill, The Greater Quiet put her back on.

Former Defense Sec. William Perry:

"In October 2020, the United Nations Treaty on the Prohibition of Nuclear Weapons was ratified by Honduras, the 50th country to do so. As a result, the treaty enters into international law January 22.

. . At the Reykjavik Summit in 1986, President Reagan made the case for eliminating these weapons.

. . . Now in 2021, a treaty has come into force that makes nuclear weapons illegal for all who sign it. America prides itself on being a nation of trailblazers; let us be the first nuclear-armed nation to blaze this new trail toward the top of the nuclear-free mountain."

Penny Hubbard,
54, Marlboro, NJ,
animal care
clinic worker,
died January
15.

Her mother
died one
week later.

Lost
in
the
pandemic.

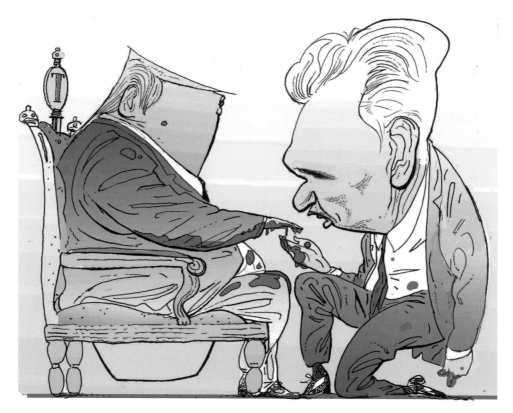

In a week of increased GOP White Nationalist branding, Minority Leader Kevin McCarthy hurries to Mar-a-Lago to clear up any misunderstandings.

TOM VILSACK, BIDEN'S SECRETARY OF AGRICULTURE, CORPORATE TOOL, RECENTLY OF DAIRY MANAGEMENT INC. AND PREVIOUSLY AS USDA HEAD, FAVORED BIG AGRI-BUSINESS. AS SMALL FARMS GO UNDER SO DO SMALL TOWNS. SCHOOLS CLOSE, OBESITY, INFANT MORTALITY, SUICIDE RATES INCREASE. BLACK FARMERS FACED FORECLOSURE 6X MORE THAN WHITES IN HIS LAST TOUR AT USDA.

DAIRY MANAGEMENT INC.™

BRODNER

Senate Minority Leader Mitch McConnell calls Rep. Marjorie Taylor Greene's embrace of "loony lies and conspiracy theories" a "cancer for the Republican Party,"

BRODNER

Marc Wilmore, beloved comedy writer, actor, comedian, a long time contributor to The Simpsons, In Living Color, F is for Family, died in Pamona. His brother comedian Larry Wilmore called him "the kindest, gentlest, funniest, lion of an angel I've ever known." Lost in the Pandemic.

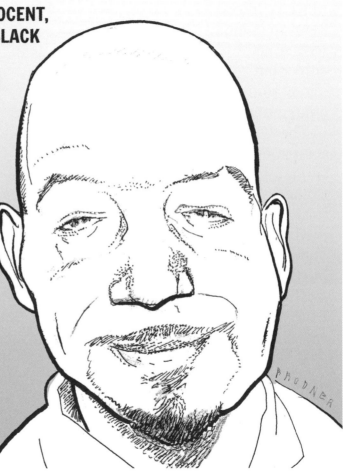

ANDRE HILL, INNOCENT, UNARMED, AND BLACK WAS KILLED BY COLUMBUS, OHIO POLICE OFFICER, ADAM COY ON DECEMBER 22. YESTERDAY, COY WAS INDICTED BY A GRAND JURY. "TRUTH IS THE BEST FRIEND OF JUSTICE," SAID OHIO AG DAVE YOST. "AND ANDRE HILL SHOULD NOT BE DEAD."

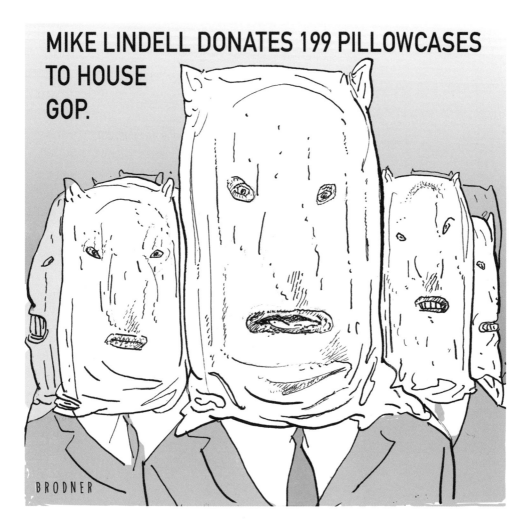

MIKE LINDELL DONATES 199 PILLOWCASES TO HOUSE GOP.

BRODNER

Taylor Bracey, student, Liberty High School, Kissimmee, Fla., suffers from headaches, memory loss, blurred vision, sleep deprivation. and depression, since being knocked unconscious by a police officer, Ethan Fournier, in an attempt to break up a fight. He slammed her head onto a concrete floor. The officer has been placed on leave.

Ashraf Hamdi, Egyptian cartoonist, was arrested and taken from his home after posting a video tribute to the 2011 uprising. Director of the Arabic Network for Human Rights Information Gamal Eid called for Hamdi's immediate release. "So will the public prosecutor take action and assume his role in protecting the law and the freedoms of citizens?" Thirty-three journalists are currently serving prison sentences in Egypt.

BRODNER

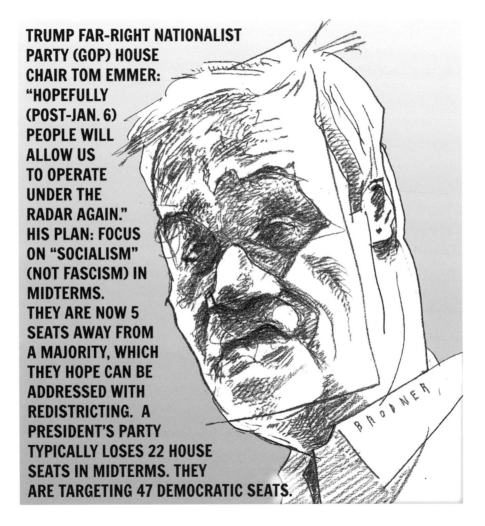

TRUMP FAR-RIGHT NATIONALIST PARTY (GOP) HOUSE CHAIR TOM EMMER: "HOPEFULLY (POST-JAN. 6) PEOPLE WILL ALLOW US TO OPERATE UNDER THE RADAR AGAIN." HIS PLAN: FOCUS ON "SOCIALISM" (NOT FASCISM) IN MIDTERMS. THEY ARE NOW 5 SEATS AWAY FROM A MAJORITY, WHICH THEY HOPE CAN BE ADDRESSED WITH REDISTRICTING. A PRESIDENT'S PARTY TYPICALLY LOSES 22 HOUSE SEATS IN MIDTERMS. THEY ARE TARGETING 47 DEMOCRATIC SEATS.

BRODNER

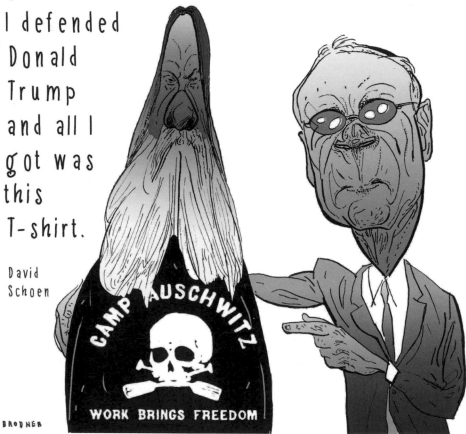

I defended
Donald
Trump
and all I
got was
this
T-shirt.

David
Schoen

BRODNER

McConnell:

Trump's actions
. . .were a
disgraceful
dereliction of duty.
Trump is
practically
and morally
responsible
for provoking
the events of the
day.

But I cannot
vote to convict him
because this
trial was
scheduled after
he left office.

By me.

Disha Ravi, 22, climate activist, was arrested by Indian authorities. She is charged with sharing an online document which was tweeted by Greta Thunberg on how to support the ongoing farmworkers protest in India. She is founder of the Indian Fridays for Future Youth climate strike.

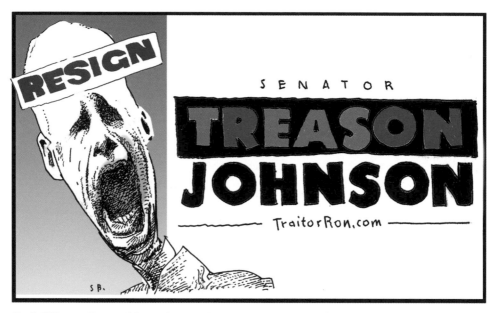

"A billboard outside Wisconsin Senator Ron Johnson's hometown identifies the Trump-aligned Republican as "Treason Johnson" and stamps the word "Resign" across his face. It was erected by Outagamie County Executive Tom Nelson, one of a number of Democrats who are preparing to challenge the incumbent. 'The trial may be over, but we won't forget this,' Nelson said on Saturday. 'The billboard I put up is a reminder that Ron Johnson should be held accountable for today's vote and his traitorous actions. He should resign, and if he doesn't, I'll be the one to beat him in 2022.'" John Nichols, The Nation.

Massive storm, blackout, and energy failure hits (off-the-grid) Texas. Thousands suffering, dying, due to gross state negligence.
Gov. Greg Abbott then dives into a misinformation campaign, blaming windmills and solar panels, when the failure came from the frozen natural gas network.
The Texas Tribune: "A grandmother slept in her car. Parents . . . burnt belongings to keep their children warm. A Richardson resident watched the battery level of her partner's oxygen machine drain away and desperately sought to have it recharged."
Police are expressing concern that they will
need to mark off houses containing the dead.

"There were CDC guidelines to vaccinate (early)... essential workers... people who work in the grocery store, driving the bus, first responders. Lots of states didn't go that way. They said, 'Let's vaccinate everyone 65 and above.' What's that done? It's left everyone who leaves their house every day, going to work, more vulnerable. (We now see) the reason of the change in life expectancy among Black and Latino workers is that they are a very high proportion of essential workers. The risk of exposure is very high. We are seeing a widening gap between Whites and Blacks and Latinos in terms of the impact of this pandemic."
Dr. Richard Besser, former acting director, CDC.

BRODNER

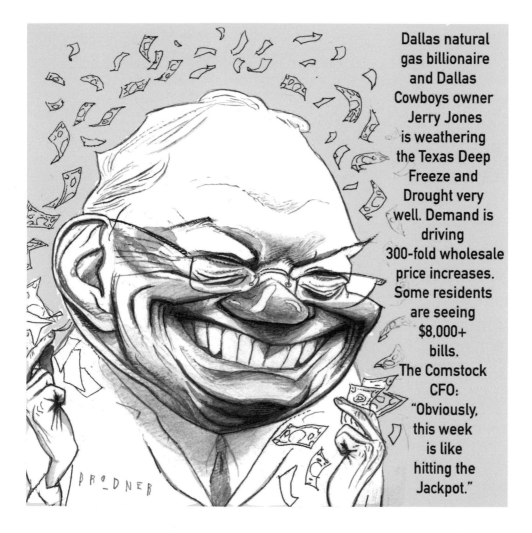

Dallas natural gas billionaire and Dallas Cowboys owner Jerry Jones is weathering the Texas Deep Freeze and Drought very well. Demand is driving 300-fold wholesale price increases. Some residents are seeing $8,000+ bills. The Comstock CFO: "Obviously, this week is like hitting the Jackpot."

Lourdes Rivera, receptionist at Columbia Prep in New York for three decades, was beloved by the students. "She was cool and we felt cool being around her", one said. Among 500,000 lost in the pandemic.

BRODNER

Thomas Webster Marine veteran and retired New York Police officer, seen at the January 6 insurrection at the US Capitol, displayed "pure rage" befitting a "junkyard dog," a federal prosecutor said Tuesday during a hearing before a magistrate judge in White Plains, N.Y. Webster repeatedly hit a D.C. police officer with the metal rod of a Marine Corps flag, prosecutors allege. When he lost control of the metal pole, Webster tried to tear off the officer's gas mask and choked him with the chin strap, according to court records.

Daniel Prude, unarmed, innocent, and in the midst of a psychotic episode, was killed by Rochester, NY police in March. The officers involved in the killing, who also apparently participated in a coverup, will not be charged by a grand jury. "The criminal justice system has demonstrated an unwillingness to hold law enforcement officers accountable in the unjustified killing of unarmed African Americans," Attorney General Letitia James.

"What makes this situation so tragic is that many of these nurses hide their trauma and are feeling isolated and alone. . . .Overworked and underpaid, they are considered secondary even in their own workplace. As others have dropped the ball nurses have worked tirelessly, out of the spotlight, to save lives . . . I worry their trauma will persist long after we re-emerge from mass hibernation. The Covid legacy will include a mass PTSD on a scale not felt since World War II. This burden should not be ignored." Alexander Stockton, NY Times.

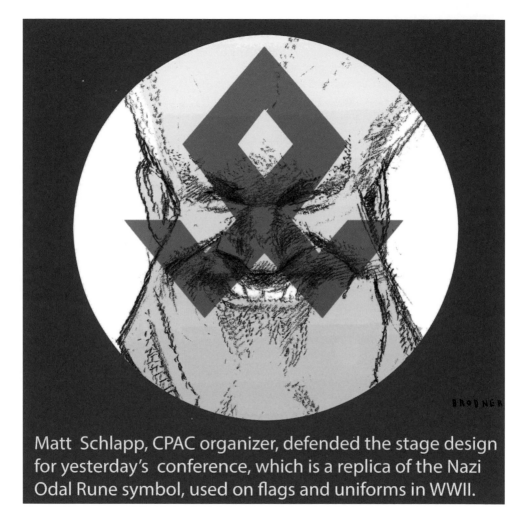

Matt Schlapp, CPAC organizer, defended the stage design for yesterday's conference, which is a replica of the Nazi Odal Rune symbol, used on flags and uniforms in WWII.

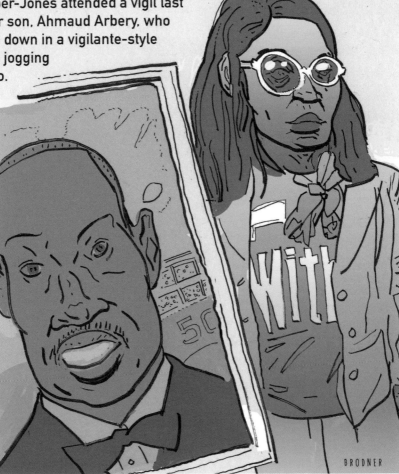

Wanda Cooper-Jones attended a vigil last week for her son, Ahmaud Arbery, who was gunned down in a vigilante-style killing while jogging one year ago. It sparked greater attention to racist murders yet to come in the US. No trial date has been set for the suspects, who are seen killing Arbery in video footage.

BRODNER

Rep. Jasmine Clark, Georgia House of Representatives, after the body passed a bill making it harder to vote: "Men lie. Women lie. Numbers don't. Numbers are clear. HB 531 is textbook voter suppression."
The bill limits absentee ballots, weakens early voting laws, ends ballot drop boxes. There are currently 250 such bills in 43 states. Ari Berman: The GOP is "breaking democracy."

BRODNER

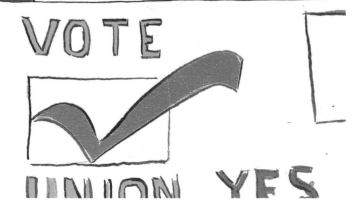

An unlikely movement by workers to unionize at a massive Amazon facility in Bessemer, Alabama has inspired other unions, the Democratic party and Pres. Biden to become the most pro-union president in 70 years: "There should be no intimidation, no coercion, no threats, no anti-union propaganda. No supervisor should confront employees about their union preferences. Every worker should have a free and fair choice to join a union."

VOTE

UNION YES

Sen. Marsha Blackburn, responding to Pres. Biden's criticism of politicians opposed to a mask mandate: "Neanderthals are hunter-gatherers, they're protectors of their family. They are resilient. They are resourceful. They tend to their own. So, I think Joe Biden needs to rethink what he is saying." (Sen. Blackburn has stated that she does not accept evolution.)

BRODNER

Daniel Vázquez, bartender, at Pico's Restaurant, Houston. After Gov. Abbott rescinded mask requirements it got ugly there. "It was horrific," said Monica Richards, Pico's co-owner. Pico's received calls, private messages on social media and emails threatening to call U.S. Immigration and Customs Enforcement (ICE) on the restaurant's staff and saying their green cards and paperwork need to be checked. "I never imagined that they would go that far." Ongoing conflict during an already stressful time for restaurants is likely. According to a survey conducted by the Texas Restaurant Association earlier this week, 72 percent of more than 700 members said they will keep the mask mandate.

BRODNER

Gov. Kristi Noem (R-SD).
In the face of the ferocious toll
Covid-19 has been claiming in her
state, Noem has doubled down on
Trumpian fantasy-based resistance
to science. She treated mask-denial
as a far-Right fashion statement. At
CPAC she proclaimed, "Dr. Fauci is
wrong a lot."Jonathan Reiner, of
George Washington University
Medical Center: "Ten percent of the
people of North Dakota have been
infected by the virus. Thousands
of people have died. So her science
denialism has resulted in the
propagation of that disease
unnecessarily."
John Nichols,
The Nation.

BRODNER

THE
WORLD
EXPRESSES
CONCERN
ABOUT
THE
TONE
OF
THE
ROYAL
FAMILY'S
SKIN.

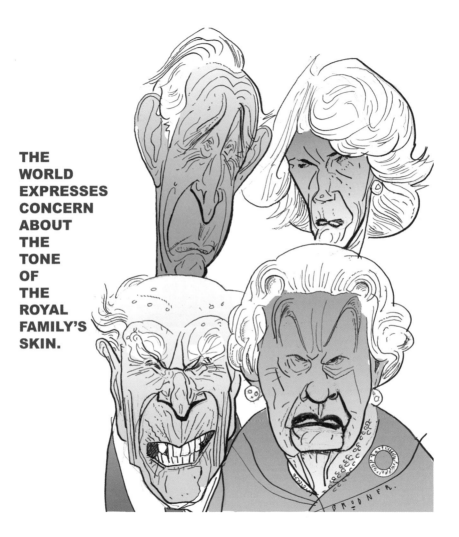

A record 3,200 unaccompanied children have been detained by the US Border Patrol, with almost half held longer than the legal three day limit. Meanwhile, children are still separated from their parents at government facilities.

BRODNER

Stewart Rhodes, founder of the Oath Keepers militia group, is under investigation by the FBI and federal prosecutors. His group, made up of former military and police officers, has been at the center of the January 6 insurrection. Two days before the riot he issued a "call for action" to his followers to rally at the Capitol, after which they entered the building in a military style "stack" formation.

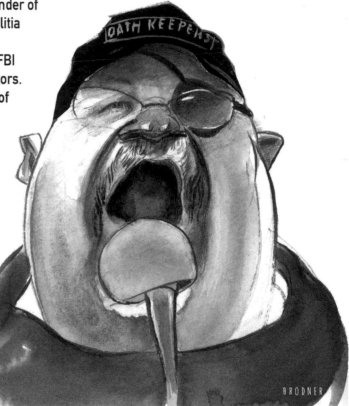

"The COVID Relief Act is with no exaggeration, the single most important piece of anti-poverty legislation since Lyndon Johnson's Great Society, itself the signature program of a man who sought to emulate F.D.R. That said, we can and should acknowledge that this bill is, as Biden once said of Obamacare, a very big deal for the country. And we can marvel, at least a little, at the trajectory of his political career, as this consummate centrist and proud bipartisan dealmaker begins to move in somewhat unexpected directions."
Jamelle Bouie, NYT.

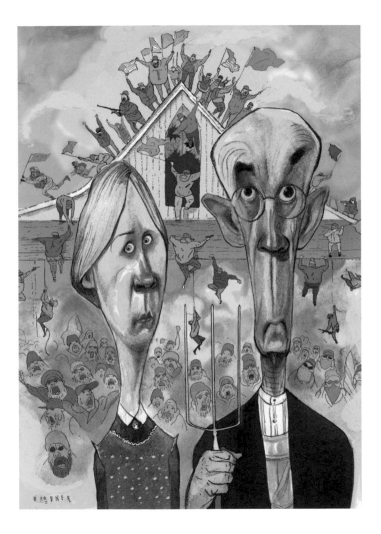

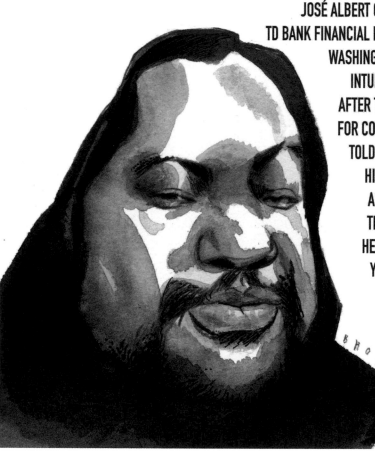

JOSÉ ALBERT ORTIZ CHAVEZ JR.,
TD BANK FINANCIAL REPRESENTATIVE,
WASHINGTON DC, 30, WAS
INTUBATED ONE WEEK
AFTER TESTING POSITIVE
FOR COVID-19. DOCTORS
TOLD HIS FAMILY THAT
HIS WAS THE MOST
AGGRESSIVE CASE
THEY'D EVER SEEN.
HE DIED ON DEC. 28.
YESTERDAY 54,437
NEW CASES
WERE REPORTED
AND 1,245
WERE LOST
IN THE
PANDEMIC.

Georgia Sheriff Spokesman Captain Jay Baker excused the mass-murderer of six people at Asian spas in the Atlanta area saying that it was a "really bad day for him." This comes in a wave of violence against Asians in the US. Baker has previously promoted anti-Asian T-shirts on Twitter.

Florentino Pamintuan, longtime creative director of Elle Decor, was a style and taste-setter for the shelter genre. He had been top designer/head creative director for Harper's Bazzaar, Vogue, Visionaire.

Lost in the pandemic.

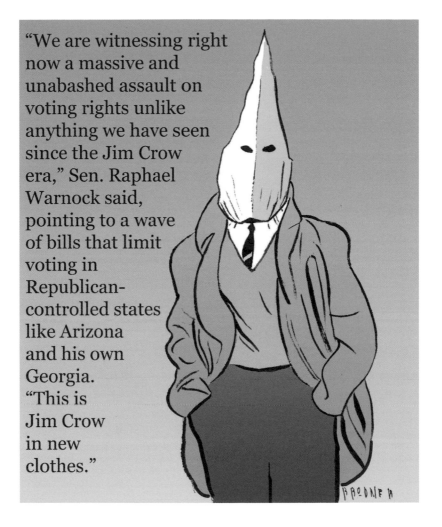

"We are witnessing right now a massive and unabashed assault on voting rights unlike anything we have seen since the Jim Crow era," Sen. Raphael Warnock said, pointing to a wave of bills that limit voting in Republican-controlled states like Arizona and his own Georgia. "This is Jim Crow in new clothes."

Alva Rosa, refugee, whose son had been murdered in Honduras, now turned back at the border, spent all her money to get her family out of danger. The Biden administration has been sending the message that the border is closed. "Smugglers and traffickers, who are incentivized to move as many people as they can, have been helping to amplify this message: 'now is the time to come.'" PBS Newshour.

BRODNER

Colorado had banned assault weapons in 2018 in response to the Parkland Massacre. Ten days before the Boulder mass murder, Judge Andrew Hartman overturned the ban, enabling the suspected shooter to purchase an AR-556.

Officer Eric Talley was a first responder to the massacre in Boulder, CO.

A father of seven, he was devoted to protecting the community. Police work, for him, was a calling. Pres. Biden: "When the moment to act came, officer Talley did not hesitate in his duty, making the ultimate sacrifice in his effort to save lives. That's the definition of an American hero."

Georgia Gov. Brian Kemp signed into law a massive voter suppression bill, stripping power from the Georgia secretary of state (who had defied Trump's election coup attempt) as well as making it a crime to give water and food to people waiting to vote. This, along with 250 blatant Jim Crow measures in 43 states, may have an unhealthy effect on the filibuster as support grows for HR1 and HR4.

Brian Kemp
New Jim Crow.

FILIBUSTER

BROONER

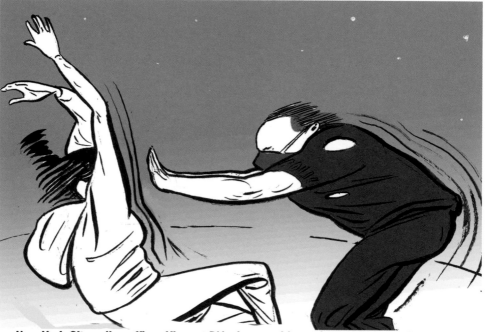

New York City police officer Vincent D'Andrea pushing a demonstrator to the ground in a May 2020 demonstration, causing her to writhe on the ground in pain. This was seen by millions on video. It turns out that New Yorkers are paying for DeAndrea's legal defense. Every year the city treasury bankrolls the police union with a legal defense fund, including for officers who's behavior is deemed indefensible. All told, the fund takes in about $5.5 million a year, which the PBA pays to the Manhattan law firm of Worth, Longworth & London to represent officers, tax filings show.

Leonard Peltier, Native American activist, was convicted of the 1975 murder of two FBI agents at the Pine Ridge Reservation, SD. Witnesses have recanted or changed their testimony. He is perhaps America's most famous political prisoner.

Still incarcerated. In the pandemic.

BRODNER

The richest Americans are hiding 20% of their earnings from the IRS. The wealthiest 1% account for 1/3 of all US taxes.

Last week Sen. Bernie Sanders revealed legislation to restore the top tax rate to 35%, levy new estate taxes and prohibit corporations from moving profits offshore to avoid US taxes.

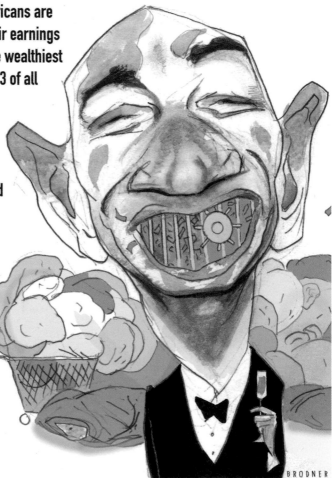

BRODNER

Rep. Matt Gaetz (R–FL), was the lone no vote on the Combating Human Trafficking in Commercial Vehicles Act, a bill allocating additional government resources to help combat human trafficking. The Department of Justice, investigating Gaetz on allegations of a sexual relationship with a 17-year-old minor in 2019, is examining whether he had violated federal sex trafficking laws by allegedly paying her to travel with him.

BRODNER

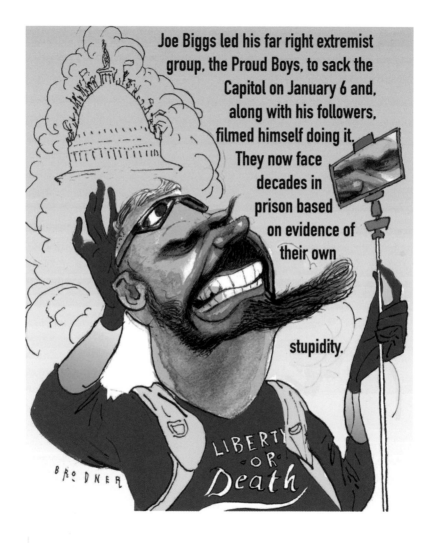

Joe Biggs led his far right extremist group, the Proud Boys, to sack the Capitol on January 6 and, along with his followers, filmed himself doing it. They now face decades in prison based on evidence of their own stupidity.

LIBERTY OR Death

John Tillman, chairman of the American Culture Project, a well-funded operation that poses as a news site in news-starved local markets, representing the GOP agenda as news. "We have created a persuasion machine." It has advocated for the imprison-ment of Anthony Fauci and Gretchen Whitmer. "It's Potemkin politics," said Tom Wheeler, ex-chairman of the FCC. "It aids in the de-democratization of the media and American life."

BRODNER

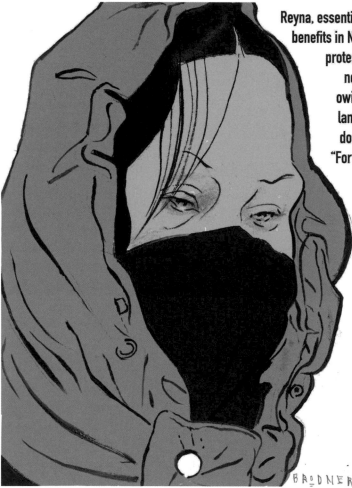

Reyna, essential worker, excluded from benefits in NY State, along with many protesters on a hunger strike, now in its 23rd day: "I am owing two months rent. The landlord is knocking on the door. I say, "Wait." He says, "For how long? I am going to take you to court." I am very scared. I have two children." Hundreds of thousands of essential workers, such as immigrants, ex-prisoners, cash economy workers, are ineligible for federal or state COVID relief, totaling $3.5 billion in extended benefits. They have been protesting in Albany for the Legislature to instate them.

BRODNER

Mayson Barillas, 11, hospitalized for heart issues, is among a large group of children and teens developing a mysterious inflammatory syndrome several weeks after contracting asymptomatic COVID-19. This occurs as coronary aneurysms and fluid buildup. Experts do not yet know why this is affecting young people and some adults.

BRODNER

The Defense Department announced Tuesday that it would retain the Trump administration's policy and keep anti-personnel land mines in its arsenal. In many mine-affected countries, children account for one in every five landmine victims. An estimated 15,000 to 20,000 people are killed or maimed by landmines every year.

BRODNER

Army Lt. Caron Nazario, who is Latino and Black, was threatened, knocked down, and pepper sprayed by two police officers during a traffic stop near Windsor, VA. A lawsuit has been filed in the US District Court of Norfolk, charging the officers with violations to Nazario's Constitutional rights.

"Holy shit, I just shot him," said a police officer upon fatally shooting Daunte Wright, a 20 year-old Black man at a traffic stop near Minneapolis Sunday. Video of the shooting was released yesterday. The officer is heard identifying the gun as a taser. As he was pulled over, Daunte called his mother to tell her that they were stopping him because "he had air fresheners hanging from his rearview mirror."

Tucker Carlson's use of "replacement theory" echoed claims of white supremacists who marched in Charlottesville, VA, in 2017, chanting "You will not replace us" and "Jews will not replace us." The Anti-Defamation League is urging Fox "News" to fire Carlson.

Dr. Nemam Ghafouri, 52, helped survivors of an ISIS genocide in Northern Iraq, and reunited women who had been sex slaves with their children, who had been taken from them. She arranged for medical care, found jobs for them, and mediated with relatives. "Let these women be full human beings and decide where they want to live, how do they want to live, and with whom they want to live," she said. Lost in the pandemic.

Adam Toledo, 13, killed on March 29 in Chicago, is seen in newly released bodycam footage raising his hands as a police officer shoots him. "Hands, show me your hands," the police officer says.

Brandon Hole, the Indianapolis gunman who killed eight, had legally bought the two assault rifles he used after the police had removed his rifle . His mother had alerted them about his mental state.

Florida Gov. Ron DeSantis (R) signed an anti-riot bill into law.

The new law prevents 'rioters' from being bailed out of jail before their first court appearance and grants immunity from civil legal action for people who drive through protesters blocking a road.

BRODNER

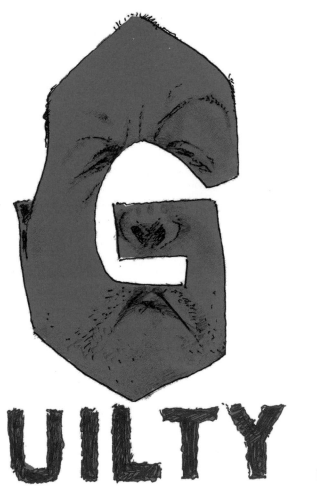

GUILTY

BRODNER

Remy Fennell, 28, who, along with Jaida Peterson, 29, was shot to death in Charlotte, North Carolina. North Carolina police arrested two men over the shooting They are believed to be at least the 14th and 15th transgender or gender nonconforming people to be violently killed this year.

India recorded more than 310,000 new infections yesterday, the most recorded by any country on a single day. PM Narendra Modi has failed to prepare for a second Covid wave. A massive Hindu festival and packed political rallies have been permitted.

Hundreds of demonstrators hit the streets of Elizabeth City, North Carolina, Monday for a fifth day to protest last week's police killing of Andrew Brown Jr., a 42-year-old Black man. On Monday, authorities allowed Brown's family and attorney to watch a 20-second video clip of the shooting. The family says it shows Brown was shot in the back of the head while his hands were on the steering wheel of a car.

BRODNER

The FBI executed search warrants at Rudolph Giuliani's residence today, stepping up an extensive criminal probe.

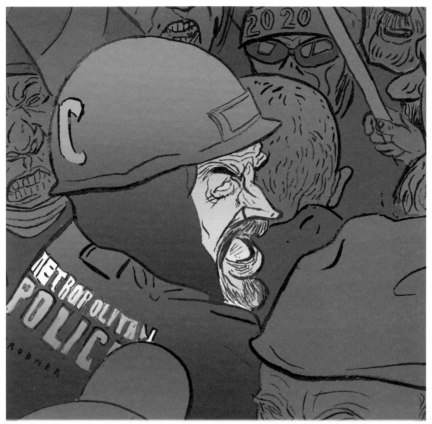

Officer Michael Fanone, Metropolitan DC Police on Jan. 6, 2021: "Some have used the terminology 'very fine people.' Very different from what happened. I experienced the most brutal, savage hand-to-hand combat of my entire life.
I felt that they were trying to kill me."

Isiah Brown, 32, is in critical condition after he was shot while making a 911 call in the middle of the night, an attorney for Brown and his family said. The Northern Virginia sheriff's deputy who fired the shots mistook a cordless house phone for a gun. He was shot 10 times.

BRODNER

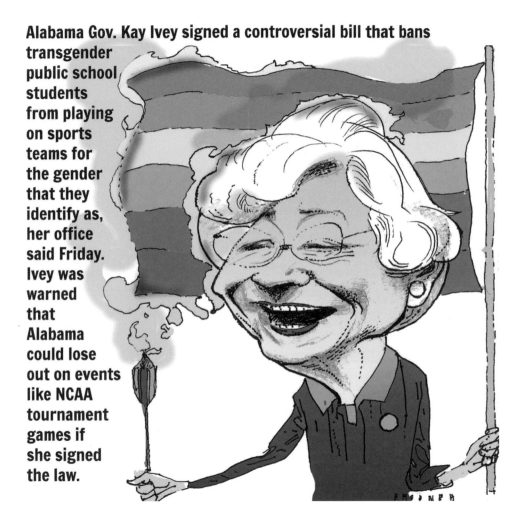

Alabama Gov. Kay Ivey signed a controversial bill that bans transgender public school students from playing on sports teams for the gender that they identify as, her office said Friday. Ivey was warned that Alabama could lose out on events like NCAA tournament games if she signed the law.

Oregon Republican state Representative Mike Nearman, who opened the doors of the state Capitol to far-right protesters in December, is facing criminal charges. The far-right mob, who were calling for an end to public health restrictions aimed at slowing the spread of COVID, attacked security officers with chemical sprays and assaulted a number of journalists.

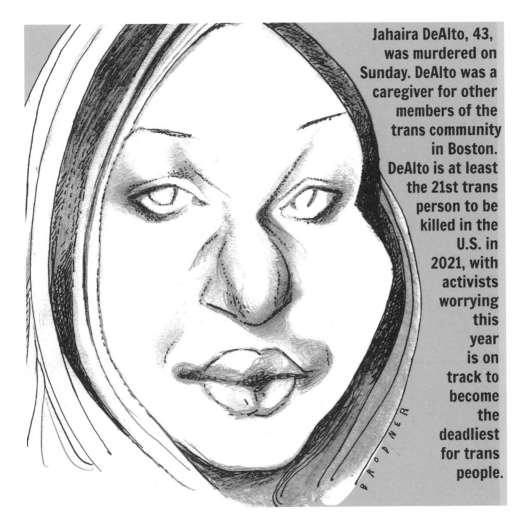

Jahaira DeAlto, 43, was murdered on Sunday. DeAlto was a caregiver for other members of the trans community in Boston. DeAlto is at least the 21st trans person to be killed in the U.S. in 2021, with activists worrying this year is on track to become the deadliest for trans people.

Liz Cheney, when last seen.

Idaho state Rep. Aaron von Ehlinger, has had rape allegations brought against him by a 19-year-old intern. A committee unanimously agreed to suspend him. In the meantime right wing supporters have revealed the victim's name and opened up a widespread attack on her online. And members of a far-right, anti-government activist group tried to follow and harass the young woman after she was called to testify in a legislative public ethics hearing.

The investigation underscores why many alleged sex crimes go unreported.

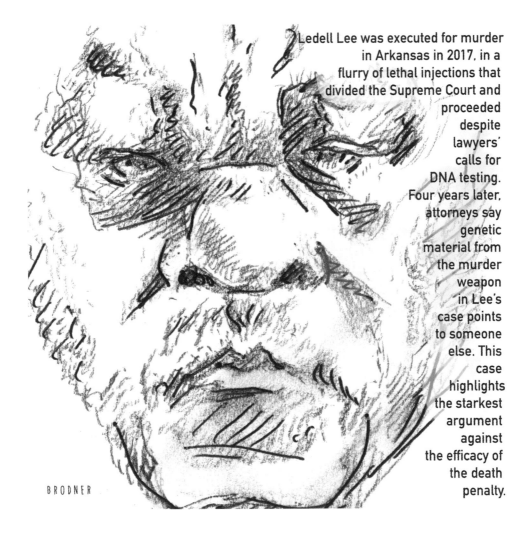

Ledell Lee was executed for murder in Arkansas in 2017, in a flurry of lethal injections that divided the Supreme Court and proceeded despite lawyers' calls for DNA testing. Four years later, attorneys say genetic material from the murder weapon in Lee's case points to someone else. This case highlights the starkest argument against the efficacy of the death penalty.

BRODNER

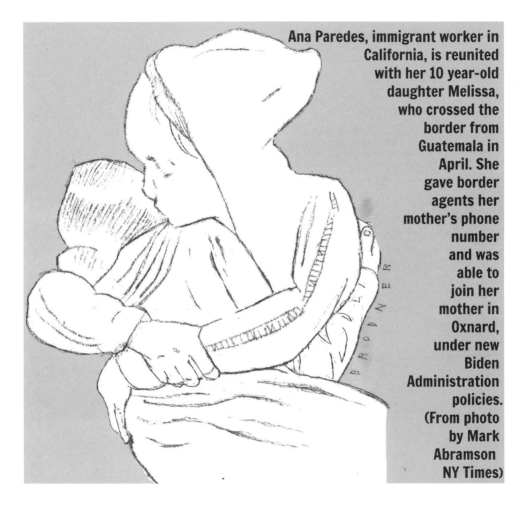

Ana Paredes, immigrant worker in California, is reunited with her 10 year-old daughter Melissa, who crossed the border from Guatemala in April. She gave border agents her mother's phone number and was able to join her mother in Oxnard, under new Biden Administration policies. (From photo by Mark Abramson NY Times)

A viral video shows Palestinian East Jerusalem home owner Munna Kurd, confronting a Far Right settler from Brooklyn, who has been occupying half her home since 2009.

Kurd: "Yakov, you know this is not your house."

Settler: "But if I go you don't go back so what's the problem?"

Kurd: "You are stealing my house."

Settler: "But if I don't steal it, someone else is going to steal it."

The Israeli program of Palestinian removal has triggered resistance and the raiding of the Aqsa Mosque, wounding hundreds of Palestinians and scores of police.

Hundreds of families in East Jerusalem are facing expulsion. Many Palestinians consider this a form of ethnic cleansing.

Some rights groups view this as apartheid.
The UN rights agency calls this policy a potential war crime.

BRODNER

Rep. Adam Kinzinger:
"Right now it's basically the Titanic. We're in the middle of this slow sink. We have a band playing on the deck telling everybody it's fine. Meanwhile, Donald Trump's running around trying to find women's clothing and get on the first lifeboat."

"[Netanyahu] had an interest in escalation, perhaps not to this extent. But it served his political purposes. [He] not only distracted from his legal troubles, but was able to prevent his opponents from forming a government. For Hamas this is an opportunity to show that they can act when the Palestinian Authority is hopeless." Shibley Telhami, Brookings Institute.

BIBI STILL INDICTED BIBI STILL UNABLE TO FORM GOV'T

"They targeted the house that they were in. There were no rockets there, only women and children . . . A rocket hit their house, over their heads, without warning or communication. Three whole floors fell on them and we had to recover their body parts."
Mohammed Al-Hadidi, who lost family in a Gaza air raid.

BRODNER

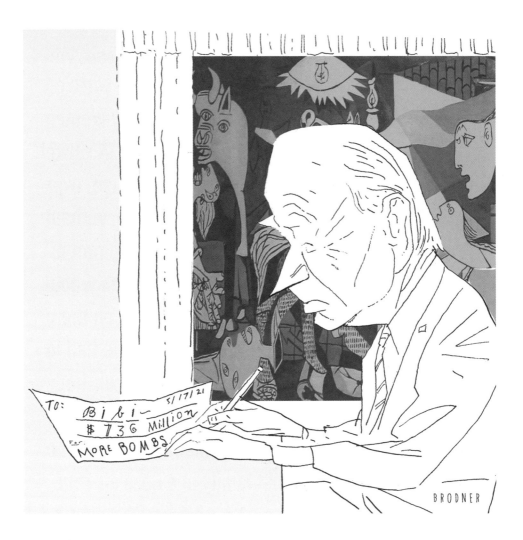

BRODNER

This week an ad began appearing on Facebook showing Minnesota Rep. Ilhan Omar's face next to Hamas rockets. A caption reads: "When Israel targets Hamas Rep. Omar calls it an 'act of terrorism.'" She never said it. The ads are false. AIPAC bought the ads, which are still running. Omar's office is calling on Facebook to immediately remove the ads, which blatantly peddle both anti-Muslim hate speech and disinformation. "It's not just irresponsible, it's incitement," Omar's spokesman, Isi Baehr-Breen told The Nation.

Viola Fletcher, 107, the oldest surviving victim of the 1921 Tulsa Massacre, testifying before Congress yesterday, pleading, at last, for justice. Over three hundred Black citizens of Black Wall Street were killed, many others financially and psychologically destroyed.

"I will never forget the violence of the white mob when we left our home. I still see Black men being shot, Black bodies lying in the street. I still smell smoke and see fire. I still see Black businesses being burned. I still hear airplanes flying overhead. I hear the screams. I have lived through the massacre every day." The hearing was told that there has never been any direct compensation to the victims, many of whom, like Ms. Fletcher, have been living their lives out in grinding poverty.

Allen Weisselberg, CFO of the Trump Organization for 50 years, is now under criminal investigation. "I think he will [flip on Trump] because he's seen Trump throw so many people under the bus now for decades without blinking or regretting it. He knows that Trump will blow him up if it meant Trump could protect his own hide ... I don't think he will be loyal to Donald Trump now." Tim O'Brien, columnist, Bloomberg Opinion.

BRODNER

I dreamed that a Palestinian theater company put on a production of Fiddler on the Roof, in which Tevye was Palestinian and Bibi Netanyahu was the Russian officer.

Instead of having three days to leave their homes, they are told the shtetl would be blown up in 10 minutes.

It was a short play.

BRODNER

Roman Protasevich, Belarusian anti-Lukashenko dissident, was arrested in Minsk after his plane was forced down by a MiG-29 fighter jet. In a short video he confessed, under duress, with traces of struggle and/or torture on his face, to taking part in large street protests. European leaders con-demned the "state-sponsored hijacking."

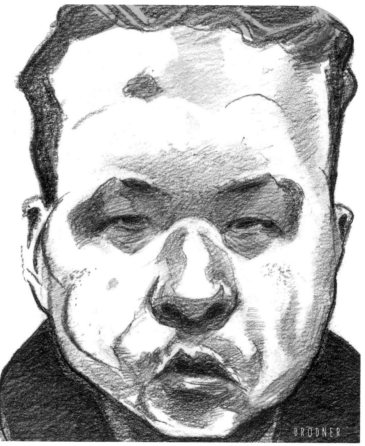

BRODNER

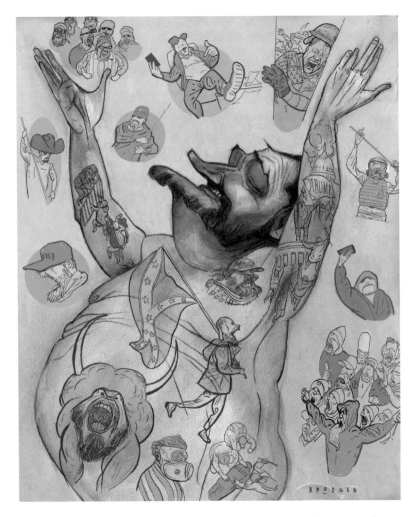

"Proud Boy."

1. Exxon Mobil CEO Darren Woods was defied Wednesday by shareholders who unexpectedly voted to send at least two activist candidates to the board of directors, a victory for a small hedge fund pushing Exxon Mobil to move to the transition to clean energy.

2. Sixty one percent of Chevon's shareholders voted to slash greenhouse gas emissions.

3. A Dutch court ordered Shell Oil to halve greenhouse gas emissions by 2030.

Exxon

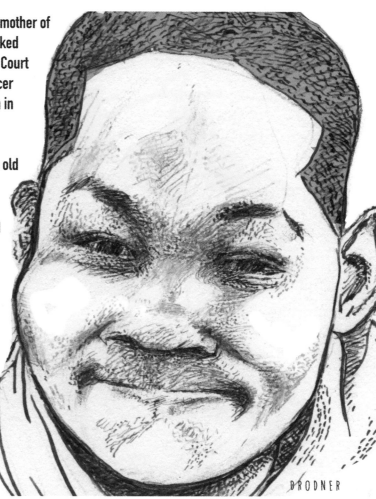

Samaria Rice, the mother of Tamir Rice, has asked the Ohio Supreme Court to prevent the officer who killed her son in 2014 from being reinstated. Tamir Rice was 12 years old when Timothy Loehmann fatally shot him, claiming he thought Rice's toy gun was real.

He was never charged but was eventually fired after it was revealed he lied on his job application. A police union is now seeking to reinstate him,

BRODNER

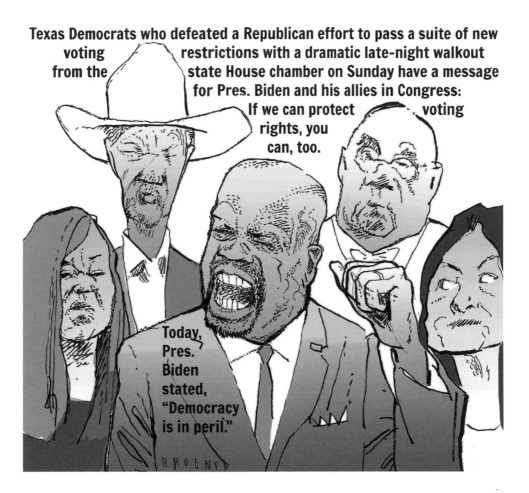

Texas Democrats who defeated a Republican effort to pass a suite of new voting restrictions with a dramatic late-night walkout from the state House chamber on Sunday have a message for Pres. Biden and his allies in Congress: If we can protect voting rights, you can, too.

Today, Pres. Biden stated, "Democracy is in peril."

The movement to rush out state bills that make voting harder for minorities is part of a coordinated effort by the Heritage Foundation. "We did it quickly and we did it quietly," said Jessica Anderson, the executive director of Heritage Action. To "create this echo chamber," as Anderson put it, Heritage is spending $24 million over two years in eight battleground states- Arizona, Michigan, Florida, Georgia, Iowa, Nevada, Texas, and Wisconsin- to pass and defend restrictive voting legislation.

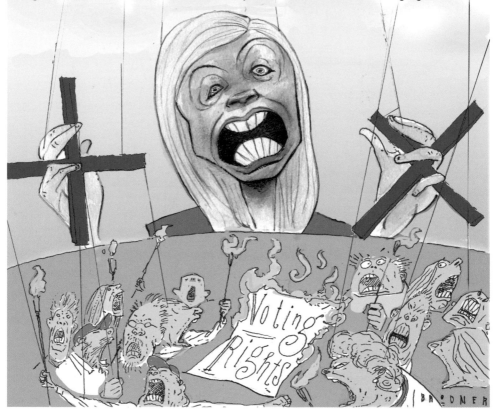

Paxton Smith, valedictorian at Lake Hylands High in Dallas, swapped her pre-approved speech for a ringing response to Texas' new draconian anti-abortion law.

"I am terrified that if my contraceptives fail me, that if I'm raped, then my hopes and efforts and dreams for myself will no longer be relevant. I hope you can feel how gut-wrenching it is, how dehumanizing it is, to have the autonomy over your own body taken from you. And I'm talking about this today, on a day as important as this, on a day honoring the students' efforts in twelve years of schooling, on a day where we're all brought together, on a day where you will be the most inclined to hear a voice like mine, a woman's voice, to tell you that this is a problem. A problem that can't wait. I refuse to give up this platform to promote complacency and peace, when there is a war on my body and a war on my rights. A war on the rights of your sisters, a war on the rights of your mothers, a war on the rights of your daughters.

We cannot stay silent. "

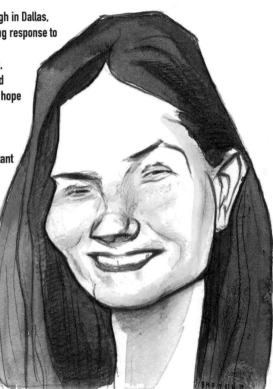

PROFILES IN DIRT.
Barre Seid, is a Chicago industrialist known for funding Heartland Institute's climate denial and other extremist causes. According to leaked documents obtained by DeSmog.org, an anonymous donor contributed at least $13,342,267 to Heartland between 2007 and 2011. This is purported to be Seid. Seid has personally poured millions of dollars into Republican campaigns and conservative causes, and his foundation has given generously to the Cato Institute, the Americans for Limited Government Foundation, and the David Horowitz Freedom Center.

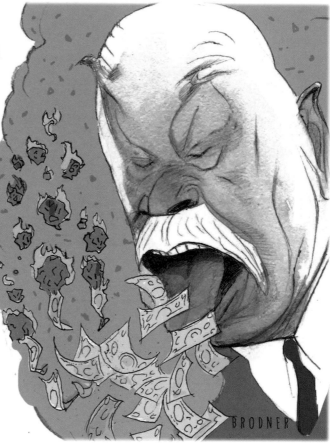

Paul Rusesabagina, who saved many lives during the Rwandan Genocide (as described in the film "Hotel Rwanda") has been kidnapped and returned to Rwanda where he reportedly is being starved and tortured. He is being suffocated by police, he says. He refers to his jail as a slaughterhouse. His family is gravely concerned for his life.

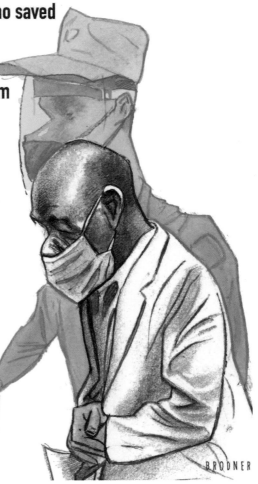

BRODNER

Judge Roger T. Benitez, of the U.S. District Court for the Southern District of California, has overturned the state's three-decade-old ban on assault weapons, which he called a "failed experiment."

Gov. Gavin Newsom criticized the opening lines of Judge Benitez's decision, in which he wrote that, like a Swiss Army knife, the AR-15 assault rifle "is a perfect combination of home defense weapon and homeland defense equipment," calling the ruling "a direct threat to public safety and the lives of innocent Californians."

Sen. Joe Manchin (D-WV) has been under intense pressure from Koch Network dark money advocacy groups to oppose voting and filibuster reforms. Americans for Prosperity has been orchestrating an online campaign to push Manchin to stand against proposals like the For The People Act, or S.1, Democrats' keystone voting rights bill, and the abolition of the filibuster.

Heritage Action leaders have bragged about writing voter suppression legislation that is then hawked by Republican state legislators across the country.

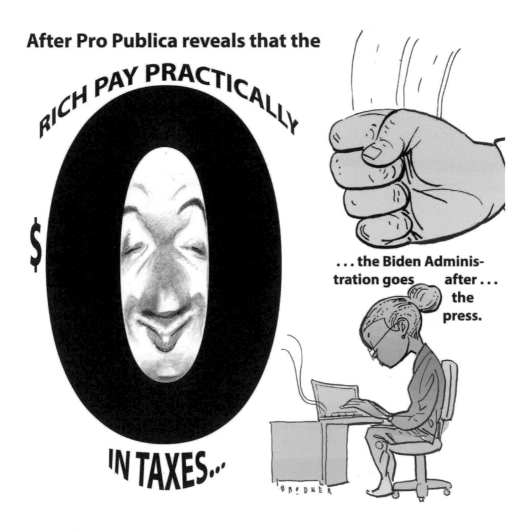

After Pro Publica reveals that the

RICH PAY PRACTICALLY

$0 IN TAXES...

. . . the Biden Adminis-
tration goes after . . .
the
press.

BRODNER

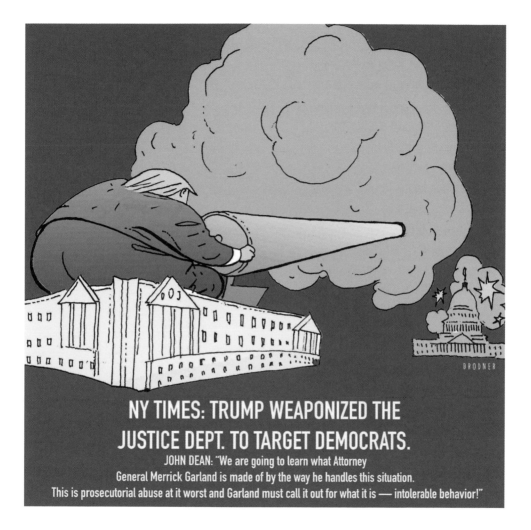

NY TIMES: TRUMP WEAPONIZED THE JUSTICE DEPT. TO TARGET DEMOCRATS.

JOHN DEAN: "We are going to learn what Attorney General Merrick Garland is made of by the way he handles this situation. This is prosecutorial abuse at it worst and Garland must call it out for what it is — intolerable behavior!"

"Cartoonist Ahmed Kabir Kishore and writer Mushtaq Ahmed were detained in May, 2020 for posting on Facebook satirical cartoons and comments critical of the Bangladeshi government's response to COVID-19 pandemic. Denied bail six times, Mushtaq Ahmed died in prison on 25 February 2021. Released on bail, a week after Mushtaq's death, Ahmed Kabir Kishore has suffered injuries allegedly caused by incidents of torture while in custody. Charged under Bangladesh's draconian Digital Security Act, Ahmed Kabir Kishore and nine others in the same case could face up to 10 years in prison solely for peacefully exercising their right to freedom of expression, if convicted."------------------ Amnesty International

"In Guatemala, transgender and human rights advocates are demanding justice for two trans women assaulted and killed in recent days. Twenty-eight-year-old Andrea González was shot to death in Guatemala City Friday. She was a leader of the organization OTRANS Queens of the Night, which denounced local media for dead-naming and misgendering González when reporting news of her killing."

Democracy Now

"If Americans were pandemic novices who didn't trust experts, that also made us clay to be molded by news personalities such as Carlson, as well as by those on social media and elsewhere who had other agendas. People like Carlson didn't provide the news as much as provide a reason to be angry about it or dismissive of it. To Carlson and those like him, the coronavirus was little more than a word, a concept; it was invisible, and therefore easy to distort.",

Andy Slavitt, "Preventable"

BRODNER

German climate researcher Markus Rex has released his report following a North Pole science expedition. It states that Arctic ice is receding at a rate faster than ever and may have already passed a tipping point of no return on global heating. Markus Rex: "There are several tipping points in the climate system which lead to irreversible, sudden changes, which are triggered when the planet reaches a certain temperature. We have seen that we are on the verge of that tipping point which will lead to the disappearance of the ice in the Arctic summer."

(There is no truth to rumors that the image of Charles Koch can be seen in Arctic ice floes.)

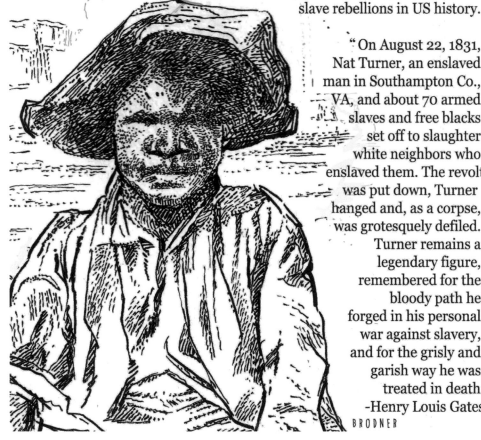

On the first Juneteenth national holiday, remembering the numerous slave rebellions in US history.

"On August 22, 1831, Nat Turner, an enslaved man in Southampton Co., VA, and about 70 armed slaves and free blacks set off to slaughter white neighbors who enslaved them. The revolt was put down, Turner hanged and, as a corpse, was grotesquely defiled. Turner remains a legendary figure, remembered for the bloody path he forged in his personal war against slavery, and for the grisly and garish way he was treated in death."
-Henry Louis Gates

BRODNER

Christopher Rufo finds his "Critical Race Theory" is the next big hit on Fox.
As ratings are triggered by anger, he has found the
perfect trigger for the Trump base. Rufo: "Political correctness"
is a dated term and, more importantly, doesn't apply
anymore. It's not that elites are enforcing a set of manners
and cultural limits, they're seeking to reengineer the
foundation of human psychology and social institutions
through the new politics of race . . . The other frames
are wrong, too: 'cancel culture' is a vacuous term
and doesn't translate into a political program;
'woke' is a good epithet, but it's too broad, too
terminal, too easily brushed aside. 'Critical race theory'
is the perfect villain," -- The New Yorker.

"The goal is to have the public read something crazy in the
newspaper and immediately think 'critical race theory.'
We have decodified the term
and will recodify it to annex the
entire range of cultural constructions
that are unpopular with Americans."
-- Rufo quoted in Esquire.

FOX

CRITICAL RACE THEORY FUTURES

BRODNER

Today the For the People Act, our lifeline to preserve this democracy now under mortal attack, will be blocked, by the senate GOP mob, from even having a debate.

Then all senators will return home for recess and will be listening to voters. Stacey Abrams. of Fair Fight Action, says: call both of your senators, every single day until this is passed. This is the time for action, in Hot Call Summer: 888-453-3211. Every single day.

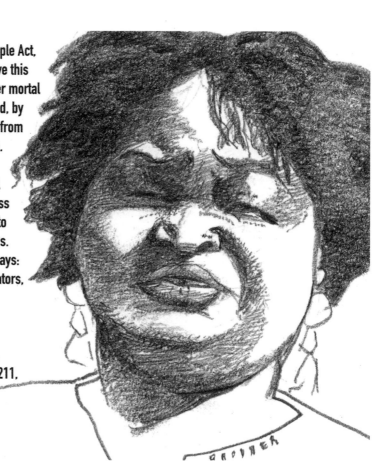

The Justice Dept. has released its first videos showing the 1/6 involvement of the Proud Boys far right terror group. All three videos feature leader Charles Donohoe.
The videos show Donohoe, among the rioters and other Proud Boys preparing their moves, then pushing into the US Capitol with makeshift weapons.
One video shows Donohoe, walking in front of another alleged Proud Boy, as they both carry a police riot shield. His partner used the shield in breaking into the Capitol building.

Another video appears to show Donohoe, with his face covered with a red-and-white-striped bandana, looking on as others in the crowd take down four police officers blocking a stairwell into the Capitol. Prosecutors have made clear they believe this was a key moment in the pro-Trump crowd violently breaking police down to move farther into the building.

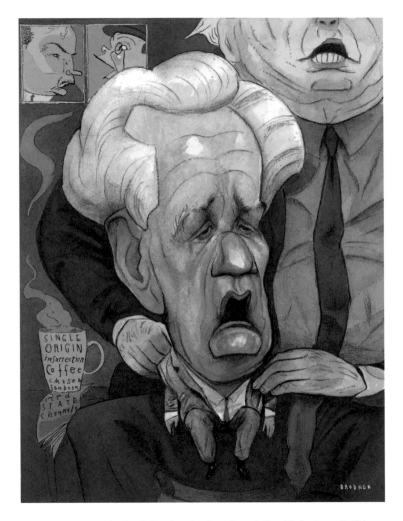

Kevin McCarthuy is Joseph and Charlie's Love Child.

Gen. Mark A. Milley defending teaching about critical race theory at West Point to Congress: "I've read Mao Tse-tung. I've read Karl Marx. I've read Lenin. That doesn't make me a Communist." Milley said it is valuable for leaders to be well-read on various subjects. He said that he wanted to understand "white rage," particularly after the deadly Jan. 6 riot at the U.S. Capitol. "What is it that caused thousands of people to assault this building and try to overturn the Constitution of the United States of America? What caused that? I want to find that out. I want to maintain an open mind here, I do want to analyze that," he said.

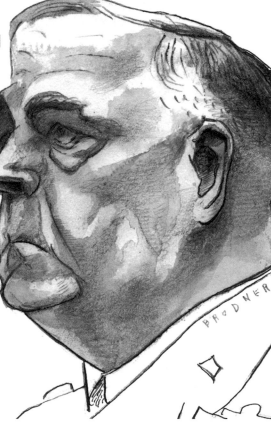

"Vaccines are effective against the Delta variant, sharply reducing the chances of infection and nearly eliminating any chance of serious illness. For unvaccinated people, however, Delta is significantly more contagious than earlier variants.

"Missouri offers the clearest example. Over the past week, it has reported more new Covid cases per capita than any other state, and they are concentrated in rural areas that have low vaccination rates, as Charles Gaba, a health care analyst, has noted. In the parts of the state with high vaccination rates — like the metro areas of Kansas City, St. Louis and Columbia — the number of new cases remains very low.", NY Times.

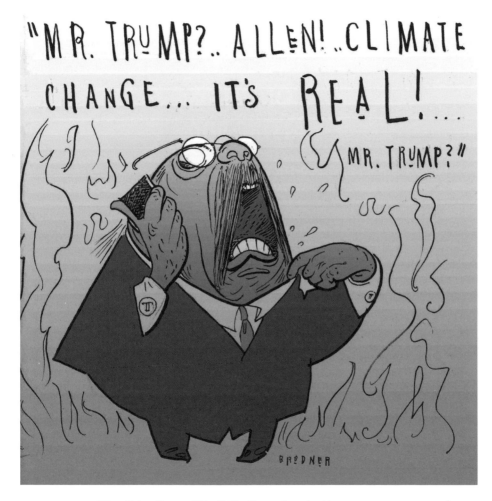

Allen Weisselberg, CFO of the Trump Organization, was called to testify in the ongoing NY state investigation.

The Supreme Court on Thursday used a ruling in a case from Arizona to signal to states that GOP attempts at voter suppression would be supported by the 6-3 conservative majority of the justices.

BRODNER

1. Dozens of activists were arrested by Secret Service agents this week at the White House, demanding that President Biden and federal lawmakers deliver an infrastructure package that invests in job creation and combats the climate emergency.
2. British Columbia sees a 195% increase in sudden deaths during the Canada heatwave. The chief coroner says more than 300 deaths could be attributed to the extreme temperatures.

BRODNER

"What, to the American slave, is your 4th of July? I answer: a day that reveals to him, more than all other days in the year, the gross injustice and cruelty to which he is the constant victim. To him, your celebration is a sham; your boasted liberty an unholy license; your national greatness, swelling vanity; your sounds of rejoicing are empty and heartless; your denunciations of tyrants, brass fronted impudence; your shouts of liberty and equality, hollow mockery; your prayers and hymns, your sermons and thanksgivings, with all your religious parade, and solemnity, are, to him, mere bombast, fraud, deception, impiety, and hypocrisy — a thin veil to cover up crimes which would disgrace a nation of savages. There is not a nation on the earth guilty of practices, more shocking and bloody, than are the people of these United States, at this very hour."

Frederick Douglass, Rochester, NY, July 4, 1852

EXXON lobbyist Keith McCoy was tricked by Greenpeace UK into spilling his plans on video. He reveals that behind the scenes, Exxon is undermining green energy provisions in Pres. Biden's $2 trillion infra-structure plan.

REPORTER: "Who's the crucial guys for you?"

KEITH McCOY: "Well, Senator Capito . . . Joe Manchin, I talk to his office every week, and he is the kingmaker on this . . . So, on the Democrat side, we look for the moderates on these issues. So it's the Manchins. It's the Sinemas. It's the Testers. One of the other ones that aren't talked about is Senator Coons, who's from Delaware, who has a very close relationship with Senator Biden. So we've been working with his office. As a matter of fact, our CEO is talking to him next Tuesday."

BRODNER

GRAIN VALLEY, Mo.
Forty five-year-old Tricia
Jones was hesitant about
getting the vaccine and then
she became ill. The mother-
of-two's health quickly
went downhill. She
died June 9 at
Research Medical
Center. "After she got
it, she said, 'Mom
you were right,
about the shot,
about masks,
being diligent and
all that.' I was like,
'I don't want to be right.
I want you to be well. That's
all that matters,'"
her mother said.

BRODNER

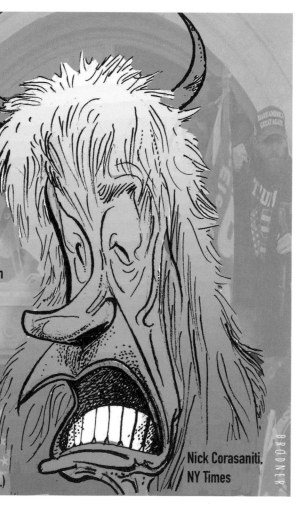

In the next months you will see more states that have passed more restrictions to voting. In Texas Gov. Abbott made it clear that voting would be the top priority. Bills that came out today were pretty much identical to the bill that failed in late May. With a host of restrictions: drive-through, 24-hour, vote by mail etc. It greatly empowers poll-watchers to have more autonomy, making it harder for Texas officials to remove them for bad behavior. And that's just the beginning. Taken together that bill would make Texas the most restrictive state, the most difficult state to cast a ballot. There is going to be a march of states with GOP legislatures to keep pushing forward. The cost of the Democrats' voting drive in Texas would be $14-17 million. (Today Biden/Harris ballyhooed $25 million ... nationwide.)

Nick Corasaniti, NY Times

In Minnesota, protesters continue to take nonviolent direct action to stop construction of Enbridge's Line 3 tar sands pipeline. On Tuesday, activists locked themselves to drilling equipment and built blockades on access roads in a bid to stop Enbridge from drilling under the Willow River. The new project would double the existing line's oil carrying capacity to 760,000 barrels per day. That's the environmental equivalent to building 50 new coal mines in the area.

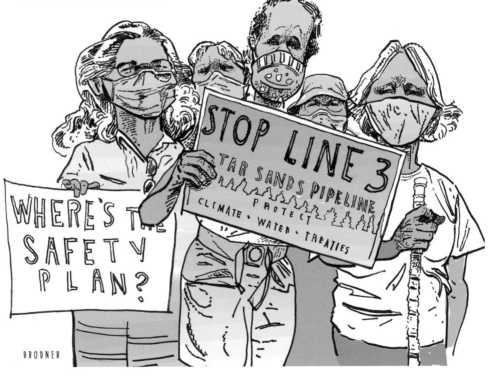

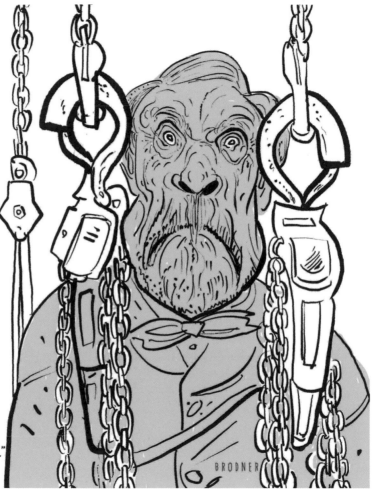

"Early Saturday morning, a green crane lifted a pair of workers beside the Lee monument, which had stood on a pedestal in a downtown Charlottesville park since 1924. They tossed red pulls and chains over the Confederate general and around the horse's legs. Just after 8 a.m. the men in neon vests lifted the statue into the air, and a small crowd of residents began to cheer from the sidewalk." The Washington Post.

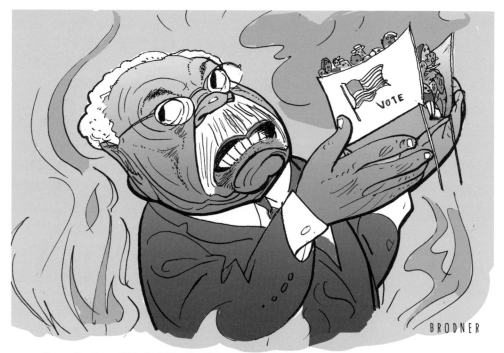

Days after House Majority Whip, Jim Clyburn (SC) called for a "carve out" to allow for federal voting rights legislation, at least 50 Democrats from the Texas legislature fled the state to bring the adoption of severe voting restrictions there to a halt. They arrived in Washington today. Their stated purpose was to, not just block this bad legislation by Republicans, but to beg the Congress to join this fight, as if democracy itself was on the line.

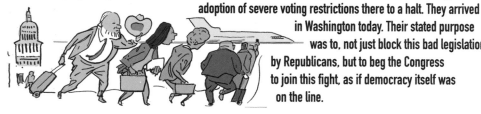

Officer James Blassingame, 40, Capitol Police, didn't think he would survive 1/6. He is still on the job and in trauma, as is much of the current force. More than 80 officers were seriously wounded that day, many with brain injuries, cracked ribs, shattered spines, stabbed, smashed in the head with bats and poles. Many are expected to have PTSD. The force will soon run out of money. Senate Republicans oppose funding. "It amounts to Congress turning its back on those who fought, bled and died on that day." Sen. Patrick Leahy.

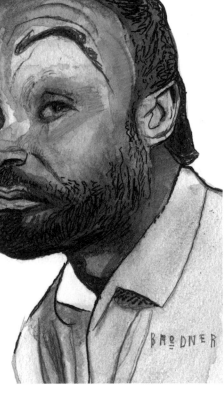

On Monday, Dr. Michelle Fiscus, Tennessee's former top vaccine official, was fired without explanation, and Republicans have talked about getting rid of the Department of Health altogether, saying it has been undermining parents by going around them and straight to teens to promote vaccines. In 46 states, the rates of new cases this past week are at least 10% higher than the rates of new cases the previous week The vast majority of new Covid-19 cases, hospitalizations and deaths have one thing in common: They're among unvaccinated people, doctors say.

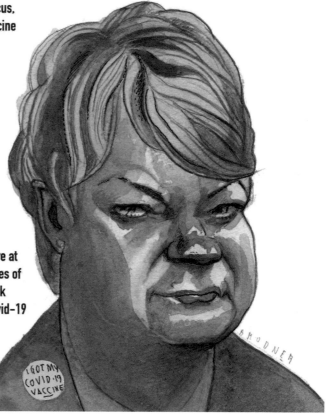

The chairwoman of the Congressional Black Caucus, Representative Joyce Beatty, was arrested on Thursday on Capitol Hill along with eight activists who were demonstrating for voting rights.

"You can arrest me. You can't stop me. You can't silence me," Ms. Beatty, an Ohio Democrat, wrote in a tweet after her arrest by the U.S. Capitol Police in the atrium of a Senate office building. A reporter on the scene noted on Twitter that her hands had been bound with zip ties before she was led away. This is the beginning of a summer of direct action to inspire activism for voting rights.

Alan Scott Lanoix, a 54-year-old Texas man, who thought COVID-19 vaccines were "poison," died from the virus last month. Lanoix's sister Lisa Adler told New Orleans' CBS affiliate,"The kids had to bury their father on Father's day. I was scared to get it myself, but you have to worry about what the consequences are, He was a great person and I urge anybody if they are on the fence about getting the vaccine, do it in my brother's memory." Lanoix spent 17 days on a ventilator before his death.

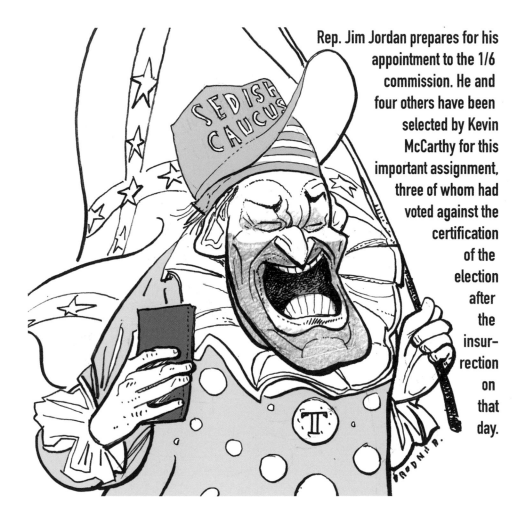

Rep. Jim Jordan prepares for his appointment to the 1/6 commission. He and four others have been selected by Kevin McCarthy for this important assignment, three of whom had voted against the certification of the election after the insur-rection on that day.

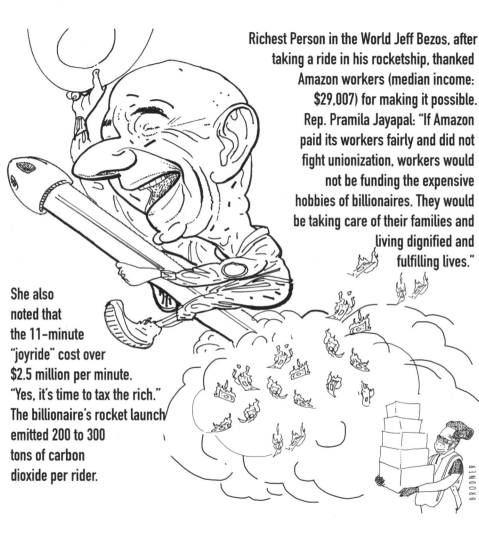

Richest Person in the World Jeff Bezos, after taking a ride in his rocketship, thanked Amazon workers (median income: $29,007) for making it possible. Rep. Pramila Jayapal: "If Amazon paid its workers fairly and did not fight unionization, workers would not be funding the expensive hobbies of billionaires. They would be taking care of their families and living dignified and fulfilling lives."

She also noted that the 11-minute "joyride" cost over $2.5 million per minute. "Yes, it's time to tax the rich." The billionaire's rocket launch emitted 200 to 300 tons of carbon dioxide per rider.

BRODNER

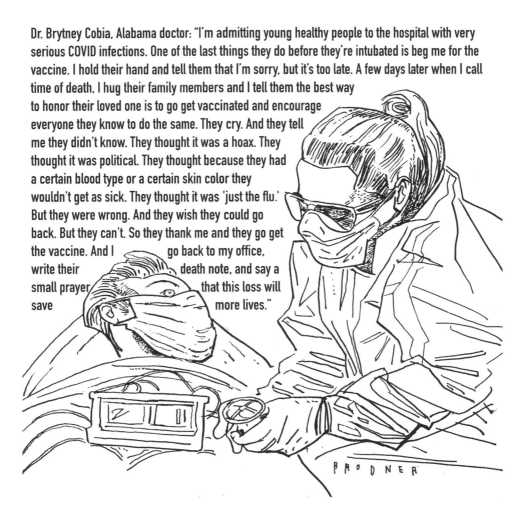

Dr. Brytney Cobia, Alabama doctor: "I'm admitting young healthy people to the hospital with very serious COVID infections. One of the last things they do before they're intubated is beg me for the vaccine. I hold their hand and tell them that I'm sorry, but it's too late. A few days later when I call time of death, I hug their family members and I tell them the best way to honor their loved one is to go get vaccinated and encourage everyone they know to do the same. They cry. And they tell me they didn't know. They thought it was a hoax. They thought it was political. They thought because they had a certain blood type or a certain skin color they wouldn't get as sick. They thought it was 'just the flu.' But they were wrong. And they wish they could go back. But they can't. So they thank me and they go get the vaccine. And I go back to my office, write their death note, and say a small prayer that this loss will save more lives."

BRODNER

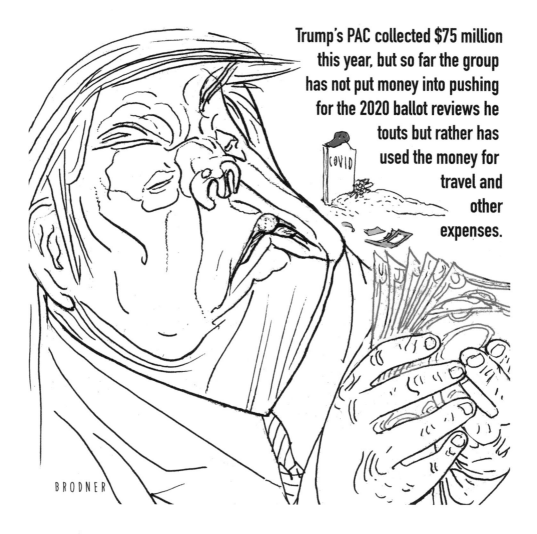

Trump's PAC collected $75 million this year, but so far the group has not put money into pushing for the 2020 ballot reviews he touts but rather has used the money for travel and other expenses.

DC Capitol Police Sgt. Aquilino Gonell: "I'm still recovering from those 'hugs and kisses' that day. If that was hugs and kisses, then we should all go to his house and do the same thing to him."

BRODNER

Biden admin's engagement on infrastructure: Since June 28, WH Office of Leg Affairs had at least 330 meetings and calls with members of Congress and their top aides.

"Jobs Cabinet" secs had 100 w/ members. Since jobs plan release on March 30, 998 leg affairs meetings and calls.

Tweet by Jennifer Epstein, Bloomberg WH reporter

Alabama Gov. Kay Ivey:
"Folks [are] supposed to
have common sense.
But it's time to start
blaming the unvaccinated
folks, not the regular folks.
It's the unvaccinated
folks that are letting
us down."

Alabama remains the
state with perhaps
the lowest vaccination
rate in the country,
according to the CDC:
Only 39.6 percent of
its residents 12 and
older have been
fully vaccinated,
compared to the
48.8 percent of
Americans nationally
who have gotten
their shots.

BRODNER

Trump's removal of the gray wolf from the Endangered List has led to its wholesale slaughter. In the Spring of 2020, there were at least 1,034 wolves in Wisconsin. The deaths brought the total number of wolves to between 695 and 751, according to The Associated Press. Between April 2020 and April 2021, 313 to 323 gray wolves were killed by humans — a majority of them killed during the February public hunt. The targeted amount of wolves to kill for population control was 119.

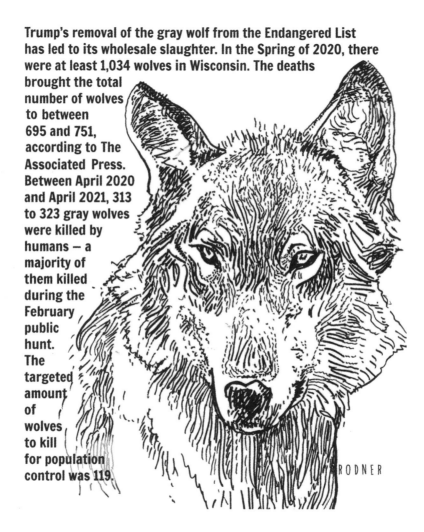

RODNER

President Donald J. Trump pressed top Justice Department officials late last year to declare that the election was corrupt, even though they had found no instances of widespread fraud, so he and his allies in Congress could use the assertion to try to overturn the results, according to new documents provided to lawmakers. In an exchange with acting attorney Jeffrey A. Rosen, and his deputy, Richard P. Donoghue.

"Just say that the election was corrupt + leave the rest to me.", Mr. Donoghue wrote in summarizing Trump's response. The conversation has been called smoking gun-level evidence of a Trump-directed coup attempt.

BRODNER

At a voting rights rally in Austin, TX on Saturday Willie Nelson sang the classics "Whiskey River" and "Good Hearted Woman." His set ended with a newer song, "Vote 'Em Out," which opens with the line: "If you don't like who's in there, vote 'em out; that's what Election Day is all about." The rally, which drew several thousand attendees, marked the end of a Selma-style march to the Capitol — a 27-mile journey from Georgetown to Austin that activists split over four days. It was organized by the Poor People's Campaign, a group inspired by Martin Luther King Jr., and is at least the fourth such demonstration that's taken place at the Capitol since May.

BRODNER

Dr. Catherine O'Neal, chief medical officer, Lake Regional Medical Center, Baton Rouge, LA: "When you come inside our walls it is quite obvious to you that these are the darkest days of this pandemic. We are no longer giving adequate care to patients. ... I have seen people with motorcycle accidents and farming accidents in the last two weeks, in the ERs in those small towns, These are my people. Those are your family members. And when they get maimed today they are not coming to a trauma center, because there are no more beds."

BRODNER

This week, Tucker Carlson, the most influential voice on the US Right, (except for a disgraced racist, corrupt, sadistic ex-president) is broadcasting from Hungary, celebrating repressive, anti-Semitic, anti-LGBTQ dictator Victor Orban. WaPo: "Carlson, of course, has said next to nothing about the autocratic character of Orban's rule, which critics on both sides of the Atlantic cast as a cautionary tale of how democracies backslide. To a certain extent, that should be expected. After all, Orbanism represents the fever dream of the American right: The Hungarian prime minister rules a government steadily captured through gerrymandering and a stacked judiciary. The overwhelming majority of media outlets are now loyal to him, while he presides over a network of patronage — and alleged graft — that ties in many of the country's titans of industry."

The Dixie Fire, driven by strong winds, tore through the small Northern California town of Greenville Wednesday night, burning much of its historic center to the ground and leaving stretches of the community unrecognizable on Thursday. "We lost Greenville tonight," Representative Doug LaMalfa said. The fire is the largest in California this year and the sixth-largest on record in the state, burning more than 322,000 acres. "It took maybe 30 minutes before all of Greenville was literally flanked by fire," said Ryan Schramel, who grew up in the town and now lives in nearby Taylorsville.

BRODNER

H. Scott Apley, 45, Texas GOP leader, tweeted in May that he wished he could attend a mask-burning in Cincinnati. He called Baltimore's health commissioner "an absolute enemy of the people." And on Friday, July 30, he republished a Facebook post implying that vaccines don't work. Two days later, Apley was admitted to a Galveston hospital with "pneumonia-like symptoms" and tested positive for coronavirus.

On Wednesday, he died.

Trump's Acting AG Jeffrey A. Rosen, has told the Justice Department watchdog and congressional investigators that one of his deputies Jeffrey Clark, tried to help Trump subvert the results of the 2020 election, according to a person familiar with the interviews. On Friday, Rosen, who remained silent during Trump's second impeachment trial, met with the DOJ's office of the inspector general and provided testimony to the Senate Judiciary Committee on Saturday. The investigations were opened after a NY Times article detailed efforts by Clark to push top leaders to falsely and publicly assert that "fraud investigations" cast doubt on the Electoral College results. That prompted Trump to consider ousting Rosen and installing Clark at the top of the department to carry out that plot.

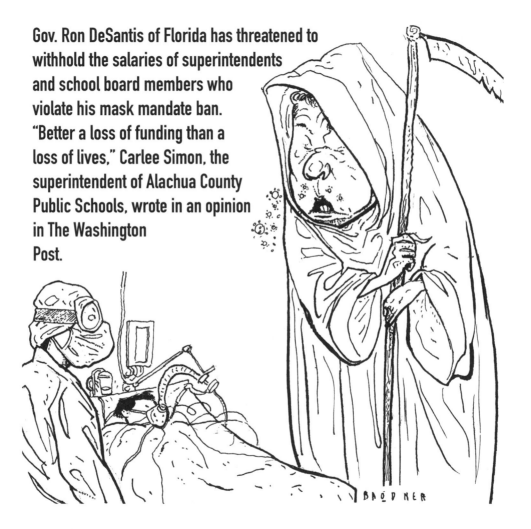

Gov. Ron DeSantis of Florida has threatened to withhold the salaries of superintendents and school board members who violate his mask mandate ban. "Better a loss of funding than a loss of lives," Carlee Simon, the superintendent of Alachua County Public Schools, wrote in an opinion in The Washington Post.

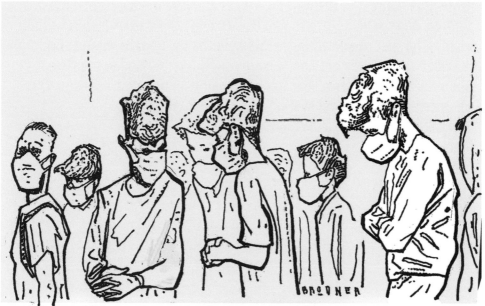

Migrant children and teens detained at the Fort Bliss Army base near El Paso and at an oil workers' camp in the city of Pecos have reported abuse, medical neglect, prolonged detention and being subjected to mental distress. Their attorneys are demanding the Biden administration immediately release them, arguing the U.S. government is violating the 1997 Flores Settlement Agreement, which established legal requirements regarding the treatment of migrant children in U.S. custody.

Texas Democrats are looking to Washington, saying, "We need you to protect us the rest of the way." ... This is an issue of civil rights, not ... politics. And so the Senate should come back. I think everybody who is wishing for justice and voting rights believes the Senate should stay in session. But that's not how Washington works. August is the time when they all leave town. And you're stepping on precious vacation days when senators can travel overseas on the taxpayers' dime. That seems to be more important than what's happening in Texas or Georgia right now."
- David Jolly, former congressman, lobbyist.

BRODNER

Former Secretary of State Mike Pompeo signed an agreement with Taliban leader Mullah Abdul Ghani Baradar in Doha, Qatar in September, 2020, pledging US evacuation from Afghanistan by May 1, 2021. Gen. H.R. McMaster: "This collapse goes back to the capitulation agreement. We defeated ourselves."

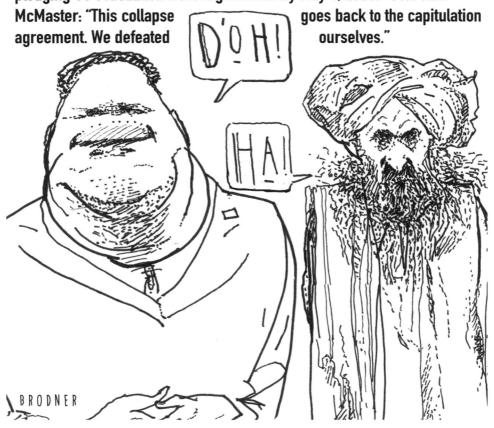

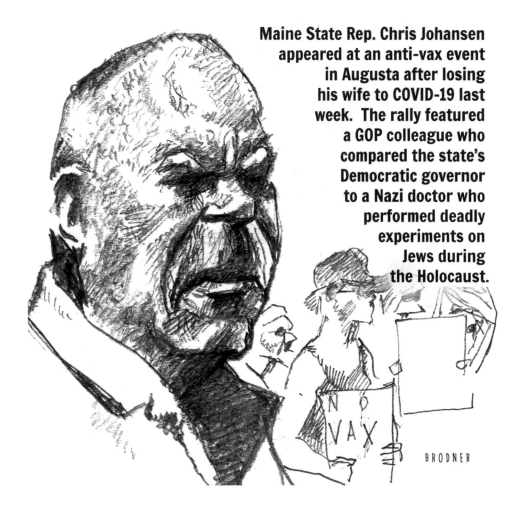

Maine State Rep. Chris Johansen appeared at an anti-vax event in Augusta after losing his wife to COVID-19 last week. The rally featured a GOP colleague who compared the state's Democratic governor to a Nazi doctor who performed deadly experiments on Jews during the Holocaust.

BRODNER

NO VAX

The John Lewis Voting Rights Act passed the House last night. Its future in the Senate is in doubt unless the filibuster can be suspended. Yesterday a demonstration took place outside the White House led by People for the American Way and the League of Women Voters, urging Pres. Biden to use maximum pressure to achieve this, in order to save democracy in the United States.

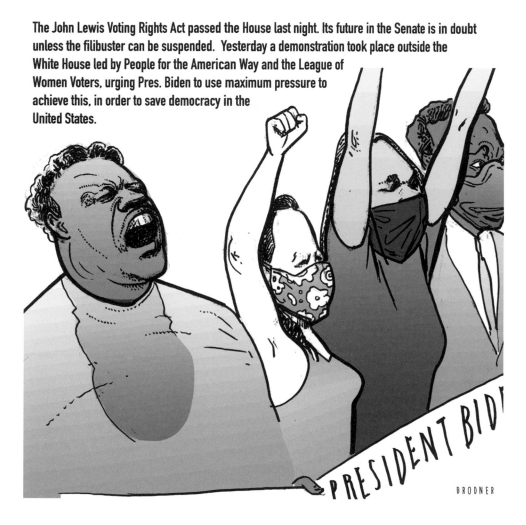

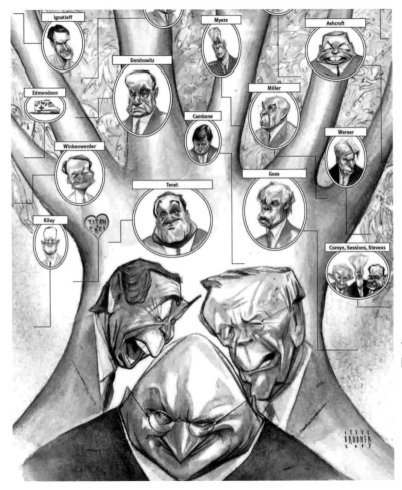

The current chaos in Afghanistan is the death rattle of the Cheney, Rumsfeld, Bush War Program. Promises and expectations created in the selling of these wars were based on lies. The wars were successful, in fact, for war profiteers like Raytheon, Northrup Grummon and Halliburton. Others, including neo-cons, were useful tools in the project (in which the Taliban's 2001 surrender was rejected). The Torture Tree was a large piece by me, designer Peter Ahlberg, researchers Sarah Goldstein and Mark Sorkin and editor Katrina vanden Heuvel. For The Nation, December, 2005.

The Supreme Court's right wing majority struck down the Biden Administration's moratorium on evictions yesterday. Hundreds of thousands are now at risk of becoming homeless. Rep. Cori Bush (D-Mo.), who organized a campout at the Capitol, said Thursday that Congress needs to step up. "Tonight, the Supreme Court failed to protect the 11 million households across our country from violent eviction in the middle of a deadly global pandemic, Congress must act immediately to prevent mass evictions."

The family of a murdered nine year-old Indian girl accused four men of raping and killing her, then quickly cremating the body. Protests have sprung up in New Delhi over rampant sexual violence against girls who are low-caste Dalit.

The local priest (himself a suspect in the case) told the family: "You are beggars. How will you fight in the court and in the police station?"

It is common for evidence of rape not to be found and for police to go free when the victim is Dalit.

BRODNER

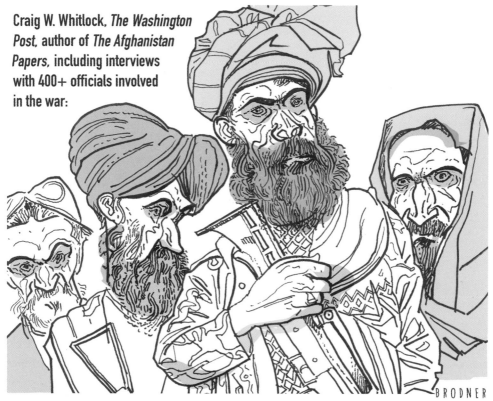

Craig W. Whitlock, *The Washington Post*, author of *The Afghanistan Papers*, including interviews with 400+ officials involved in the war:

BRODNER

"The US government didn't know what it was doing in Afghanistan. It didn't have a strategy. It mislead the American people about how the war was going for 20 years. It was the complete opposite of the message that was being delivered in public, year after year, that the US was making progress, that victory was around the corner."

A Texas law prohibiting most abortions after about six weeks of pregnancy went into effect on Wednesday after the Supreme Court failed to act on a request to block it, ushering in the most restrictive abortion law in the nation and prompting clinics in the state to turn away women seeking the procedure. The law bars state officials from enforcing it and instead deputizes private individuals to sue anyone who performs the procedure or "aids and abets" it.

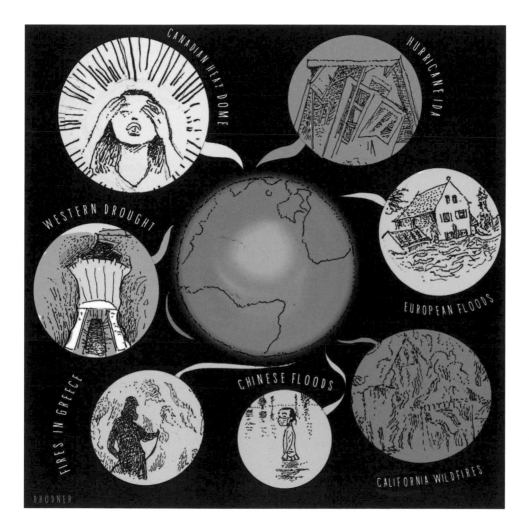

CANADIAN HEAT DOME

HURRICANE IDA

WESTERN DROUGHT

EUROPEAN FLOODS

FIRES IN GREECE

CHINESE FLOODS

CALIFORNIA WILDFIRES

BRODNER

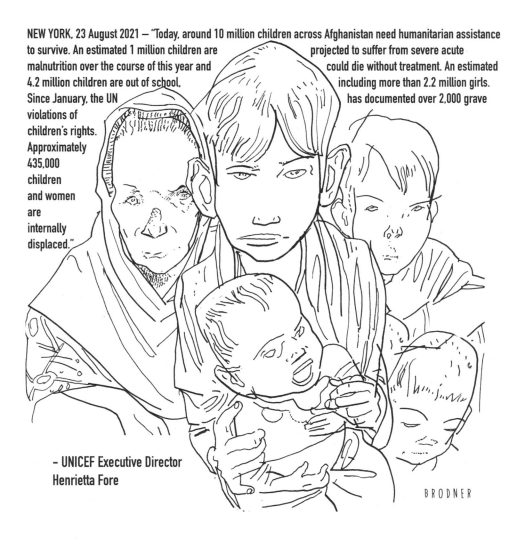

NEW YORK, 23 August 2021 — "Today, around 10 million children across Afghanistan need humanitarian assistance to survive. An estimated 1 million children are projected to suffer from severe acute malnutrition over the course of this year and could die without treatment. An estimated 4.2 million children are out of school, including more than 2.2 million girls. Since January, the UN has documented over 2,000 grave violations of children's rights. Approximately 435,000 children and women are internally displaced."

– UNICEF Executive Director
Henrietta Fore

BRODNER

Tanya Gersh, a real estate agent in Whitefish, Montana learned that White Nationalist leader Richard Spencer's mother's house there was a national headquarters for Spencer's groups. Her attempts to get Mrs. Spencer to sell sparked a Neo-Nazi attack on Gersh and the Jewish community. The governor, the Anti-Defamation League, and The Southern Poverty Law Center helped mobilize the people of Whitefish.

Spencer was soon ostracized and shunned. Mr. Spencer's lawyer withdrew from the case last year because he had not been paid.

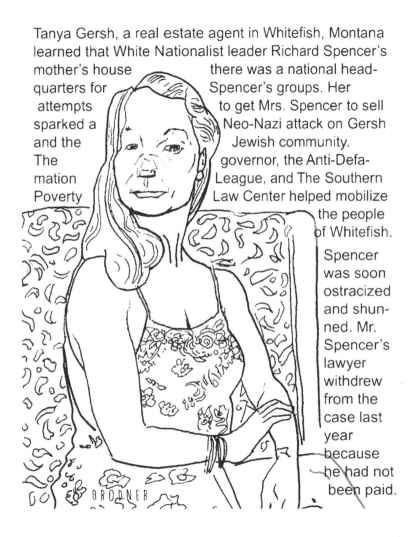

A recent CDC study found that Covid-related emergency room visits and hospital admissions among children were more than three times higher in states with the lowest vaccination coverage compared to states with high vaccination rates, underscoring the importance of community-wide vaccination to protect children. Other important factors that might affect regional differences included masking and social distancing measures, the study noted. Hospitalization rates have increased most sharply for children who are 4 or younger. In the week ending Aug. 14, there were 1.9 hospitalizations per 100,000 children in that age group, nearly 10 times as many as in late June.

BRODNER

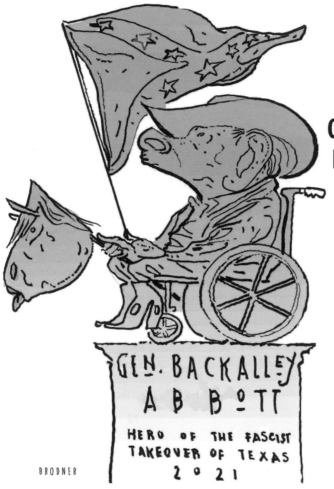

VIRGINIA
REMOVES
ONE
CONFEDERATE
MONUMENT.

TEXAS
BUILDS
A
BRAND
NEW
ONE.

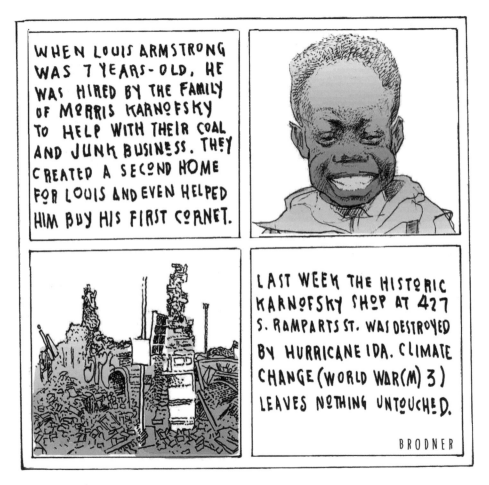

WHEN LOUIS ARMSTRONG WAS 7 YEARS-OLD, HE WAS HIRED BY THE FAMILY OF MORRIS KARNOFSKY TO HELP WITH THEIR COAL AND JUNK BUSINESS. THEY CREATED A SECOND HOME FOR LOUIS AND EVEN HELPED HIM BUY HIS FIRST CORNET.

LAST WEEK THE HISTORIC KARNOFSKY SHOP AT 427 S. RAMPARTS ST. WAS DESTROYED BY HURRICANE IDA. CLIMATE CHANGE (WORLD WAR(M) 3) LEAVES NOTHING UNTOUCHED.

BRODNER

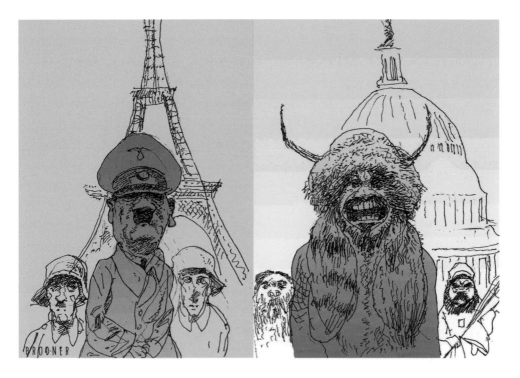

"France has fallen from the height of ten centuries of history in thirty-eight days. This is the inescapable fact, but it is so tremendous no one is capable of grasping it," Journalist Raoul De Roussy de Sales, May, 1940.
— from Saint-Exupery: A Biography by Stacy Schiff

The family of Ray Martin DeMonia of Cullman, Alabama is urging people to get vaccinated for COVID-19. Forty-three hospitals in three states refused admitting Mr. DeMonia, who was in cardiac distress, as their ICU beds were full of COVID patients. Mr. DeMonia died of cardiac failure on Sept. 1.

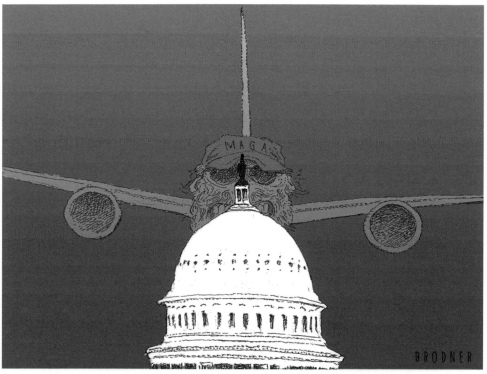

"There is little cultural overlap between violent extremists abroad and violent extremists at home. But in their disdain for pluralism, in their disregard for human life, in their determination to defile national symbols — they are children of the same foul spirit, and it is our continuing duty to confront them," George W. Bush in a speech at the Flight 93 National Memorial in Shanksville, PA.

"We carry our work home when we shouldn't. We worry about our patients constantly. We forget our own personal needs to care for patients. It's a huge fault and a huge success. There's a saying that patients may not remember your name, but they will remember the difference you made in their life... Well... same for us. We may not remember your name (more likely your room number), but we will never forget our patients. Truth is... this isn't just a job for us. It is a calling. Something we are drawn to. No matter how much we get yelled at by patients and family... We will still care for you and advocate for your best interest. We will still go home wondering if we made a difference.. or what we could've done different to change the outcome. You don't leave our mind. You are ALWAYS on it. You matter. We care. No matter any outside circumstances. We are a nurse. We will always be there for you."
Bri Lyn,
Nurse, Texas

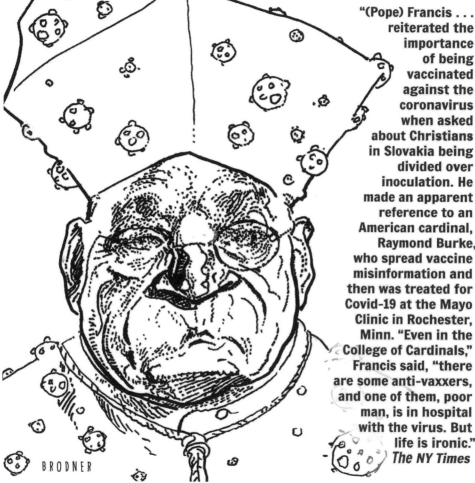

"(Pope) Francis . . . reiterated the importance of being vaccinated against the coronavirus when asked about Christians in Slovakia being divided over inoculation. He made an apparent reference to an American cardinal, Raymond Burke, who spread vaccine misinformation and then was treated for Covid-19 at the Mayo Clinic in Rochester, Minn. "Even in the College of Cardinals," Francis said, "there are some anti-vaxxers, and one of them, poor man, is in hospital with the virus. But life is ironic." *The NY Times*

BRODNER

"What we saw at Rikers island was an absolute humanitarian crisis. Garbage strewn all over the floor. People piled on top of each other, cockroaches, rotting food. The inmates didn't have access to showers, food, PPE or clean clothes."
Jessica Gonzalez-Rojas, NY State Assembly

"A lot of the people at Rikers are in pre-trial detention. They expect to be held for a few hours but are there for days. They have no access to toilets. They were given a bag to urinate and defecate in."
State Senator Jabari Brisport

BRODNER

"Unfortunately, today we have an overwhelming amount of deaths. Seventy-four people died. Seventy-four more people have died since Wednesday.

"And they'll keep dying. That's all there is to it.

"We just are going to keep lining the body bags up, and we're going to line them up and line them up."

West Virginia Gov. Jim Justice, as COVID cases explode in his low-vaccination state.

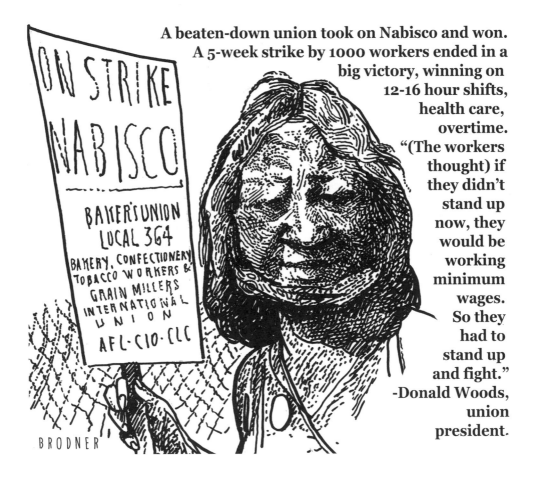

A beaten-down union took on Nabisco and won. A 5-week strike by 1000 workers ended in a big victory, winning on 12-16 hour shifts, health care, overtime. "(The workers thought) if they didn't stand up now, they would be working minimum wages. So they had to stand up and fight." -Donald Woods, union president.

ON STRIKE NABISCO

BAKER'S UNION LOCAL 364

BAKERY, CONFECTIONERY TOBACCO WORKERS & GRAIN MILLERS INTERNATIONAL UNION

AFL-CIO-CLC

BRODNER

Youth activists around the world are holding a climate strike on Friday, September 24, including in New York, which will coincide with the U.N.'s Climate Week. Ahead of the strike, climate activist Greta Thunberg said the movement also needs to tackle racism, sexism, and inequality.

Thunberg: "The climate crisis is caused by the same thing that is also fueling other crises and inequality around the world and the ecological crisis. And we cannot just solve one of these crises without also addressing the others."

BRODNER

Just five of the world's largest meat and dairy companies, among them JBS, Tyson, and Cargill, are responsible for more emissions than oil giants like Exxon and BP. This is just one of the shocking findings revealed in the latest Meat Atlas report released by Heinrich-Böll-Stiftung and Friends of the Earth Europe.

"Globally, three-quarters of agricultural land is used to raise animals or the crops to feed them. Livestock farming and soybean cultivation are the biggest contributors to deforestation, whose effects include soaring emissions, destruction of indigenous communities' and small farmers' livelihoods, and pandemics," the report summarises.

HI I'M ANDRE NOGUEIRA, PRES / CEO, JBS USA.

BRODNER

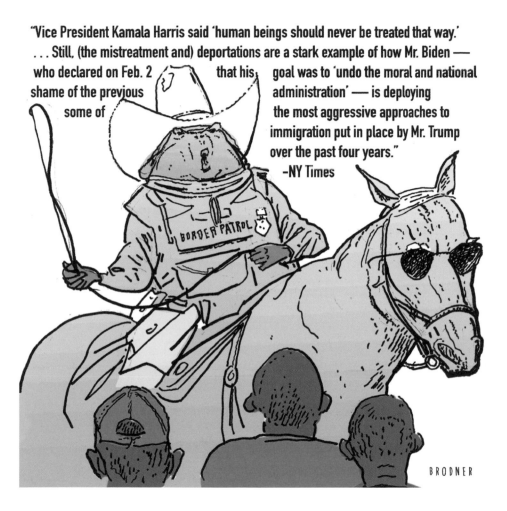

"Vice President Kamala Harris said 'human beings should never be treated that way.' ... Still, (the mistreatment and) deportations are a stark example of how Mr. Biden — who declared on Feb. 2 that his goal was to 'undo the moral and national shame of the previous administration' — is deploying some of the most aggressive approaches to immigration put in place by Mr. Trump over the past four years."
—NY Times

BRODNER

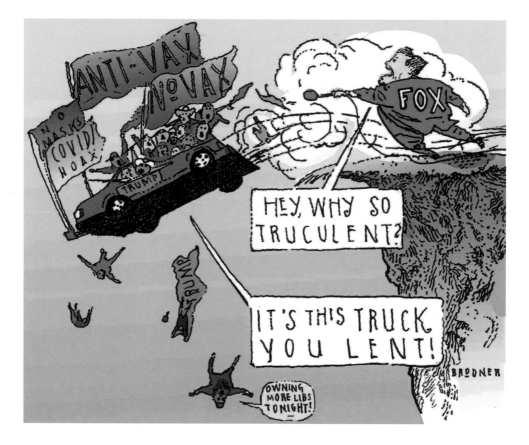

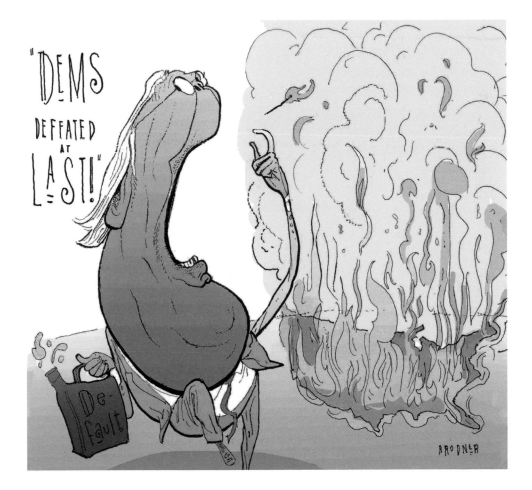

Maria Manzanilla, nurse at University Hospital, San Antonio, said that after a year and a half on the front lines as an ICU nurse, she noticed several big differences in this summer's delta surge: "This is the wave where they are a lot sicker," she said. "This is the wave where we're seeing them come in and they're dying a lot faster." Manzanilla said she, like others in her profession, is burned out and looking at a career change after the pandemic subsides. Last year held too much grief, too much death. She's decided she'd like to become a nurse practitioner, working in a doctor's office instead of on the front lines of tragedy. "It's very heavy work," she said of being an ICU nurse. "I'm going to go back to school within a year. I don't think I can stick with bedside for a long time. I thought I could, but I don't think I can."
The Texas Tribune

BRODNER

Trump lawyer John Eastman, is author of a detailed step-by-step plan to declare the 2020 election invalid and give the presidency to Trump, which was revealed in the new Bob Woodward / Robert Costa book. The story has been ignored by US media, although it is a bombshell. In numbered steps subtitled "the January 6 scenario", it outlined how Mike Pence, charged by the Constitution with counting electoral ballots from the 2020 election on that day, could simply have ignored results from seven states that tipped the presidency to Biden. Pence would effectively throw away millions of votes from Arizona, Pennsylvania, and any other state where "fraudulent groups of shadow electors" had challenged Biden's victory based on no valid legal principle whatsoever. The main thing here is that Pence should do this without asking for permission — either from a "vote of the joint session of Congress or from the Court", Eastman wrote. Why did this get very little press attention? Perhaps it is because we've become so inured to Trump's flagrant disregard for the will of the electorate.

The Washington Post

BRODNER

Former Facebook employee-turned-whistleblower Frances Haugen has internal documents that prove that Facebook biases content toward anger-triggering posts, as it significantly raises profits.

"When we are in an information environment that is full of angry, hateful, polarizing content it erodes our civic trust, it erodes our faith in each other, it erodes our ability to care for each other. The version of Facebook that exists today is tearing our societies apart and is causing ethnic violence around the world."

She cites Myanmar in 2019, where the military used Facebook to launch a genocide. And the attempt to overthrow the legitimately elected government of the US on Jan. 6, 2021.
-60 Minutes

BRODNER

"As a parting shot, on its way out of Afghanistan, the United States military launched a drone attack that the Pentagon called a "righteous strike.

" ... Instead of killing an ISIS suicide bomber, the United States had slaughtered 10 civilians: Zemari Ahmadi, a longtime worker for a US aid group; three of his children, Zamir, 20, Faisal, 16, and Farzad, 10; Ahmadi's cousin Naser, 30; three children of Ahmadi's brother Romal, Arwin, 7, Benyamin, 6, and Hayat, 2; and two 3-year-old girls, Malika and Somaya.

"... Over the last 20 years, the United States has conducted more than 93,300 air strikes—in Afghanistan, Iraq, Libya, Pakistan, Somalia, Syria, and Yemen—that killed between 22,679 and 48,308 civilians, according to figures recently released by Airwars, a U.K.-based air strike monitoring

group. The total number of civilians who have died from direct violence in America's wars since 9/11: 364,000 to 387,000, according to Brown University's Costs of War Project."
-Nick Turse, The Nation

As many as 144,000 gallons of oil have leaked from a pipeline connected to an offshore oil platform off the coast of Huntington Beach, about 30 miles south of Los Angeles. Investigators are looking into whether a ship anchor punctured the pipeline. Beaches in the area are expected to be closed for months. Orange County District Attorney Todd Spitzer:
"Orange County District Attorney's Office is deeply concerned about the wildlife impact that has occurred on our shores and the economic impact to our community. And somebody's going to pay for that, criminally or civilly." Environmental groups are calling on authorities to ban offshore oil drilling.

BRODNER

One of two unvaccinated teachers at a Texas junior high school who died in August of Covid-19 was nervous about returning to school because of the Delta variant, her sister told CNN. Natalia Chansler, a 6th grade social studies teacher in Elm Mott, Texas, died of Covid-19 complications just days after testing positive for the virus, according to an email sent to parents by the Connally Independent School District.

The Senate Judiciary Committee on Thursday released a new report shedding further light on former President Donald Trump's relentless efforts to enlist the Justice Department to challenge the results of the 2020 presidential election over baseless claims of election fraud. Senate Judiciary Committee Chairman Dick Durbin, a Democrat from Illinois, said in a statement that report shows "just how close we came to a constitutional crisis."

In other news, Donald Trump praised Attorney General Merrick Garland in a Wednesday interview with The Spectator World magazine.

". . . I think that he's a good man," Trump said.

BRODNER

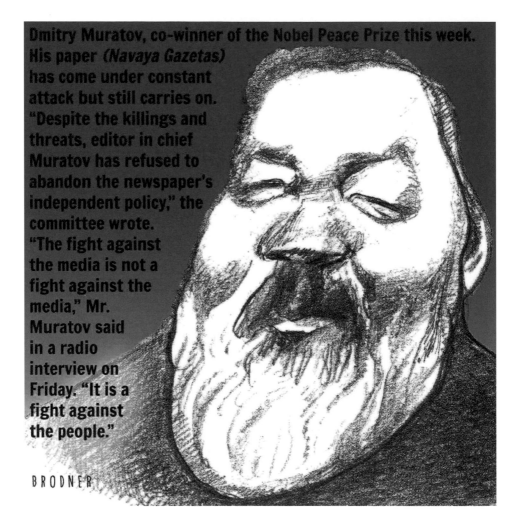

Dmitry Muratov, co-winner of the Nobel Peace Prize this week. His paper *(Navaya Gazetas)* has come under constant attack but still carries on. "Despite the killings and threats, editor in chief Muratov has refused to abandon the newspaper's independent policy," the committee wrote. "The fight against the media is not a fight against the media," Mr. Muratov said in a radio interview on Friday. "It is a fight against the people."

BRODNER

Donald Trump has invoked executive privilege to prevent his former aides from testifying before the investigative committee.
As a result, Steve Bannon has said that he won't cooperate with the committee's subpoenas. He had until midnight last Thursday to hand over documents relating to January 6 to the committee.
Adam Schiff: "He is required to testify. . . . If he doesn't . . . we will hold him in contempt and refer him to the DOJ for criminal prosecution . . ."

BRODNER

The Pandora Papers reveal that South Dakota is a tax haven for Dominican sugar plantation owners, who have sheltered $14 million made on the backs of workers living in squalor, working in extreme heat in dangerous conditions with little medical care. Maria Magdelena Alvarez was evicted in a drive to plow under the homes of the poor to expand sugar cane plantations.

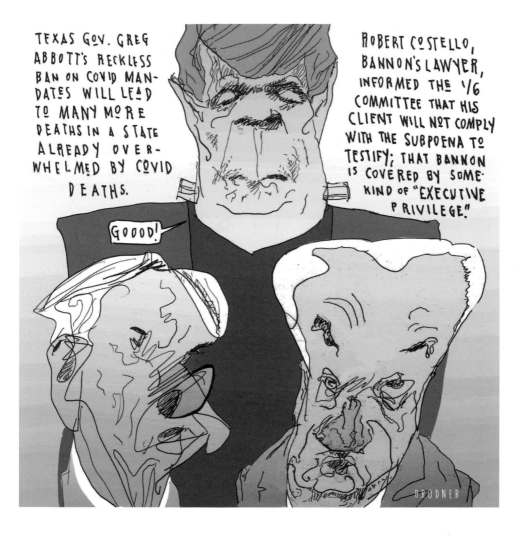

A Jefferson Parish, Louisiana video shows police brutalizing 34-year-old Shantel Arnold. On Sept. 20, they arrived on the scene after she had fought off an attack by white children. The video shows an officer holding the wrist of Arnold, who is lying on her back on the sidewalk. The deputy appears to be dragging her along the pavement. The deputy then grabs Arnold's arm with his other hand and jerks her upward, lifting her body off the ground. They briefly disappear behind a parked white vehicle. When they come back into view, the deputy is holding Arnold by her braids, slamming her repeatedly onto the cement. At one point, he whips her down so violently her body spins around and flips over. The footage ends as the deputy crouches down and places a knee onto Arnold's back. The Sheriff's Office is conducting an investigation into the incident, something it has not done in some similar cases, according to court records.

Sen. Joe Manchin responded to calls for voting for Climate Change reforms in the Build Back Better bill by denouncing out-of-staters "who try to tell West Virginians what is best for them." This suggests that in this state, the most vulnerable of all, in a major flood, losing most power stations, half the roads, one third of schools and nearly two thirds of all fire stations, is what is best for West Virginia.

Joe Manchin has received more money from the oil, coal and gas industries than any other senator.

Victor Mercado, 64, in Rikers Island since July, in lieu of $100,000 bail, died there of COVID-19 on Friday. He had underlying health conditions. On Friday, the Bronx District Attorney's Office agreed to request emergency release. By noon, the judge had granted Mercado conditional release. But it was too late. Mercado's death — he's the 13th person to die in custody in New York City's jail system this year — underscores the deepening crisis at Rikers Island.

The Brazilian senate is prepared to charge Pres. Jair Bolsonaro with "crimes against humanity" over his handling of the coronavirus pandemic. Some have said that the blood of some 300,000 are on his hands. He denied the reality of the pandemic for many months, urging people to disregard the emergency. He even publicly injested hydroxychloroquine.

The recommended charges against Bolsonaro carry 50 to 150 years in prison.

BRODNER

Sen. Angus King (I–ME), now supports reforming the filibuster:

"There has been a great deal of talk in recent months of a possible Constitutional crisis in 2022 or 2024.

Mr. President, we don't have to wait that long; we are in the midst of such a crisis right now. One of our great political parties has embraced the idea that our last election was fraudulent, that our president is illegitimate, and that they must move legislatures across the country to "fix" the results of future elections. A substantial proportion of our population has lost faith in our democratic system and seems prepared to accept authoritarianism; all but the most extreme sources of information have been devalued; and violence bubbles just below the surface."

BRODNER

Jason Kessler seen at the racist march on Aug. 11, 2017. In Charlottesville, VA. 24 white supremacists are being brought to trial, under the Ku Klux Klan Act of 1871, beginning today. This racist rally resulted in the death of 32-year-old Heather Heyer. "One message of this case is that these events — like Charlottesville, like Jan. 6 — they're not these spontaneous, flukish events that just happen," said Karen Dunn, a prominent trial lawyer serving as co-lead counsel for the plaintiffs. "There is an enormous undercurrent of planning, of intent and of purposefulness that we all need to wake up to."

"Repugnant, conspiratorial views that seemed bizarre and shocking to most Americans on Aug. 11 and 12, 2017, are absolutely being mainstreamed now every single day," said Megan Squire, a professor in computer science at Elon University who tracks online far-right organizing, including the planning ahead of Unite the Right. "You can add vaccine conspiracies, covid hoax conspiracies, QAnon-type stuff — it's all completely mainstream on the right at this point."

BRODNER

Rolling Stone magazine reports that Republican members of Congress aided in planning the January 6 insurrection and attempted overthrow of the US government. Rep. Alexandria Ocasio-Cortez (D-NY) has called for the expulsion of any member of Congress who helped plan the storming of the U.S. Capitol.

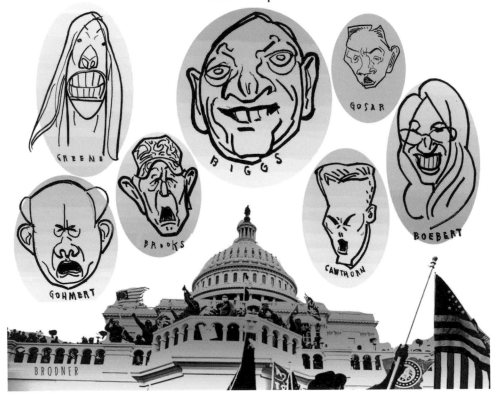

Secretaries of state and election officials around the country are being persecuted by organized GOP mobs. Without support many officials will leave the field to Trump goons in the near future. Yesterday there was a senate hearing regarding this. They are called, texted, tracked with grisly personal attacks and threats. They are using small amounts from their meager salaries to hire security.

"I'm really jonzing to see your purple face after you've been hanged," said an email. "Your security detail is far too thin and incompetent to protect you," another message said, probably correctly.

BRODNER

On Aug. 25, 2020, two men protesting the police killing of Jacob Blake, Joseph Rosenbaum and Anthony M. Huber, were killed in the streets of Kenosha, WI. trying to disarm 17-year-old vigilante Kyle Rittenhouse, who fired an automatic weapon. Yesterday the judge overseeing the trial of Rittenhouse ruled that the protesters shot by the teenager cannot be labeled "victims" during the trial but can be called "rioters," "looters" or "arsonists," if the defense can provide evidence to justify such terms.

Beryl Howell, the chief judge of the federal District Court in Washington, D.C., said prosecutors appeared "almost schizophrenic" in describing the insurrection in extreme terms but then settling for second-tier misdemeanor plea agreements with dozens of defendants. "This is a muddled approach by the government," said Howell, an appointee of Pres. Obama. "I'm trying to make sense of the government's position here." "The rioters attacking the Capitol on Jan. 6 were not mere trespassers engaging in protected First Amendment conduct or protests," Howell added. "They were not merely disorderly, as countless videos show the mob that attacked the Capitol was violent. Everyone participating in the mob contributed to that violence."

The Biden administration has restored protections for migratory birds that had been swept away by Trump. Oil businesses, landowners, etc. will no longer be able to kill birds and not be punished. North America has lost nearly 3 billion birds in the last 50 years. Climate change, collisions with buildings, power-lines, oil waste pits and spills are major causes of these losses. There are one million species at risk of extinction in the growing biodiversity crisis caused by human activities.

BRODNER

Tina Stege represents the Marshall Islands at the COP26 summit in Glasgow. Rising sea levels could sink much of her island nation. Time is running out. "I don't think it should be acceptable to any person in this world to write off a country," she told the BBC. "Those who are the larger, wealthier nations who have really created the problem in the first place, unfortunately, have the resources to respond and we do not. We need to start thinking about how to raise land, buildings, how we are going to survive."

BRODNER

"Manchin is the perfect example of how Big Oil works. He's taken more money than any other senator from the fossil fuel industry. And, you know, there was that sting videotape released a couple of weeks ago where Exxon's chief lobbyist reported talking to him every week and calling him their "kingmaker." There was a report yesterday that Manchin spent part of September huddled with all the leading coal barons at a golf resort."

– Bill McKibben

Mackenzie Atwood, a senior at Franklin High School, Franklin Mass, was speaking at a school committee meeting on Tuesday about bullying toward LGBTQ students when she was interrupted by a parent who, as if to demonstrate what bullying looked like, began yelling, "This has to stop. This is indoctrination." The situation escalated. Atwood, shocked and fighting tears, removed her face mask and expressed disbelief that the woman could look her "in the eye and say that I'm not being oppressed at this."

BRODNER

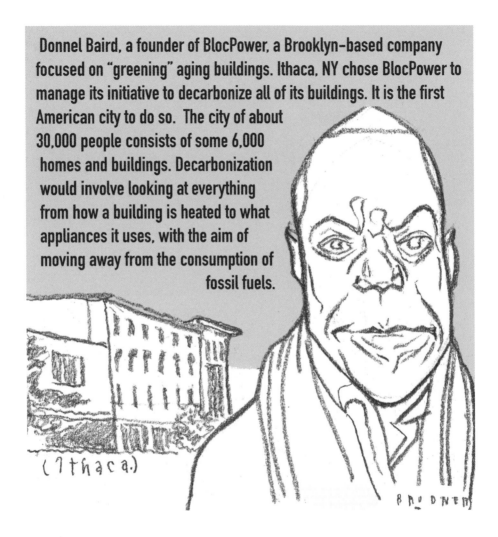

Donnel Baird, a founder of BlocPower, a Brooklyn-based company focused on "greening" aging buildings. Ithaca, NY chose BlocPower to manage its initiative to decarbonize all of its buildings. It is the first American city to do so. The city of about 30,000 people consists of some 6,000 homes and buildings. Decarbonization would involve looking at everything from how a building is heated to what appliances it uses, with the aim of moving away from the consumption of fossil fuels.

(Ithaca.)

BRODNER

Miriam Adelson, widow of Sheldon, has come out of mourning to host GOP leaders and 2024 hopefuls at her Las Vegas home. She is the 5th richest woman in the world with an estimated fortune of $32.4 billion. The Adelsons have given $1/2 billion to the Republican party in the last decade.

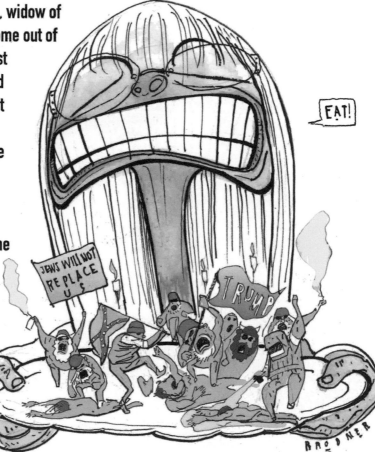

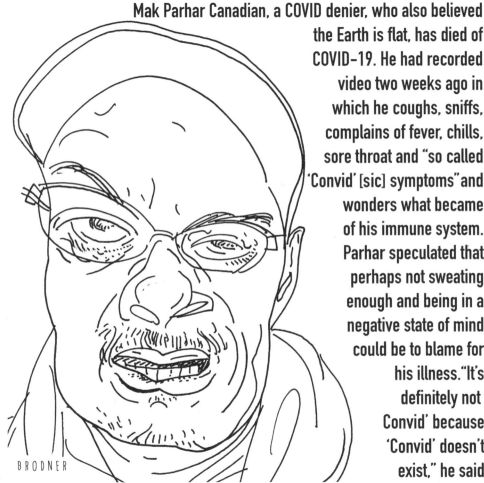

Mak Parhar Canadian, a COVID denier, who also believed the Earth is flat, has died of COVID-19. He had recorded video two weeks ago in which he coughs, sniffs, complains of fever, chills, sore throat and "so called 'Convid' [sic] symptoms" and wonders what became of his immune system. Parhar speculated that perhaps not sweating enough and being in a negative state of mind could be to blame for his illness. "It's definitely not 'Convid' because 'Convid' doesn't exist," he said.

BRODNER

Judge Tanya S. Chutkan, ruling that Trump must turn over his documents to the House committee, wrote. "... Presidents are not kings, and plaintiff is not president." Laurence Tribe: "Perhaps Merrick Garland ...was waiting to hear a court say that executive privilege doesn't apply to the former president when the current president does not assert that privilege . . . He got it tonight. And if he does not move immediately (in indicting Bannon). . . he will be obstructing Congress."

BRODNER

Fresh evidence emerged yesterday supporting Josh Hawley's warning about the decline of American manhood.

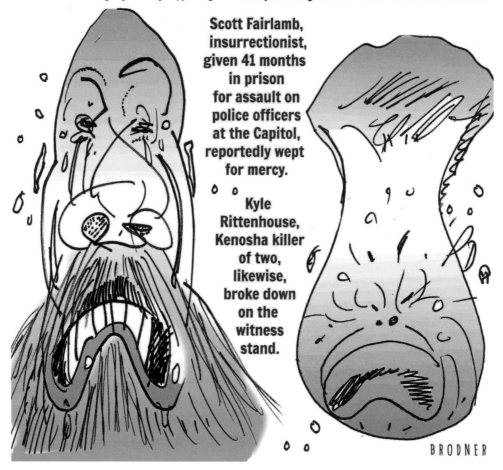

Scott Fairlamb, insurrectionist, given 41 months in prison for assault on police officers at the Capitol, reportedly wept for mercy.

Kyle Rittenhouse, Kenosha killer of two, likewise, broke down on the witness stand.

BRODNER

When San Francisco police officer Jack Nyce missed the city's Nov. 1 deadline to submit his coronavirus vaccination record, he was placed on a month of paid administrative leave. He died Saturday of covid-19. He was 46 years old.

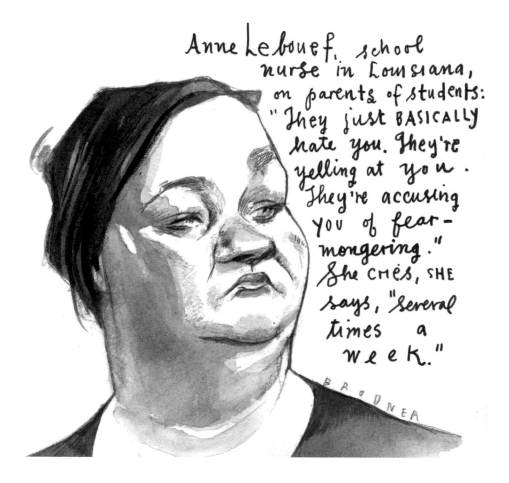

Anne Lebouef, school nurse in Louisiana, on parents of students: "They just BASICALLY hate you. They're yelling at you. They're accusing you of fear-mongering." She cries, SHE says, "several times a week."

BRODNER

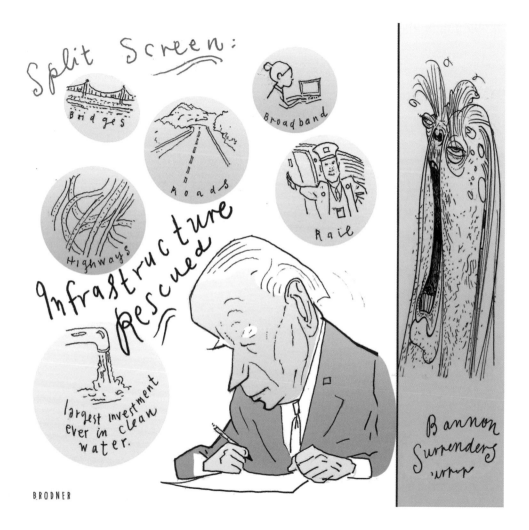

Split Screen:

Bridges

Roads

Broadband

Highways

Rail

Infrastructure Rescued

largest investment ever in clean water.

BRODNER

Bannon Surrenders

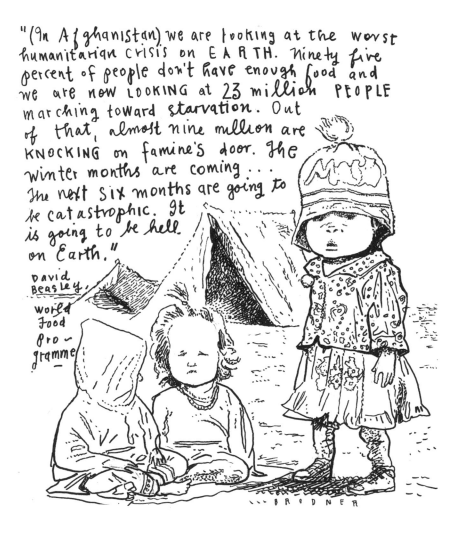

"(In Afghanistan) we are looking at the worst humanitarian crisis on EARTH. Ninety five percent of people don't have enough food and we are now LOOKING at 23 million PEOPLE marching toward starvation. Out of that, almost nine million are KNOCKING on famine's door. The winter months are coming... The next six months are going to be catastrophic. It is going to be hell on Earth."

David Beasley, World Food Programme

BRODNER

Split Screen II:
① The House yesterday VOTED to censure Paul Gosar for a murder-signaling video.

② "QAnon Shaman" Jacob Chansley was sentenced to 41 months for his role in the 1/6 riot. (Gosar's sister: "Always stand up to fascism. NEVER back down.")

BRODNER

Martín Espada won a National Book Award for his book of poetry, *Floaters,* which honors asylum seekers who've drowned trying to cross the Rio Grande into Texas.

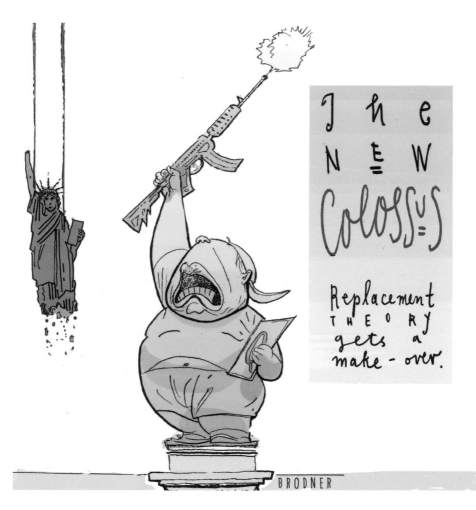

The NEW Colossus

Replacement THEORY gets a make-over.

BRODNER

Kyle Rittenhouse, the 18-year-old who fatally shot two people during unrest in Kenosha, Wis., was acquitted of all charges in a criminal trial.

"EVERY day I wish I could COME home to him and unload some of this weight that's on my shoulders BUT I can't because he's dead. And now THE system is telling me THAT nobody has to account for that."

— Hannah Giddings, partner of Anthony Huber, killed by Kyle Rittenhouse.

Tucker Carlson EXALTED Rittenhouse Monday with an HOUR-LONG interview encouraging vigilante "justice".

"THE STAGE IS BEING SET FOR CHAOS. IMAGINE (IN 2024) ... COMPETING MASS PROTESTS ... AS LAWMAKERS FROM BOTH PARTIES CLAIM VICTORY, PARTISANS ON BOTH SIDES WILL BE BETTER ARMED AND MORE WILLING TO INFLICT HARM THAN IN 2020.

AS IT WAS, TRUMP CAME CLOSE TO BRINGING OFF A COUP EARLIER THIS YEAR... THE FOUNDERS DID NOT FORESEE A TRUMP PHENOMENON... THEY ANTICIPATED THE THREAT OF A DEMAGOGUE, BUT NOT OF A NATIONAL CULT OF PERSONALITY... HIS EGOMANIA IS PART OF HIS APPEAL. IN HIS PROFESSED VICTIMIZATION

BY THE MEDIA AND THE "ELITES", HIS FOLLOWERS SEE THEIR OWN VICTIMIZATION. THAT'S WHY MILLIONS OF TRUMP SUPPORTERS HAVE BEEN WILLING TO RISK DEATH AS PART OF THEIR SHOW OF SOLIDARITY. WHEN TRUMP'S ENEMIES CITED HIS MISHANDLING OF THE PANDEMIC TO DISCREDIT HIM THEIR ANSWER

WAS TO REJECT THE PANDEMIC. ... ALREADY THERE HAVE BEEN THREATS TO BOMB POLLING SITES, KIDNAP OFFICIALS AND ATTACK STATE CAPITOLS, SO IF THE RESULTS COME IN SHOWING ANY DEMOCRATIC VICTORY, TRUMP'S SUPPORTERS WILL KNOW WHAT TO DO... "

ROBERT KAGAN

The lynch mob THAT murdered
Ahmaud Arbery was
convicted Wednesday.
Thanks to organizing,
using video, the case,
after being buried by
police, came to trial.
Theawanza Brooks, his aunt,
was a leader,
documenting the case,
GOING live on Facebook:
" The ACTIVISM kicked
in me that I never saw
myself being a PART of.
I feel that every day
that I GO out, I have
to have some kind
of REPRESENTATION
of Ahmaud."
she said.

BRODNER

Maj Ian Fishback's report on torture AND abuse of prisoners in Iraq led to THE passage of the Detainee Treatment Act with bipartisan support. He returned FROM combat tours in the Middle East WITH PTSD. while advocating for human rights his life fell APART. He died in an adult foster care facility on Nov. 19.

"The system FAILED him utterly and tragically." a family statement said. HE was 42 years old.

BRODNER

A flood of mostly unvaccinated Covid-19 patients has been ARRIVING at Michigan ERs, already packed with people suffering FROM other issues, sending capacity TO unprecedented levels. EXPERTS fear a 5TH surge.

BRODNER

KIWIS are a group of flightless birds that are endangered and vulnerable. The ROWI species of KIWI is tagged as facing extinction. The current population is around 450. Deforestation and climate change are the biggest threat to THEIR survival.

BRODNER

Izabela, a 30 year old pregnant mother arrived at a Polish hospital. Her fetus WAS showing abnormalities, but had a heartbeat. Because of strict Polish anti-abortion laws, doctors could NOT operate. Both Izabela and fetus died. Polish protesters marched with her image on a sign THAT read: "Her heart was beating too." Today the U.S. Supreme COURT will consider knocking down abortion rights in the United States.

BRODNER

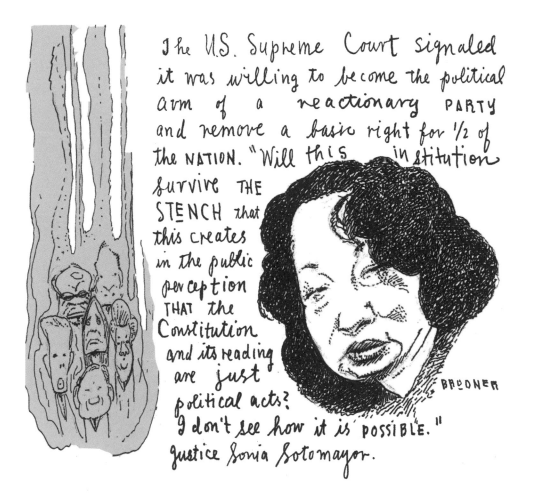

The U.S. Supreme Court signaled it was willing to become the political arm of a reactionary PARTY and remove a basic right for ½ of the NATION. "Will this institution survive THE STENCH that this creates in the public perception THAT the Constitution and its reading are just political acts? I don't see how it is POSSIBLE." Justice Sonia Sotomayor.

BREONER

TATE MYRE, one of 4 students murdered in the Oxford High school shooting in Michigan, reportedly, while trying to DISARM the gunman.

He was 16 years old.

BRODNER

Javiera Rojas, Chilean environmental ACTIVIST was found dead in her home with her body bearing multiple wounds. She had led a successful protest against a dam that would have STOLEN water from LOCAL communities and harmed WILDLIFE. Two men have been arrested.

"The Democratic emergency is already HERE.", Richard Hasen, UC Irvine, told me in late October. ..." WE face a serious risk that American democracy as we KNOW it will come to an END in 2024.", he SAID,"But urgent action is not happening." ... For more than a year now with... SUPPORT from the GOP's national leaders, STATE ELECTED officials in AZ, TX, GA, PA, WI, MI have studied Donald TRUMP's crusade to overturn the 2020 election. ... some have REWRITTEN STATUTES to seize partisan control (over)...which ballots to count... THEY are DRIVING out or stripping POWER from officials... They are fine-tuning a legal ARGUMENT that purports to allow STATE legislators to override the CHOICE of the VOTERS.

WHO or what will safeguard our Constitutional ORDER is not APPARENT today.

Barton Gelman

... some (Democrats), including PRESIDENT Joe Biden, have taken PASSING rhetorical notice but their attention wanders. They ARE making a GRIEVOUS mistake... Our TWO-party system has only ONE party LEFT that is willing to lose an ELECTION. The other is willing to win at THE COST of BREAKING THINGS that a democracy cannot live without."

BRODNER

Gen. Charles Flynn and Lt. Gen. Walter Piatt resisted calling in the National Guard to the Capitol on Jan. 6, 2021, according to a new report calling them "absolute and unmitigated liars." Flynn is the brother of Michael Flynn.

BRODNER

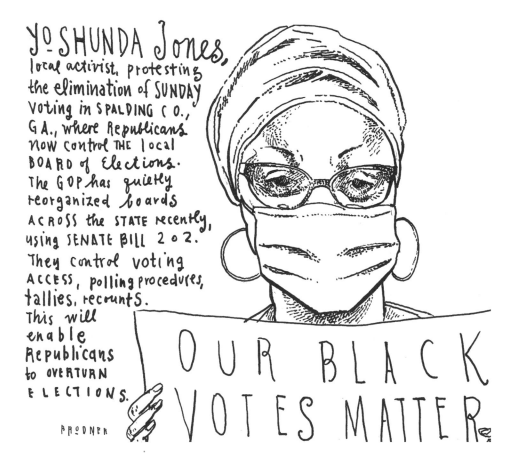

YO-SHUNDA Jones, local activist, protesting the elimination of SUNDAY voting in SPALDING CO., GA., where Republicans now control THE local BOARD of Elections. The GOP has quietly reorganized boards ACROSS the STATE recently, using SENATE BILL 202. They control voting ACCESS, polling procedures, tallies, recounts. This will enable Republicans to OVERTURN ELECTIONS.

PRODNER

OUR BLACK VOTES MATTER.

PAUL WALDRON.

2020 election denier, circulated a 38-page POWER POINT document to Trump allies and members of CONGRESS detailing a conspiracy THEORY of how the ELECTION was fraudulent. The document claims that people in ITALY used satellites to alter voting machines in the U.S. Waldron's background in the U.S. military was in, in his words, "information warfare."

BRODNER

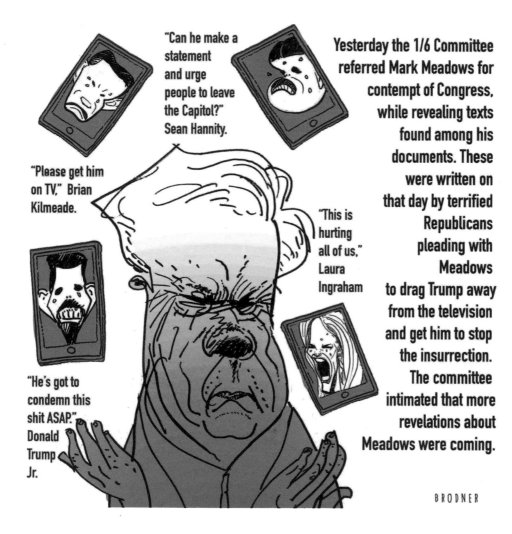

"Can he make a statement and urge people to leave the Capitol?" Sean Hannity.

"Please get him on TV," Brian Kilmeade.

"This is hurting all of us," Laura Ingraham

"He's got to condemn this shit ASAP." Donald Trump Jr.

Yesterday the 1/6 Committee referred Mark Meadows for contempt of Congress, while revealing texts found among his documents. These were written on that day by terrified Republicans pleading with Meadows to drag Trump away from the television and get him to stop the insurrection. The committee intimated that more revelations about Meadows were coming.

BRODNER

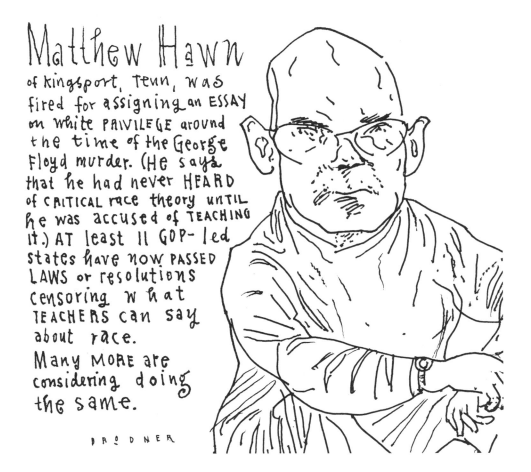

Matthew Hawn of kingsport, Tenn, was fired for assigning an ESSAY on white PRIVILEGE around the time of the George Floyd murder. (He says that he had never HEARD of CRITICAL race theory until he was accused of TEACHING it.) AT least 11 GOP-led states have now PASSED LAWS or resolutions censoring what TEACHERS can say about race. Many MORE are considering doing the same.

PRODNER

In the path of the devastating tornadoes that struck Kentucky, the OWNERS of a scented CANDLE factory reportedly refused to allow their employees to LEAVE the facility. "...God, where are you at? Why did you LET this happen?", said Kyanna Parsons-Perez, a worker buried for hours in RUBBLE. (survivors JUSTIN and SUNNY at a shelter in Wingo, KY. Sunny's brother didn't make it out alive.)

BRODNER

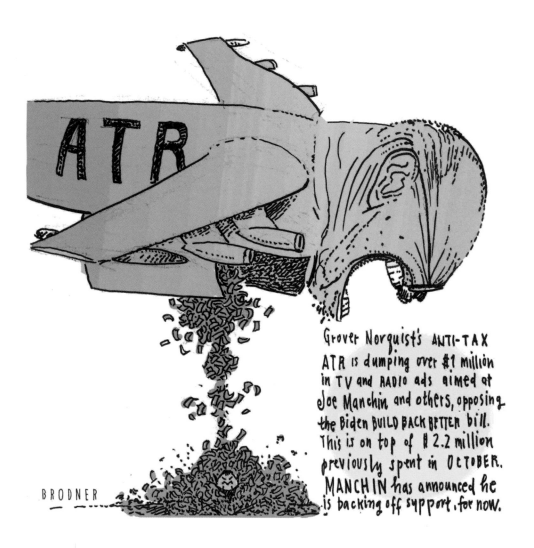

Grover Norquist's ANTI-TAX
ATR is dumping over $1 million
in TV and RADIO ads aimed at
Joe Manchin and others, opposing
the Biden BUILD BACK BETTER bill.
This is on top of $2.2 million
previously spent in OCTOBER.
MANCHIN has announced he
is backing off support, for now.

BRODNER

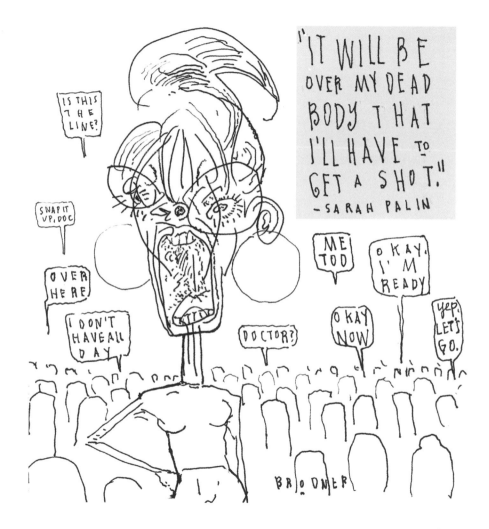

Gabriel Boric

has been elected PRESIDENT of Chile. At 35 he will be Chile's youngest PRESIDENT. HE vowed to fight for progressive social REFORMS and overturn ECONOMIC policies left OVER from THE US-backed DIC-TATORSHIP of Augusto Pinochet.

BRODNER

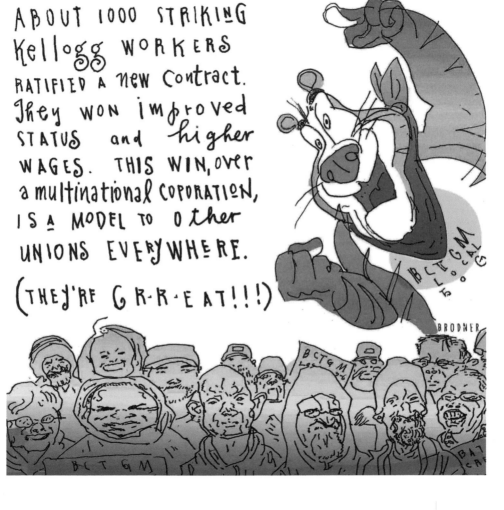

ABOUT 1000 STRIKING Kellogg WORKERS RATIFIED A new Contract. They WON improved STATUS and higher WAGES. THIS WIN, over a multinational CORORATION, IS A MODEL TO other UNIONS EVERYWHERE.

(THEY'RE G·R·R·E·AT!!!)

BRODNER

In Benjamin Franklin's FINAL SPEECH, he urged the ratification of CONSTITUTIONAL government, but added:

"I believe that this is LIKELY to be well administered IN the COURSE of years AND can only END in DESPOTISM, as other forms have done before IT, when the PEOPLE shall become so CORRUPTED as to need despotic government, being incapable of ANY OTHER."

As reported by James Madison, Philadelphia, 1787

BRODNER

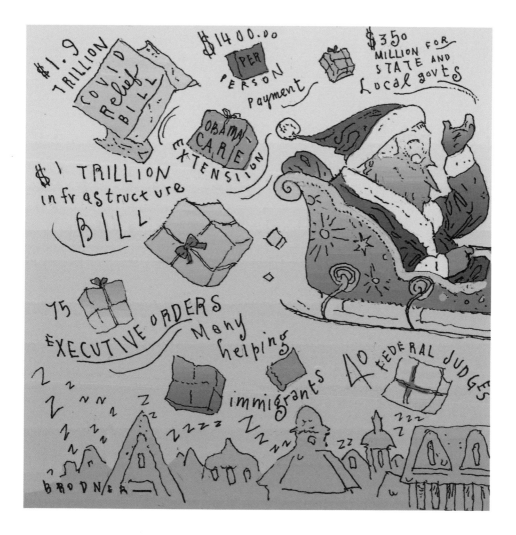

Eudes PIERRE, 26,

in the throes of a MENTAL health crisis, was shot 10 times by police on EASTERN Parkway in Brooklyn. The shooting occured near where JAHEED VASSELL, also Black and with mental problems, was killed by POLICE in 2018. "when you call 911 the POLICE come and SURROUND you," said IMANI HENRY, of Equality for FLATBUSH. "We don't need the cops. They're NOT trained."

BRODNER

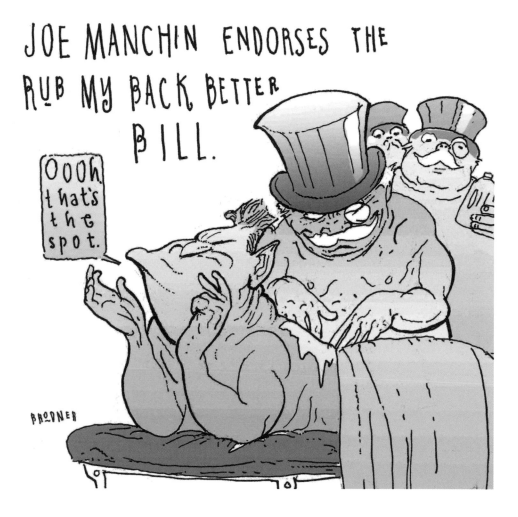

Valentina Orellana-
Peralta, 14, had
moved from Chile to the
U.S. this year and was
already a top student.
At a store in the San
Fernando Valley, while
trying on a dress, she was
killed by a ricocheting
bullet, fired from an
automatic weapon by
an LAPD officer, who was
trying to subdue an unarmed
suspect, who was attacking
shoppers with a bike lock.
"This is what my daughter
found here: death,"
said her father.

BRODNER

BRI LYN
NURSE,
TEXAS:
"SO TODAY WAS
THE BUSIEST
DAY EVER. I
THOUGHT I LEFT
COVID... TURNS
OUT GOD LAUGHED
IN MY FACE.
YÁLL. 2 NURSES.
42 PATIENTS.
FORTY - TWO!!
MOST ARE COVID+.
I'M ... WORE ... OUT.
ON A SIDE NOTE,
I THINK I CAN START
AN IV ON ANYONE
WITH MY EYES CLOSED
NOW.
EXHAUSTED."

THE TOP STORY OF 2022:*

"DONALD TRUMP IS NOT JUST A WILD AND CRAZY GUY WHO HAPPENED TO LUCK INTO THE PRESIDENCY. HE'S, IN A SENSE, SYSTEMATICALLY UNBUILDING AMERICAN DEMOCRACY AND IS PREPARING FOR THE FINAL STAGE OF THAT. IT'S AN AUTOCRATIC MOVEMENT THAT HE IS HEADING." — JAY ROSEN

* ALSO 2016, 17, 18, 19, 20, 21, 23, 24

(HAVE A HEALTHY, ACTIVE AND LOUD NEW YEAR! — SB.)

466 DECEMBER 31, 2021

Liz Cheney said on CBS that the 1/6 Committee had first-hand testimony that during the insurrection Trump was watching television in his private dining room. He "went to war with the rule of law," she said. "Any man . . . who would provoke a violent assault on the Capitol to stop the counting of electoral votes, any man who would watch television as police officers were being beaten, as his supporters were invading the Capitol of the United States is clearly unfit for future office, clearly can never be anywhere near the Oval Office ever again."

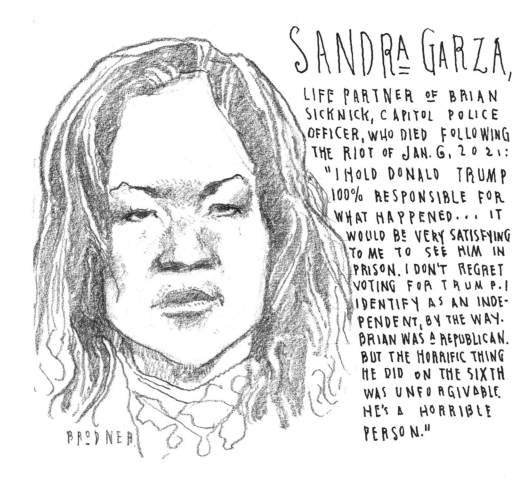

SANDRA GARZA,

LIFE PARTNER OF BRIAN SICKNICK, CAPITOL POLICE OFFICER, WHO DIED FOLLOWING THE RIOT OF JAN. 6, 2021:

"I HOLD DONALD TRUMP 100% RESPONSIBLE FOR WHAT HAPPENED... IT WOULD BE VERY SATISFYING TO ME TO SEE HIM IN PRISON. I DON'T REGRET VOTING FOR TRUMP. I IDENTIFY AS AN INDEPENDENT, BY THE WAY. BRIAN WAS A REPUBLICAN. BUT THE HORRIFIC THING HE DID ON THE SIXTH WAS UNFORGIVABLE. HE'S A HORRIBLE PERSON."

BRODNER

Facebook is revealed to be more of a massive source of hate-group organizing and misinformation than previously thought. There were over 650,000 posts attacking the legitimacy of the election in 2020. Facebook had attempted to police these groups but dissolved the effort in November, 2020, according to a new Washington Post/Pro Publica story. As some administrators are themselves conspiracy theorists about vaccines, etc., reliable enforcement rarely takes place, say former employees. Preserving "groups" is essential to Meta's bottom line.

LAURENCE TRIBE ON THE JAN. 5
SPEECH BY MERRICK GARLAND:
" He said absolutely nothing
about the larger plot to
overturn the election. That
was not Jan. 6. Jan. 3 was
the date the ex-president
twisted the arm of
Raffensperger. In late
December he was doing
things with Jeffrey Clark.
That was Plan A. Plan B
was the one they had to
resort to with the violence
at the Capitol... It
doesn't necessarily take a long
time to build a case for SEDITIOUS
CONSPIRACY...
The clock is ticking. There is
no indication that the D.O.J. is
investigating the broader plot."

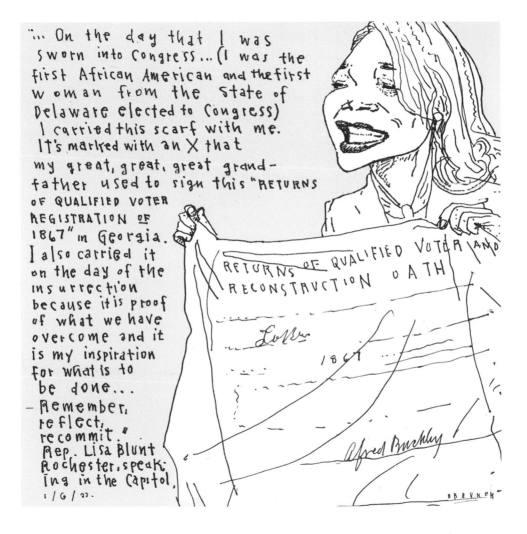

"... On the day that I was sworn into Congress... (I was the first African American and the first woman from the state of Delaware elected to Congress) I carried this scarf with me. It's marked with an X that my great, great, great grand-father used to sign this "RETURNS OF QUALIFIED VOTER REGISTRATION OF 1867" in Georgia. I also carried it on the day of the insurrection because it is proof of what we have overcome and it is my inspiration for what is to be done...
- Remember, reflect, recommit."
Rep. Lisa Blunt Rochester, speaking in the Capitol, 1/6/22.

RETURNS OF QUALIFIED VOTER AND RECONSTRUCTION OATH

1867

Alfred Buckley

BRAUNER

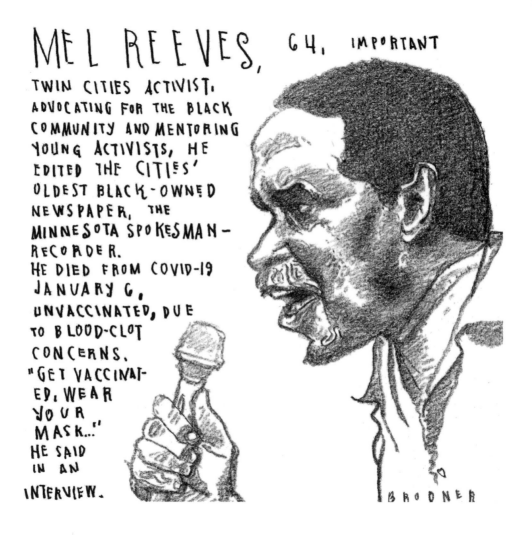

MEL REEVES, 64, IMPORTANT

TWIN CITIES ACTIVIST. ADVOCATING FOR THE BLACK COMMUNITY AND MENTORING YOUNG ACTIVISTS, HE EDITED THE CITIES' OLDEST BLACK-OWNED NEWSPAPER, THE MINNESOTA SPOKESMAN-RECORDER. HE DIED FROM COVID-19 JANUARY 6, UNVACCINATED, DUE TO BLOOD-CLOT CONCERNS. "GET VACCINATED, WEAR YOUR MASK..." HE SAID IN AN INTERVIEW.

BROONER

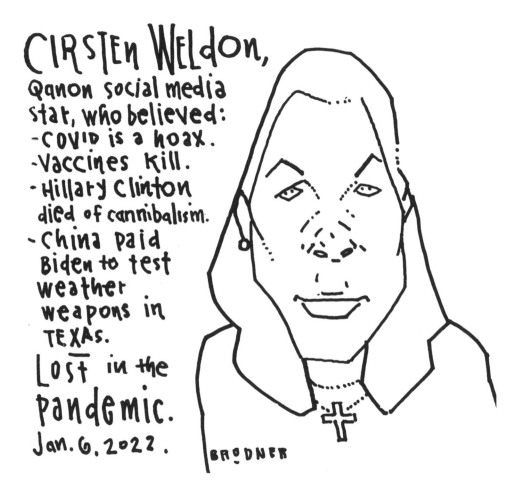

CIRSTEN WELDON,
Qanon social media star, who believed:
- COVID is a hoax.
- Vaccines kill.
- Hillary Clinton died of cannibalism.
- China paid Biden to test weather weapons in TEXAS.
Lost in the pandemic.
Jan. 6, 2022.

BRODNER

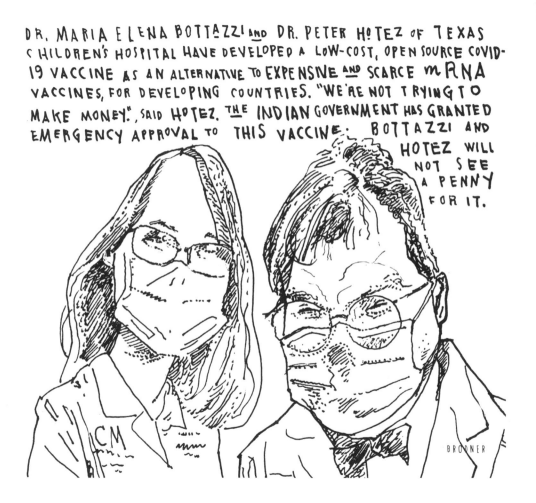

DR. MARIA ELENA BOTTAZZI AND DR. PETER HOTEZ OF TEXAS CHILDREN'S HOSPITAL HAVE DEVELOPED A LOW-COST, OPEN SOURCE COVID-19 VACCINE AS AN ALTERNATIVE TO EXPENSIVE AND SCARCE mRNA VACCINES, FOR DEVELOPING COUNTRIES. "WE'RE NOT TRYING TO MAKE MONEY.", SAID HOTEZ. THE INDIAN GOVERNMENT HAS GRANTED EMERGENCY APPROVAL TO THIS VACCINE. BOTTAZZI AND HOTEZ WILL NOT SEE A PENNY FOR IT.

Dr. Anthony Fauci: " (While) virtually everybody is going to wind up getting exposed and likely get infected… If you're vaccinated and if you're boosted, the chances of you getting sick are very, very low." Fauci later said that unvaccinated people are 20 times likelier to die, 17 times likelier to be hospitalized and 10 times likelier to be infected than the vaccinated. A World Health Organization official on Tuesday predicted that the omicron variant will have infected more than half of the population in the European region in the next six to eight weeks.

"We used to give the title "anti-fascist" to the older comrades. . . We never thought. . . how soon we might earn that great title of honor for ourselves. In the Berthold Brecht play, Arturo Ui, . . . the leader steps forth, after Hitler's body has turned to carrion, and says, "Well this is the thing that nearly had us mastered. But do not think that is all, for though we rose up to beat the bastard, the bitch that bore him is in heat again." And I think that the stench of the rubble and carrion from Oklahoma is a kind of a warning. . . . Those who want to turn our democratic republic into an empire. They say they are pioneers, frontiersman. Who are they? . . . What is antigovernment about these extruded forces of the state? They will, when the time comes . . . be the Freikorps. They are the people who will take orders. These are the people who will be docile forces of a government who will always regard them as deniable. And we have been warned."

Christopher Hitchens, Nation Panel, 1995

BRODNER

ARTIST'S STATEMENT

March 2020. Like many people, I was beginning to feel overwhelmed by the widening COVID-19 crisis. I have always dealt with my down periods by making pictures and writing things down. Journaling helps me look at my feelings as they occur, in real time; later, as those feelings shift around, Journaling can help me achieve perhaps a bit more perspective. I began with a simple portrait of a young New York male nurse. Soon I was drawing every day and placing them on social media: finding people who were suffering in this terrible mass death, whose faces and names our consciousness might retain for an extra moment, making more vivid the lives that had been cut tragically short. This became a personal memorial spot for me, like lighting candles around a photo on a street corner. As the consequences of the pandemic became exacerbated by Trump administration malfeasance and mendacity, calling those political actors out became a clear part of the story as well. Soon this was getting picked up by the *Washington Post*, *American Prospect*, and media. *The Nation*, where I have been a contributor for 25 years, published it as a weekly column. It has since become my daily practice to isolate a moment in the day's events and memorialize it in word and image. It is in this exercise that I hope to freeze the firehose of news for just a moment for the sole purpose of contemplation. Some stories, like those of Black men and women persecuted by police or the developing conspiracy against the 2020 election, demanded our focus before we moved on to the next mind-bending horror. That would be the best thing that can happen when looking through this book: another precious minute spent on a human being you may never have heard of or a story you may have missed, or one that got big headlines but turned out to be different in retrospect. I am sure your internal chronicle of the two years in question would be different. This is just one man's take. But if some of these pieces help you connect the political dots or make you pause and consider the human toll, then this modest project will have been a successful one. ✳ SB

"Each portrait of a person in this collection of extraordinary drawings by Steve Brodner about day-to-day life in a pandemic-ruled world represents our daily confrontation with death — often by politically derived deception — and stays imprinted in our reflective memory.

As art, they are brilliant combinations of graphic invention that use shifts from sharp black lines of vicious caricature to tonal portraits of poignant remembrances of unsung heroes."

— Burt Silverman
 An acclaimed painter for over sixty years, whose artistic engagement with politics began
 with a 1956 series of drawings in collaboration with Harvey Dinnerstein, when the pair
 embedded with the Montgomery Bus Boycott.

"Day after day — as the pandemic raged and anxiety increased prior to the election of 2020 — and continuing on for 500 days and counting, Steve Brodner has produced a daily visual column. Written in his literate, compassionate voice, and drawn, it seems, with a stiletto dipped in ink, his goal has been to memorialize those who have been lost, and to skewer those whose malevolence and willful ignorance have threatened our humanity and our country. The result is this extraordinary book, Living & Dying in America, an epic and heart-breaking chronicle of our disquieting times."

— Rick Meyerowitz
 Illustrator for the National Lampoon and *The New York Times*, and author of the
 Lampoon history *Drunk Stoned Brilliant Dead*.

"I've begun to think of your daily drawings as some sort of auto-drawing response to the overwhelming insanity now upon us, allowing us to distill this madness into manageable bites. Thank you for your dedication to this project."

— McClain Moore
Commercial artist, editorial illustrator and painter, raised on Choctaw and Cherokee land

"Steve Brodner is one of the finest caricaturists of this era, in the sharp, scathing tradition of the late great Miguel Covarrubias, Al Hirschfeld, and David Levine."

— Jake Tapper
journalist on CNN's The Lead with Jake Tapper and State of the Union.

"It would take a lot of words, too many words, to capture the wit, insight and beauty of a single work by Steve Brodner. He is alone in his mastery of the form."

— Alec Baldwin

Actor, writer, talk show host, known for his roles in
Glengarry Glenn Ross, It's Complicated, and 30 Rock.

"An example of visual journalism at its finest, this patchwork of sensitive portraiture, searing caricature and hilarious political cartoons deftly capture the tragedy, heroism and comic absurdities of our time in ways that few others have."

— Terry Brodner
Illustrator

"In a world where the temptation is great to give up on hope and disconnect, Steve remains the single most committed, driven, empathic, and talented chronicler of our era. He is our Art Young."

— Victor Juhazs
Illustrator of Matt Taibbi's essays in *Rolling Stone*, and visual journalist of
US armed forces in training, combat and recovery from injury.